RULING FROM THE
DRAGON THRONE

RULING FROM THE
DRAGON

THRONE

COSTUME OF THE QING DYNASTY (1644–1911)

JOHN E. VOLLMER

TEN SPEED PRESS

Berkeley / Toronto

Copyright © 2002 by John E. Vollmer

All rights reserved. No part of this book may be reproduced in any form, except brief excerpts
for the purpose of review, without written permission of the publisher.

Ten Speed Press
P.O. Box 7123
Berkeley, California 94707
www.tenspeed.com

Distributed in Australia by Simon & Schuster Australia, in Canada by Ten Speed Press Canada, in
New Zealand by Southern Publishers Group, in South Africa by Real Books, in Southeast Asia by
Berkeley Books, and in the United Kingdom and Europe by Airlift Book Company.

Jacket and text design by Jeff Puda
Copyediting by Clancy Drake
Illustrations by Richard Sheppard

Library of Congress Cataloging-in-Publication Data
Vollmer, John, 1945–
Ruling from the Dragon Throne : costume of the Qing dynasty
(1644-1911) / John E. Vollmer.
p. cm.
Includes bibliographical references and index.
ISBN 1-58008-307-2
1. Costume—China—History—Ming–Qing dynasties, 1368–1912.
2. China—History—Qing dynasty, 1644–1912. I. Title.
GT1555 .V65 2002
391'.00951—dc21
2002009713

First printing, 2002
Printed in Hong Kong

1 2 3 4 5 6 7 8 9 10 — 07 06 05 04 03 02

TO MENTORS AND COLLEAGUES WITH
RESPECT AND ADMIRATION:

Katharine Brett

Dorothy K. Burnham

Harold B. Burnham

Veronika Gervers-Molnar

Donald King

Krishna Riboud

CONTENTS

ILLUSTRATIONS

CHRONOLOGIES

LATE IMPERIAL CHINA

1279–1368 Yuan dynasty (Mongol)

1368–1644 Ming dynasty

1644–1911 Qing dynasty (Manchu)

MANCHU EMPERORS*

1616–1626 Nurgaci (1559–1626)

1626–1643 Hongtaiji (1593–1643)**

1643–1661 Shunzhi (1638–1661)

1661–1722 Kangxi (1654–1722)

1722–1735 Yongzheng (1678–1735)

1735–1795 Qianlong (1711–1799)

1796–1820 Jiaqing (1760–1820)

1821–1850 Daoguang (1782–1850)

1850–1861 Xianfeng (1831–1861)

1861–1875 Tongzhi (1856–1875)

1875–1908 Guangxu (1871–1908)

1909–1911 Xuantong (1906–1967)

* Although the Qing dynasty was proclaimed in 1635, the Manchu were not in power in Beijing until 1644, following the collapse of the previous Ming dynasty. In customary Chinese Confucian practice, imperial titles were bestowed on the father and grandfather of the Shunzhi emperor, the first Manchu to sit on the Dragon Throne in the Forbidden City. Hence, this list of Qing emperors includes Nurgaci and Hongtaiji. In addition, it includes the accession date of Hongtaiji's five-year-old son in 1643.

** Hongtaiji proclaimed the Great Qing dynasty in 1635. At the same time, he changed his title from khan of the Later Jin, first used by his father, Nurgaci, in 1616, to emperor of the Qing.

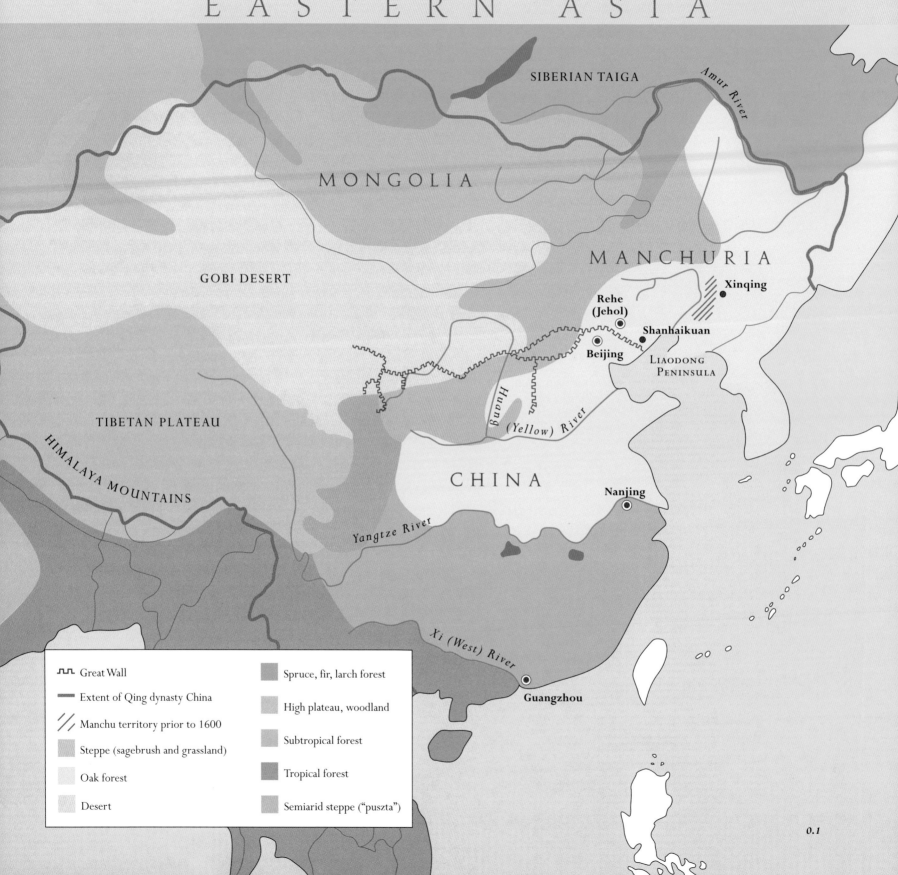

EASTERN ASIA

SIBERIAN TAIGA

Amur River

MONGOLIA

MANCHURIA

GOBI DESERT

Xinqing

Rehe
(Jehol)

Shanhaikuan

Beijing

Liaodong
Peninsula

TIBETAN PLATEAU

Huang

(Yellow) River

CHINA

HIMALAYA
MOUNTAINS

Nanjing

Yangtze River

Xi (West) River

Guangzhou

Great Wall

Extent of Qing dynasty China

Manchu territory prior to 1600

Steppe (sagebrush and grassland)

Oak forest

Desert

Spruce, fir, larch forest

High plateau, woodland

Subtropical forest

Tropical forest

Semiarid steppe ("puszta")

0.1

INTRODUCTION

In the summer of 1644, an army of Manchu warriors, augmented by Mongol tribesmen and renegade Han Chinese soldiers, conquered China. General Wu Sangui, in an effort to restore the Ming dynasty against the Chinese rebel Li Zhicheng, had invited this alien Manchu force to join in battle against the rebel army near Shanhaikuan. The rebel army stubbornly held its ground against Wu Sangui's troops, but the military prowess of the Manchu army proved decisive and the rebels were scattered. The victorious Manchu army continued on to Beijing, where they routed the remains of the rebel forces that had fled westward. Amid the ruins of the capital, where the dethroned Ming emperor Chongzhen (r. 1628–1644) committed suicide a few weeks earlier, the Manchu stayed on, claiming the *tienming* (mandate of Heaven) by which the Chinese empire had been ruled since around 1000 B.C.E. The Manchu rulers had recently named their dynasty Qing (pure), and this now became the name of what would be the last imperial dynasty to rule China. This alien dynasty continued until 1911, when, under the pressures of internal decline and external threat, the six-year-old emperor Xuantong—better known in the West by his personal name,

Puyi—abdicated. Heaven's mandate was withdrawn, bringing nearly 3,000 years of imperial rule in China to an end.

The Manchu were keenly aware of the history of assimilation that had undermined all of the other nomadic conquerors that had preceded them. To avoid a similar fate, the Manchu developed a political organization sufficient to sustain a Chinese-style bureaucracy while at the same time maintaining their own identity. They also brought with them a structured military organization that helped ensure the separation of conqueror and conquered.

To further counter the threat of sinification, the Manchu stressed a variety of cultural attributes that emphasized their ethnicity. Among the simplest differences to maintain were language and custom; probably the most visually distinctive was costume. In a simple but emphatic gesture, the Manchu changed Chinese court attire from the ample, flowing robes and slippers with upturned toes of the sedentary Ming to the boots, trousers, and functional riding coats of nomadic horsemen. All males in service of the Qing emperors were obliged to wear their hair in Manchu style: whether Manchu, Mongol, or Chinese, men shaved their foreheads and grew the remaining hair long, braiding it into a single plait, or queue, that hung down the back. Thus the queue and Manchu dress became symbols of the authority of a small group of nomadic warriors over a much larger Chinese population. By imposing their native costume on all in government service, the Manchu both acknowledged their steppe origins and legitimized their claims to rule by linking the Qing dynasty with the other nomadic dynasties that had preceded them.

This book traces various aspects of the origins and development of Qing period costume, focusing on the cultural and social history of Qing costume as well as its political significance. Chapter 1 sketches the early history of the Manchu and their conquest of China. Chapters 2 and 3 reconstruct a history of Qing dynasty costume from its origins as the clothing of steppe-dwelling nomadic clans to the sumptuous wardrobes appropriate for the rulers of the Chinese empire. Chapter 4 examines the spectacular manifestations of Manchu costume as expressions of Chinese ideals of imperial power.

A central tenet of costume history is that traditional garments embody the continuity of a people's lifestyle—its social mores, cultural values, and technological developments. Change in clothing is often bound up with psychological and philosophical considerations, and is seldom achieved without external influence. Historically, people have derived part of their identity from the clothing they wear. Kinship and rank, political function, and social occasion have frequently been denoted by a particular costume deemed acceptable by a peer group. Deviations from the norm have implied a change of identity.

Costume history makes an important distinction between garment construction and garment style. Construction determines costume shape. Technological, social, or cultural developments may effect gradual changes in construction, changes that are often almost imperceptible over long periods of time. Even the more dramatic influences such as war, migration, or industrialization may not have an immediate effect on traditional garment constructions. Frequently some simple modification to a basic garment structure may persist long after the reasons for its original development have been forgotten. In this way, changes in garment construction are most often an evolution of, rather than a radical departure from, tradition.

Style, however, is more sensitive to changes in taste, status, or rank. It is subtle and hard to define, frequently involving only minor variations such as changes in color, material, decoration, or manner of wearing a garment. Quite often style functions independently of construction. For example, the lower sleeve extensions that characterize later Qing court attire were made of a fabric that contrasted with the main part of the coat. The sleeve extensions were pleated or marked with sets of parallel lines to imitate a much longer sleeve pushed up the arm to expose the hand. Although these sleeves visually suggested an undercoat exposed under a shorter-sleeved overcoat, they nonetheless were part of the single construction of the main garment itself. Style may be linked to timeliness and is often related to class, rank, ethnic origin, or political affiliation. Lower sleeve extensions were a stylistic innovation of the early eighteenth century that was concerned with Manchu identity and attempts to integrate ancient Chinese modes of imperial

dress. Basic Manchu garment construction remained unchanged. Hence these traditional forms can be illustrated using any of a number of garments from throughout the span of the Qing empire; aspects of style tend to point to more particular moments in Qing history.

Traditional garments often serve as the collective memory of a people's history. By tracing developments in both garment construction and garment style, costume history enables us to appreciate and possibly to better understand past cultures.

METHODOLOGY

In 1973, *Scientific American* reviewed *Cut My Cote,* a slim exhibition catalogue written by Dorothy K. Burnham for a special exhibition of regional costume at the Royal Ontario Museum in Toronto. The publication caused a considerable stir in the museum. For many in the natural and earth sciences, the decorative arts departments within the "arts and archaeology" side of the institution were a necessary and historical nuisance. For them, "real" research was conducted on the "sciences" side of the house. Nonetheless, *Cut My Cote* was the first museum-sponsored research to be discussed in the pages of *Scientific American*.

The exhibition title was inspired by text from John Heywood's *Proverbs in the English Tongue* (1546): "I shall cut my cote after my cloth." This proverb is now generally read as an admonition to live within one's means; however, originally its meaning was much more literal. In today's world of readily obtained, mass-produced goods, textiles are taken for granted and wasting cloth is not of concern, but historically textiles were an investment of time and resources that retained value. Squandering one's wealth by wasting parts of it was considered foolish.

Dorothy Burnham's research indisputably demonstrated that traditional garments in cloth-producing cultures were directly linked to the rectilinear form of the loom-woven cloth produced by them. Generally, cultures that developed wide looms, which produced generous lengths of cloth, made garments that were wide and draped. In contrast, where looms were narrow, garments were seamed and fit more closely to the body. These links not

only were true of the past, but also continued to determine how traditional garment-makers approached their craft even when raw materials of different dimensions were used.

The initial research for the exhibition was undertaken by my colleague Veronika Gervers-Molnar and me with Dorothy's advice and counsel. Together we methodically examined garments in the museum's collection to identify how they had been cut and shaped; we rearranged the components on the original width to determine how much cloth had been used. Hundreds of measured drawings later, it was clear that across Asia and throughout much of central and northern Europe there were essentially two garment-making traditions: (1) garment components had cut edges that were as straight as possible, often utilizing the selvages as hems or to give strength, and when laid out on the original fabric had very little or no wastage, and (2) garment components had curved edges and almost never made economical use of the woven cloth from which they were made. In other words, garment cuts were dependent on the rectilinear form of loom-woven cloth, or they were based on animal skins. These strategies represent separate developments, which during historical times merged. However, throughout the circumpolar regions and the adjacent areas where cloth replaced traditional animal skins, garment constructions continued to be affected by the tradition of working with hides.

The Chinese child's bib garment shown in figure 0.2 calls to mind the most ancient clothing traditions of northern Asia. Mythology and archaeology reveal that long before cloth was produced on the central Chinese plains, people dressed in animal skins. Vestiges of these precloth garments survive in festival hats, collars, bibs, and wrappers for male children, which by the nineteenth and early twentieth centuries were almost exclusively constructed of luxury silk textiles. In this garment example, a miniature flayed feline skin complete with legs and claws is cut out of silk satin. The garment-maker dealt with the new cloth "hide" as if it were an animal skin, modifying it for human wear by slashing the head area along the spine to a cut-out neck hole. The "forequarters" folded over the child's shoulders and fastened with sets of loops and toggles; the "rear quarters" wrapped around the torso, secured with a pair of ties. This construction strategy is a familiar feature of

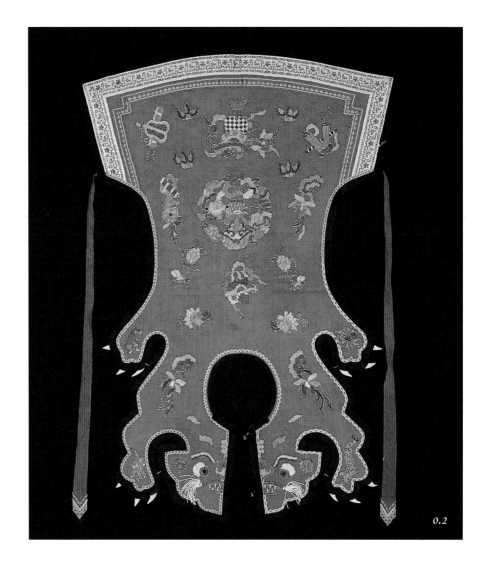

0.2

Although made of fine silk textiles, this child's garment imitated rudimentary hide garments of the north Asian peoples.

Fig. 0.2
Chinese child's bib garment; late nineteenth or early twentieth century. Embroidered silk satin; length 64 cm. Mactaggart collection, Edmonton.

the reindeer hide garments of eastern Siberian nomads (see discussion of Even and Evenk animal hide costume in chapter 2, page 35). While the survival of such garments is at odds with the dominant woven-cloth culture of China, their construction demonstrates the power of a cultural memory that once sought to protect a child's life by clothing him in the skin of a ferocious beast.

In contrast, there is no doubt about the respect for the integrity of textiles in the construction of a *mangpao,* commissioned by seventeen members of a community as a donation to a local Daoist temple to clothe a statue (see figure 0.3). This generously proportioned garment uses four loom-widths of cloth seamed selvage-to-selvage—two for the body and two more to

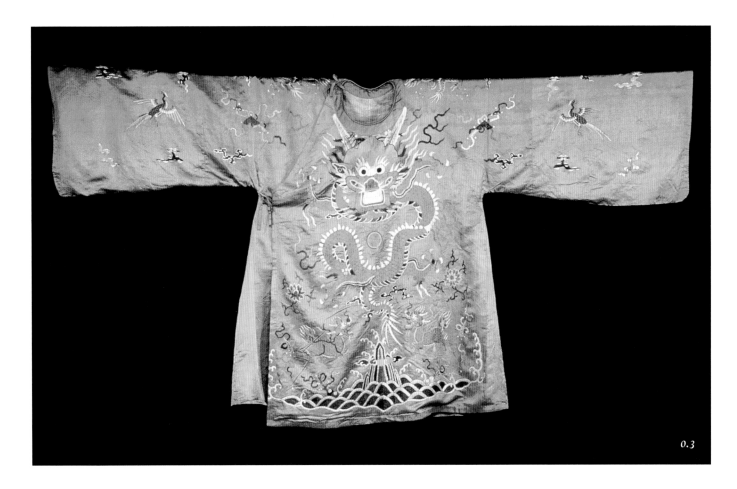

0.3

extend the sleeves. Another loom-width forms the overlap at the front. Fabric was removed to make the garment narrower at the sides and to form a neck opening, but most of these pieces were used as facings and for the angled side pieces to give the hem of the skirt greater flare. An inscription on the lining dates the manufacture of this garment to the sixth year of the Qianlong emperor's reign (1741), nearly a century later than the period when its construction was the norm for Chinese coats. The full-sleeved style with round, corded neck and pairs of fabric tie fastenings were hallmarks of the previous Ming dynasty (1368–1644); see discussion of the Ming dynasty *pao* in chapter 2, page 27. The garment itself preserves the cultural memory of past practice; however, the construction embodies an even older memory of cloth garment-making traditions, dating to the second century B.C.E., when loom widths were narrower. In adjusting the width of the garment at the sides, the eighteenth-century maker opted to retain the

Honoring gods with gifts of clothes at the new year paralleled domestic practice within the family. This was essentially a Han Chinese custom, and robes with full-cut sleeves and corded necks reflect Ming dynasty styling.

Fig. 0.3
Robe *(mangpao)* for a statue; dated by inscription to 1741. Embroidered silk satin; length 130 cm. Jobrenco Limited, trustee, Hall Collection Trust, Hong Kong.

strength of the selvage-to-selvage seam at the shoulder rather than reduce the width to approximate older fabric dimensions. The shift of the seam line off the shoulder minimized the stress on the original seam placement. Yet the garment-maker followed the standard strategy of joining additional loom-widths at the arms to create the excessively long sleeves that the Chinese assigned to ritual and ceremonial attire.

The search for explanations of such technological inconsistencies involves a wide-ranging examination of costume utilizing a variety of sources: actual garments from many cultures that occupy eastern and central Asia, depictions of period garments that do not survive, political history, ethnography, geography, biology, and the history of technology. The Royal Ontario Museum, with its incomparable collections of regional costume (which are particularly extensive and comprehensive for east and southeast Asia), its collections of Chinese decorative and fine arts, its Asian language reference library, as well as its access to geologists, ethnographers, and biologists on staff, provided a perfect research laboratory for my initial efforts to understand why Chinese garments were made the way they were. Out of the initial inquiries into how Chinese clothes were cut and constructed emerged a complex picture of overlaying cultural influences. Multiple garment-making traditions coexisted, each strongly resisting change.

As with most non-Chinese conquerors that attempted to impose their will on a much larger Chinese population, issues of ethnic separation and cultural accommodation became central to Manchu government policy. How these issues played out in Qing dynasty dress is the focus of this book. The Manchu reconfirmed the Chinese-style bureaucracy of previous dynasties as the apparatus through which the government reached the population; but the clothes worn by the bureaucracy, and everyone else associated with the new imperial power, changed dramatically. In their shape and construction these garments reveal a clash of cultural values. Most of the surviving Qing dynasty clothing is made of silk, as is appropriate for the rulers of China; but the garment forms and constructions are inherently wasteful of rectilinear cloth.

The framework for this book is established by the standard approach to Chinese cultural history. This history is shaped by official Chinese dynastic historiography that both divides time into sequential periods based on who

ruled as emperor and preserves a notion of continuity stretching back to ancient times. However, most dynasties have a history that predates their first emperor's ascension to the Dragon Throne. It is also evident when studying the arts of China that a style attributed to one dynasty often continued into the next. Adding to this mixing of styles and dates is the Chinese preference of looking back to the past as a means of justifying contemporary practice, or the copying of old art styles and techniques as a way of revering the past and claiming legitimacy.

While the legislation imposing Manchu garments on the entire population can be pinpointed to 1632, its implementation is less precisely known, particularly since parts of the extended Chinese empire remained outside Manchu control until the 1770s. When we focus on the details of Manchu garment construction in China we are faced with even less concrete data. Decisions to use Chinese prestige silks must have seemed elementary to the Manchu. The textiles in existence at the time of the conquest, particularly those that came under the control of a new Office of the Imperial Household (*Neiwufu*), would have come from silk factories under Ming dynasty control and management. These wide lengths of cloth, designed to be seamed up the center back, required garment-makers to cut away areas under the arms to achieve the more form-fitting shapes of Manchu clothing. But since the Manchu had had nearly a century of experience adapting these types of textiles for their ceremonial garments, it should not be surprising that the Qing government did not find it necessary to alter the dimensions of the imperial silk textiles or to devise new strategies for cutting a Manchu-style garment from Chinese fabrics. The Qing took over the system of silk factories and workshops directly from the Ming, who had inherited the Yuan dynasty practice established in the thirteenth century. As a result, late imperial period silk textile production was largely impervious to the subtleties of dynastic politics. The basic properties of Chinese luxury fabrics remained unchanged over the period. Looms did not change, therefore fabric widths continued to meet old imperial standards. Decorative patterns evolved, rather than changing radically with each change of dynasty.

Although there are records of court actions involving costume from the early seventeenth century, no pre-conquest Manchu garments survive.

Furthermore, the sample of surviving garments ranging in date from the mid-seventeenth century to the early twentieth century is skewed in several ways. Almost no seventeenth-century garments survive that have not been altered. More than 80 percent of surviving garments date from the last twenty-five years of the dynasty. Nearly all of these garments belonged to the social elite; they are made of silk and have decorative patterns. Plain clothes, underwear, utilitarian clothing, and non-silk garments were rarely saved. Only a very small percentage of the sample can be firmly dated. There are a very small number of excavated items from dated tombs. There is a larger number of garments in the Palace Museum in Beijing and the Shenyang Palace Museum in Jilin Province that are associated with individual emperors; hence they can be assigned dates spanning the reign of those emperors. Rarely does an object have an inscription like that on the lining of the image robe dated to 1741 in figure 0.3. Mostly we are left with stylistic considerations to determine the relative placement of one garment within the continuity of all garments of its type. Weave structures, tactile qualities of the fabric and its colors, decorative patterns and their details, the shapes and proportions of garment components, the thread and stitches that hold the garment together—all of these factors contribute to a determination of a garment's identity and relative age.

Despite the problems these factors raise, the disciplined, detailed analysis of costume construction can be critical to an understanding of how and why these garments were made, who made them, who wore them, and what they meant to their wearers. Unlike the data revealed by more sophisticated levels of technology that can often be linked to points in time, garment-making technology discloses a less specific time dimension that can point to a garment's origins as well as subsequent developments. The persistence of tradition over time and across vast spaces may remain in the physical evidence of a relatively new garment. Garments themselves bear the physical evidence of cutting and sewing, wear and alteration. While we can tease much information from this evidence, data about how garment-making technology was passed from generation to generation is largely missing from the historical record. Sewing and cutting tools are part of the archaeological record dating back to the fifth century B.C.E., while the oldest woodcut-

illustrated pattern books with directions for making Chinese clothing only date from the first two decades of the twentieth century. Fiction and poetry as well as travelers' descriptions offer insights into the processes of clothes-making. Measuring sticks, marked strings, and chalked plumb lines on the cloth or even on a table top are all mentioned as ways of plotting, then cutting garments. Domestically, garment-making in China we assume would have been passed from mother to daughter through observation, oral direction, and hands-on practice. As in other cultures, old garments would probably have served as the model for new ones. Professionally, master tailors passed information to apprentices in much the same manner. These factors contribute to technical conservatism. Added to this are the strong emotional and psychological qualities that tie our identities to what we wear. They are also manifest in the garments that survive.

I have used surviving garments, pictorial evidence, and legislation governing official dress in Qing dynasty China to reconstruct this history of Manchu costume against the social, economic, and political histories of the period. Looking at the technological aspects of costume construction is a critical tool in this study. By examining the technological aspect of clothing we can gauge how closely a garment's construction adheres to or deviates from one of the two East Asian garment-making traditions. Those correspondences and deviations can be documented and studied to construct a historical framework of garment development, helping to fill the gaps in our knowledge when other evidence is missing. By studying costume technology we gain a broader understanding of costume within imperial China and how it functioned on aesthetic, political, and social levels. As this book reveals, East Asian costume reflects a fundamental rivalry between two cultural paradigms—plainspeople and nomads. Although these two lifestyles competed for ascendancy, both participated in the development of Chinese civilization.

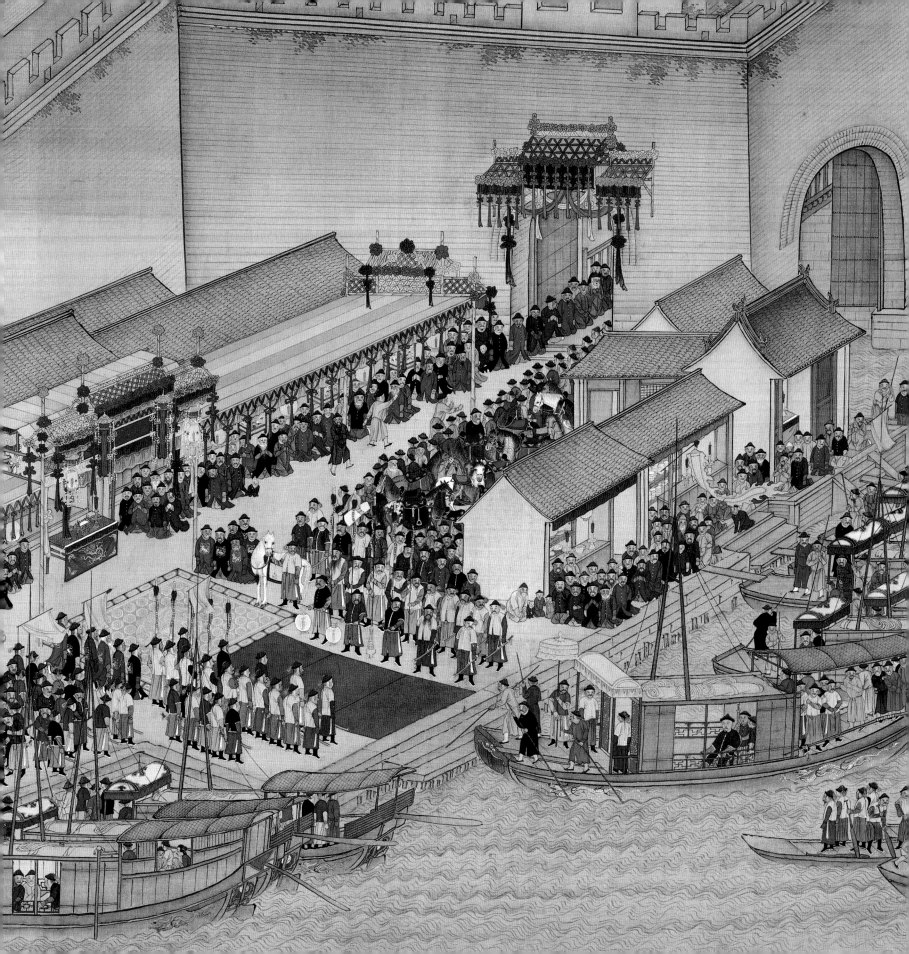

THE QING DYNASTY: HISTORICAL BACKGROUND

The Great Wall stretches in a vast arc across China's northern frontier. Built as a defense system to protect the agricultural foundation of China's urban culture from the intrusions of horse-riding nomads, it was more a symbol of power than an effective deterrent to invasion. South and east of this barrier, on the central Chinese plains along the Huang (Yellow) River drainage, agriculture supported by vast irrigation works made sedentary urban existence possible; to the north and west, breeders of horses, sheep, and cattle were obliged to live as nomads following their herds in search of forage on the rolling grasslands of the steppe.

CONTACT BETWEEN NOMADS AND PLAINSPEOPLE

Chinese culture and the civilization it produced arose at points of contact between the geographic and climatic zones of steppe and plains. From prehistoric times farmer and herder were in conflict. Farming tied up rangeland; herding destroyed fields, crops, and irrigation systems. Yet agriculture supported the urban culture that sustained the luxuries so coveted by the nomad. In turn, nomads supplied their sedentary neighbors with horses,

Manchu government efficiently organized the court into an elaborate structure through the use of external markers, including banners and prescribed costume and accessories. In this scroll detail, yellow flags wave overhead while palace guards wear yellow surcoats and elder statesmen are dressed in surcoats with court rank badges.

Fig. 1.1
Wang Hui (1632–1717), detail from *Nanxantu di qi juan* (Pictures of the Southern Tour), seventh scroll, the arrival of the Kangxi emperor in Suzhou; dated to 1698. Hand scroll: ink and color on silk; 26.8 × 865 cm. Mactaggart collection, Edmonton.

furs, wools, jade, and various herbal medicines, such as ginseng. At times, this nomadic trade was conducted through formal diplomatic ties with the Chinese state, in which the Chinese emperor viewed nomadic chieftains as tribute-bearing vassals.

Chinese dynastic history reflects the conflict between the nomads and the sedentary plains dwellers. The nomadic way of life fostered vigorous independence and militancy, and the steppe afforded rapid movement across the land. In periods of empire, with strong dynasties on the throne, China extended the limits of its control onto the southern edges of the steppe. But when central control weakened, nomadic groups repeatedly were able to use their mounted cavalry to seize control, whereupon they consolidated their power and established their own dynasties, some of which exerted authority over all of China. In the third century C.E., the Turkic-speaking Xiongnu (or Asiatic Huns) brought the weakened Han Empire to an end. Seven hundred years later, the mighty Tang Empire collapsed before Mongol Khitans, who established the Liao dynasty in northern China in 907 C.E., only to be replaced by the Tungus Jurched in the twelfth century. In the thirteenth century, the Mongols swept into southern China to establish the Yuan dynasty and were in turn overthrown when the native Han Chinese Ming dynasty was founded in 1368. However, such an overview tends to obscure the fact that nomad and plains dwellers both contributed to the development of East Asia.

Beyond the eastern extremity of the Great Wall, where it touches the sea at Shanhaikuan, lies the home of other nomadic peoples who repeatedly threatened and on occasion subjugated the inhabitants of the Chinese plains. Among these peoples were the Manchu. The names Manchu (*Manju* in Manchu, *Manzu* in Chinese) and Manchuria (*Manju gurun* in Manchu, literally, "Manchu nation") were invented in the early seventeenth century to bolster the ascendancy of the Aisin Gioro clan, from whom the Qing dynasty emperors claimed lineage. Prior to the Manchu nation building of the 1630s, this area bore no specific name, having neither defined borders nor a uniform population.

The zones of human contact and interaction in this area were not static. Geographically, it consists of three distinct and overlapping regions. The

first, lying just outside the Great Wall, was the northernmost extension of the territory that sustained Chinese-style agriculture. Here, an agrarian economy supported a Chinese urban lifestyle, albeit on a reduced scale, and a bureaucratic government to manage administrative affairs. This region served as a political buffer zone between farmer and herder; through it passed routes of communication between China proper and the tribute-bearing nomads farther north. Despite the Chinese presence, the area was isolated and vulnerable, particularly in times of waning central control and the ascendancy of nomadic power.

To the west and the northwest are the easternmost extensions of the steppe, which stretches westward across the Asian landmass to the plains of central Europe. These grasslands supported nomadic tribal peoples who lived in felt tents and bred horses, sheep, and cattle. Farther north, the grasslands give way to the spruce, fir, and larch forests of the eastern Siberian taiga. This environment imposed another type of nomadism. In an arc extending north to east, the forests and marshes of the Amur River drainage were home for hunting and fishing nomads of Tungus origin. Reindeer were used for transportation in the north; dogsled and canoe to the east; and in areas of Chinese contact the horse was used. The pig was the chief domestic animal, and by the fifteenth century, a desultory agriculture was practiced.

THE RISE OF MANCHU POWER

The development of a Manchu political state can be traced to a small frontier group that held a favorable political and trade position on the Liaodong Peninsula between Korea and the grass steppe of Liaoning Province farther west. The ancestors of the Manchu were hunting and fishing nomads, who had been transformed into a militant steppe society by the end of the sixteenth century. Genealogically, Manchu society was divided into *hala* (clans). In this ancient tribal organization, each Manchu's status was fixed by kinship. On a territorial level, Manchu tribesmen often functioned outside clan affiliation by forming small, flexible groups to meet common hunting or battle objectives, as was common among Mongols and other horse-riding groups living on the steppe. Since these groupings existed for a specific purpose,

they tended to dissolve once the hunt or campaign was accomplished. Forming a cohesive social and political structure was the first step in laying claim to the mandate of Heaven. External pressures as well as the Manchu's own social practices challenged the authority of Manchu leaders.

Early Ming dynasty emperors had created an elaborate defense system with self-supporting military colonies along the northern frontier. The purpose of these garrisons was to maintain a political and military buffer zone between the empire and those who threatened it. Tribal chieftains, including Manchu, were placed in tributary relationships with the Ming Emperor. In exchange for recognizing Chinese suzerainty, these leaders were given official Ming titles and the trappings of vassal rulers, including bolts of dragon-patterned silks (see figure 3.10 in chapter 3). Robes with woven or embroidered dragon patterns were among the most prestigious garments of the Ming court. From the outset of the dynasty, Ming emperors conferred dragon robes on the highest-ranking nobles as a matter of entitlement; awarding these robes to especially worthy courtiers and military officials as well as to foreign leaders became custom by the early fifteenth century. With their direct links to the person of the emperor and the prestige of the Chinese imperial court, dragon robes and the silk yardages from which they were made became much-coveted status symbols as well as tools of diplomacy. By elevating one Manchu chief at the expense of others—and by playing them off against each other—Ming frontier commanders usually succeeded in keeping the tribesmen disunited. By the sixteenth century, the Chinese garrisons were much reduced; however, they continued their time-honored policies of divide and conquer among the Manchu clans.

Nurgaci, recognized as the founder the Manchu state, was a member of the Aisin Gioro clan. He began his career within the world of feudal rivalry created by the Ming garrisons. Called to leadership in 1583 after his father's murder, Nurgaci had to secure his own position against his chief rival, another Manchu nobleman of a different clan who had caused the death of Nurgaci's father and grandfather while on a looting raid conducted with Chinese support. In destroying his rival, Nurgaci pitted himself and his followers against the Chinese frontier officials, in effect setting the Manchu in opposition to the Ming dynasty.

Throughout the late sixteenth and early seventeenth centuries, Nurgaci secured an ever larger territorial base, consolidating Manchu power north of the Great Wall through diplomacy, marriage, and conquest. Each step enhanced his personal authority and shifted loyalties from tribal clan affiliations to a system that recognized bureaucratic rank and inherited privilege. In 1616, Nurgaci claimed the title khan over all Manchu and declared the dynastic name Ho Jin (Later Jin). This reference was to the Jin dynasty (1115–1234), which had been founded by Jurched tribesmen from whom the Manchu claimed descent. The Jin had driven the Chinese emperors out of northern China in the twelfth century, precipitating the collapse of the Northern Song dynasty (960–1127).

Manchu dynastic intentions became manifest in 1618 when Nurgaci began to drive the Ming forces out of the Liaodong Peninsula. Between 1618 and 1621, he built a walled city at Xinqing as his imperial capital. In 1626, his assault on the Ming garrison at Ningyuan, only fifty miles north of the Great Wall, was repulsed with help of Portuguese-made cannons and rifles. Within eight months, Nurgaci was dead.

Nurgaci's son Hongtaiji, better known by his personal name, Abahai, succeeded to power. During the second quarter of the seventeenth century, he brought the remaining Chinese parts of Manchuria under his control, even leading plundering forays deep into Chinese territory south of the Great Wall. He increased the number of Han Chinese troops enrolled in Manchu military and transformed the Manchu government by appropriating Chinese civil officials to the Manchu ranks. Hongtaiji extended Manchu control westward, bringing Mongol tribes into the banner system. In 1635, the name Manchu was first used and the dynastic title Qing (translated as "pure") was proclaimed. With this action, Hongtaiji declared his opposition to the Ming imperial government and signaled Manchu determination to make his own claim to the Dragon Throne of imperial China. Abahai died in 1643. A year later, internal disorder and decay brought about the collapse of the Ming dynasty, giving the Manchu regent, Dorgon, the chance to place the six-year-old son of Abahai on the Dragon Throne as the Shunzhi emperor.

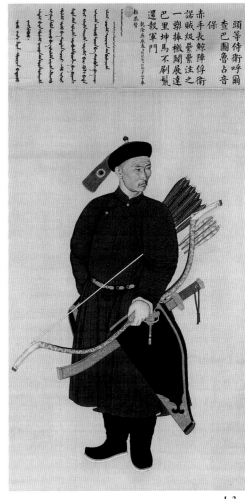

1.2

Coats with loops and toggles, long close-fitting sleeves, a tight belt, and vented skirts—all features of Qing dynasty costume are ultimately linked to clothing developed for a horse-riding military.

Fig. 1.2
Anonymous, portrait of Zhan yinbao; dated to 1760. Hanging scroll: ink and color on silk; 188.6 × 95.1 cm. The Metropolitan Museum of Art, New York. Purchase, Dillon Fund Gift, 1986. 1986.206.

MANCHU MILITARY ORGANIZATION

The Manchu conquest had begun on the margins of the Chinese world—where the cultures of farmer and herder overlapped. Throughout history, these marginalized agricultural areas had repeatedly served as the economic base for political organization in northern Asia, and control over them was essential if nomadic conquest of the great agricultural plains was to be attempted. Thus, the Manchu followed an age-old pattern of learning Chinese administrative practice on a small scale before subjugating the empire. Their political organization grew as they penetrated further and further onto the Chinese plains.

Much of the success of their conquest rested upon an internal organization that permitted the Manchu to effect the transition from nomadic conquerors to civil administrators. In 1601, Nurgaci organized all Manchu troops into companies of three hundred warriors called *niru* (literally, "arrow"); five companies formed a *jalan* (regiment). These in turn were grouped into four large units called *gusa* (banners), which were distinguished by their yellow, white, red, and blue flags. Enrollment of an individual warrior into the banner system extended to his family. From the outset, the banner system provided both effective military discipline and a comprehensive register of civilians, allowing the leaders to monitor the Manchu population and to guarantee the equitable distribution of lands and taxes that would ensure the livelihood of its members.

As the banner ranks increased during the first decades of the seventeenth century, Nurgaci continued to develop new companies and attach them to various banners. In 1615, he created four more banners, making a total of eight. (To distinguish the new banners, flags of the original yellow, blue, and white banners were given contrasting red borders, while the original red banner was bordered with white.) Manchu ranks were also increased by Chinese who switched loyalties and by alliances with various Mongol tribes. By 1634, eight separate Mongol banners had been created, followed in 1642 by eight Chinese banners.

MANCHU CIVIL ORGANIZATION

The head of each banner was a lieutenant general appointed from within the imperial clan; he was responsible for both civil and military affairs. In the formative period, these clansmen formed a council to advise the ruler, but as the size and complexity of the state grew, a civil administrative structure developed to match the military one. After the second quarter of the seventeenth century, executive power was concentrated in the person of Hongtaiji and his immediate family. Deliberative bodies were appointed to facilitate internal management and external (or colonial) administration. In addition, boards responsible for civil affairs, finance, rites, war, justice, and public works were established, all patterned on Chinese models: the large number of Chinese officials already within the Manchu ranks influenced the structure of the Manchu bureaucracy.

After the capture of Beijing in 1644, the Qing government settled just under 95,000 bannersmen and their families adjacent to the imperial residence at the Forbidden City. This settlement was ordered by banner colors, segregating Manchu, Mongol, and Chinese groups ethnically within each section, thus creating a garrison city, the so-called Tartar city, within its own wall. The Chinese civilian population was resettled within its own walled city to the south. The original intention was strategic—keeping the conquering military elite apart from the conquered Chinese. The Manchu also seized the former Ming imperial manors in and around the capital for the use of the Qing imperial family. At the same time, the Manchu government confiscated more than two million acres of land in a 175-mile radius around the capital. Here they settled more than 169,000 bannersmen and their families. As Qing control was extended across the empire, banner garrisons were established in each major city, imitating the precedent at the capital.

Once the Manchu government was in place in Beijing and the country pacified under the Kangxi emperor, the Hanlin Academy was reestablished. The Hanlin Academy served as a kind of state university, and its time-honored examination system based on Confucian learning and notions of statecraft continued to supply the necessary scholar-officials to fill the numerous administrative positions that were essential for governing the

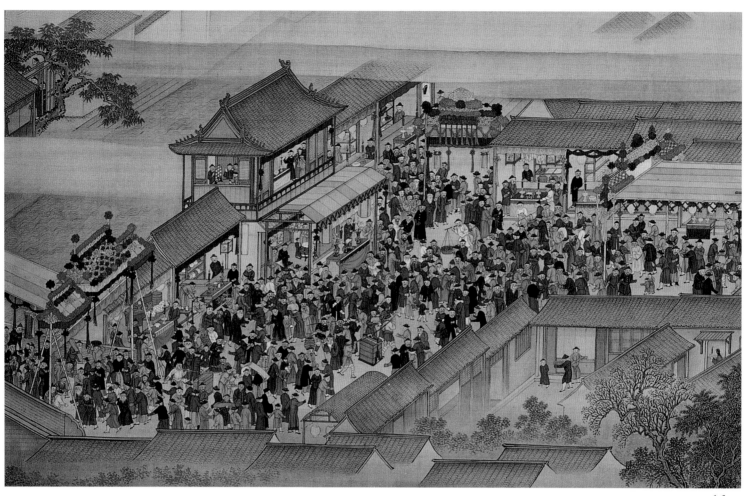

The forms of urban imperial government re-
mained fairly consistent throughout the late
imperial period; however, what people wore
during the Qing dynasty changed fundamentally.
All court officials and their representatives, regard-
less of ethnic origin, were obliged to dress like
horse-riding Manchu. By the eighteenth century,
Manchu-style garments were adopted by most lev-
els of society.

Fig. 1.3
Wang Hui (1632–1717), detail from *Nanxantu di
qi juan* (Pictures of the Southern Tour), seventh
scroll, crowd at a street festival in Suzhou; dated
to 1698. Hand scroll: ink and color on silk; 26.8
× 865 cm. Mactaggart collection, Edmonton.

sedentary population. To deter Chinese elitism and lessen the threat of assimilation of the ruling non-Chinese by the subject Chinese, the Manchu instituted a quota system to limit the number of Chinese degree holders in the bureaucracy.

MANCHU ARISTOCRATIC ORGANIZATION

Paralleling and, in some instances, superseding the elaborate hierarchy established in the civil and military bureaucracies was an aristocratic hierarchy based on clan affiliation. In addition to belonging to a banner organization, which held him in a fixed position loyal to an autocratic emperor, every Manchu man was also a member of a clan in which his position to the emperor was fixed by kinship. By the early seventeenth century, each clan group owed feudal allegiance to the Aisin Gioro clan, from which the Qing emperors claimed lineage. Imperial clansmen, the heads of the imperial household and bodyguard, lieutenant generals of the Manchu banners, and the chief metropolitan officers were held together by rank and inherited privilege to form a Manchu elite. The banners probably never numbered more than 10 percent of the Han Chinese population at any point during the two and a half centuries of Qing rule. Of this number, a few thousand individuals wielded the power of an autonomous government against the overwhelming forces of Chinese culture.

Successful government relied on an efficient bureaucracy, which organized thousands of individuals into an elaborately graded structure that related in all of its functions to the emperor. Distinctions of title, rank, and status in the imperial court, in metropolitan and provincial administrations, and in the military organizations were in no little part furthered by the prescribed costume and paraphernalia worn by each courtier, official, and officer in service of the Dragon Throne. From the outset of their imperial rule, the Manchu distinguished their dynasty from the Chinese tradition by imposing the wearing of the queue *(bian)* and Manchu national dress by all in the service of the Qing government.

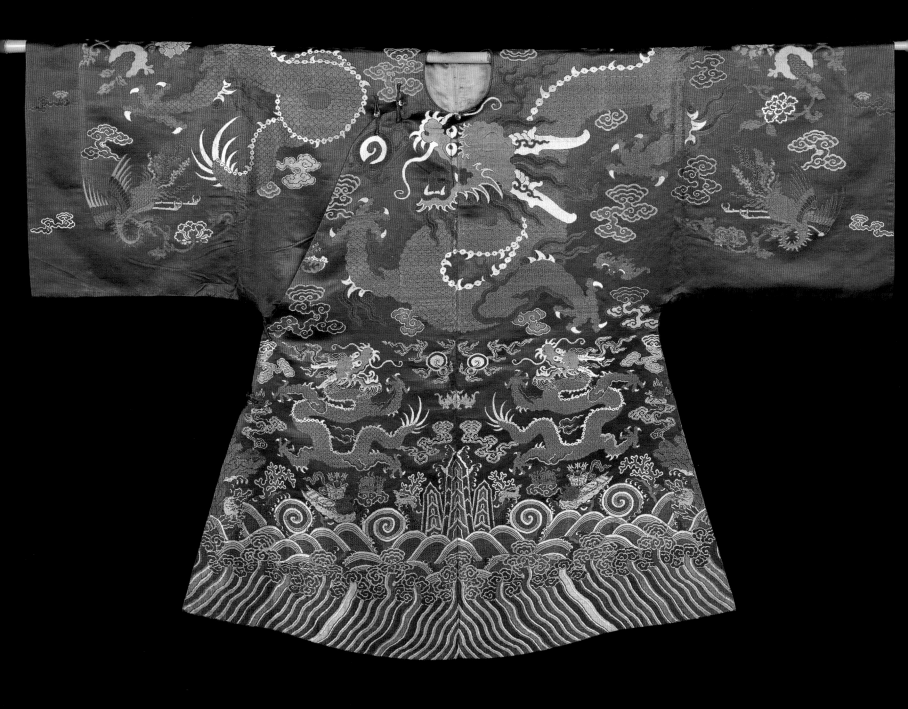

2

EAST ASIAN
CLOTHING TRADITIONS

Most studies of Far Eastern costume have been concerned with tracing the evolution of styles in attempts to establish chronology. Others have described garment types to distinguish among regional groups. Few have dealt with costume technology as it relates to both the origin and the development of costumes. The study of costume technology includes all aspects of costume construction, from the selection of materials to the way individual costume components are shaped to how these pieces are assembled and the resulting garment finished. While costume technology is concerned with the practical issues of how a specific article of clothing is made, it also focuses on the social, economic, and political history of the people who made and wore that garment and the other articles of apparel that constituted a wardrobe. Costume technology also looks at theoretical questions: why some methods or materials are favored, while others, which are equally accessible, are not used; or why construction strategies typical for one raw material are retained when new materials are utilized.

This garment honored the Ming dynasty court precedents in its color and in the design convention, which looped the dragon's body around the wearer's shoulders.

Fig. 2.1
Chinese bridal coat *(longao)*; nineteenth century, third quarter. Brocaded silk satin, length 99.5 cm. Seattle Art Museum; gift of Mrs. William Grimshaw. 51.74.

INTERPLAY BETWEEN CHINESE AND NOMADIC STYLES

In eastern Asia, costume technology underscores the complex relationships between steppe and plains societies. From written sources and historical data it is possible to distinguish two costume styles within Qing period China. Although a Manchu style can be distinguished from a Chinese style, when we examine actual garments it is impossible to discuss one style or costume tradition without reference to the other. Style is frequently equated with shape, but little attention has been given to the reasons why those shapes exist, or, even more fundamentally, how they are constructed. Although nomadic garments based on animal hide constructions offer a clear contrast with Chinese cloth constructions, the surviving ethnographic evidence demonstrates a long period of interaction between them. We can find animal hide garments made by tribal groups who lived along China's northern frontiers that imitated the lines and decorative details of Chinese cloth clothing. Conversely, the hide garment types, like leggings and short vests, were made in cloth and completely integrated into the Chinese wardrobe at a very early date.

Manchu garments were only the most recent nomadic costume influence imposed upon traditional China. At the time of the conquest, the Chinese had already adopted many nomadic garments, naturalizing them as part of the Chinese national costume. Trousers and paired aprons resembling a skirt, which had been worn informally by Chinese women since at least the second century B.C.E., related directly to formal Manchu male court costumes. Both derived from a common general source, although each represented a separate line of development.

Both steppe and plains traditions are represented in Qing dynasty costume, but neither the nomadic Manchu style nor the agrarian Chinese style existed in isolation. While Chinese cultural history has been interpreted in terms of recurring styles of native development and nomadic intrusion, care must be taken not to polarize these influences. Nomadic and agrarian traditions are but two aspects of a larger phenomenon of cultural development in East Asia.

CHINESE CONTINUITY

Although agriculture began to be practiced on the central Chinese plains more than 10,000 years ago, the emergence of a highly stratified society around 2500 B.C.E. with a localized ruling elite imposing their will on an extended area gave Chinese culture its particular character. The ruling elite imposed a sedentary lifestyle on agriculturalists and encouraged the growth of cities as both ritual and economic centers. Over the next thousand years, the emerging Chinese empire witnessed the development of writing, the formation of a sophisticated bureaucracy, and the creation of the great classics of Confucian thought. The Zhou kings usurped the throne of the Shang dynasty (c. 1600–1027 B.C.E.) in 1027 B.C.E., proclaiming they had won the mandate of Heaven *(tienming)* from a morally corrupt dynasty. Five hundred years later, Confucian thinkers adopted this notion of moral retribution, claiming a ruler fulfilled Heaven's mandate by cultivating his moral propriety (*li,* often translated as "virtue"). If a ruler observed Confucian obligations of social interaction by being filial to his parents, attentive to his ministers, and paternalistic to his subjects, then the empire would prosper and civilization would flourish.

During the Han dynasty (206 B.C.E.–220 C.E.), the cosmic role of emperor as Son of Heaven evolved. Imperial ritual observance was linked to numerology, astrology, and a complicated theory of connecting the ruling house to specific colors and natural elements. These ceremonials were thought to contribute to harmony between heaven and earth, a requisite for moral governance. Imperial duty also extended to studying the history of the past and applying its lessons to the present. During the Han dynasty, the Chinese state created a unified legal code, founded state universities, expanded and rationalized the bureaucratic apparatus, and turned Confucianism into a state creed. The Chinese imperial state became the dominant political and cultural force in eastern Asia. Within this sphere of influence, men were either civilized and Chinese or they were regarded as barbarians. Despite changes of political leadership, a lifestyle tied to the land and a cultural tradition that valued the past imposed uniformity and insulated China against change.

THE CHINESE TRADITION
OF GARMENT CONSTRUCTION

Most eastern Asian garments are made of cloth. Weaving in China can be
traced to the fourth millennium B.C.E. Both hemp and silk textiles have been
excavated at sites in central and eastern China. Patterned silk weaving and
finely woven hemp textiles are preserved in the patinas of bronze objects
found in Shang dynasty aristocratic burials dating from the twelfth century
B.C.E. From the Zhou (1027–221 B.C.E.) and the Han dynasties there is an
ever-increasing body of archaeological data and literary records that docu-
ment Chinese weaving and garment constructions. Artistic representations
provide additional evidence for many garment types that do not survive.

From at least the Shang dynasty, silk has been the preeminent fiber for
status garments. A millennium later, Confucian philosophers taught that it
was the duty of rulers to wear silk in order to distinguish between the noble
and the common. There is evidence that silk was used in diplomacy and
commerce around 2000 B.C.E., reaching Europe by the mid-sixth century
B.C.E. China's secrets of sericulture remained a state monopoly until the
fourth century C.E., spreading to Korea and central Asia and eventually to
Japan and to western Asia during the sixth century. Sericulture became
known in Europe during the Middle Ages.

Hemp and other bast fibers were used during the Neolithic period and
formed the basis of most nonaristocratic clothing until cotton, introduced
from India via central Asia, became widely available during the twelfth cen-
tury. Wool was noticeably absent as a significant fiber in the Chinese cultural
sphere and belonged instead to the nomadic herders, who always possessed
some source of animal hair with which to make felt.

In eastern Asia, narrow backstrap looms produced cloth of insufficient
width to cover the body in a single length. As a result, all upper body gar-
ments were made with a center back seam: they were formed of two lengths
of fabric brought over the shoulder, seamed under the arms, and leaving the
front open, in the familiar kimono-like construction. Sleeves were additional
lengths of material joined to the side edges at the shoulder. With this con-
struction the sleeves functioned independently of the body of the garment

and could be extended in length and width to almost any dimension. Additional fabric sewn on the front edges of the garment provided an overlap for more secure closure and better body covering.

TRADITIONAL CHINESE GARMENTS

Technological improvements of later historical periods increased the loom widths but did not alter traditional center back-seam constructions. From our earliest evidence this coat construction, called *pao* (translated as "robe"), had served both ceremonial and utilitarian functions. As full-length coats made of luxury silk, they enhanced the court ritual of an autocratic state. Reduced to the basic form, they were the occupational garments of farm laborers.

From ancient times, the *pao* with wide exaggerated sleeves was used for formal wear. Its form was codified during the Han dynasty, and each succeeding native dynasty attempted to restore this classic form in order to stress continuity and evoke the grandeur of the past. When the Ming overthrew the Mongol Yuan dynasty in 1368, they gradually restored the *pao*, rejecting the more closely fitting coats of the Mongols. As its skirts were widened with additional widths of cloths at the sides and its sleeves extended enormously in width and length, the *pao* became impressive in its bulk and lavish use of silk. At the time of the Manchu conquest, the extremely generous cut of the Ming court coat required nearly twelve meters of silk.

Such a heavy coat encumbered movement, imposing a slow and orderly pace appropriate to court pageantry. The sleeves honored the Chinese aversion to displaying the hands in public on formal occasions and had the practical merit of reducing the threat of assassination—since both arms were required to manage the sleeves, any hand gesture was instantly detected. The *pao* was always worn over layers of underrobes, and during the hot, humid summers a bamboo mesh undershirt helped keep the robes from sticking to the body.

After the Manchu invasion, variants of the full-cut *pao* were retained in areas of Chinese society that were unaffected by Manchu costume regulation. Bridal coats, either *mangao* or *longao* (also referred to as *mangpao* or

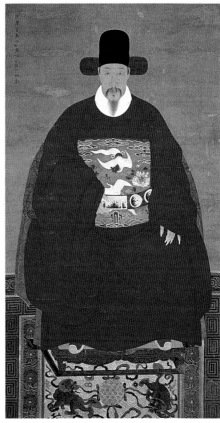

2.2

The Ming court coat *(pao)* served a function as well as being a lavish representation of imperial grandeur. A system of accessories attached to and worn with the *pao* was used to differentiate among those attending at court. This portrait shows an insignia badge with a pair of flying silver pheasants and rigid belt with agate plaques, indicative of a fifth-rank civil official. Rank badges were later adopted by the Qing for use on their court robes.

Fig. 2.2
Anonymous, posthumous ancestor portrait inscribed "Yang Woxing [official pseudonym] Shen Shou, honorific palace official of the Ming [dynasty]"; late sixteenth century. Hanging scroll: ink and color on silk, 177.4 × 97.8 cm. Royal Ontario Museum, Toronto; George Crofts collection. 921.1.149.

Nearly 11.5 meters of bright red silk damask with a scrolling peony design, which has now faded to tan from burial, were used to construct this round-collar, informal court coat *(pao)* for a Ming court official. The significance and value of woven cloth was demonstrated by a construction strategy that minimized wastage through careful cutting, folding, and seaming. The excessive fabric under the arms was pleated into projecting flanges at the sides that also accommodated deep vents. A wedge-shaped gusset placed under the arm at the front assured the drape of the "lute shaped" sleeve. Ties and belt carriers, most of which are missing from this garment, would have utilized nearly all of the unallocated scraps in the accompanying cutting layout. This robe was once emblazoned at the chest and back with rank badges *(buzi),* which are now missing.

Fig. 2.3
Ming informal court coat layout: (a) cutting; (b) assembly; (c) front profile.

Scale in centimeters

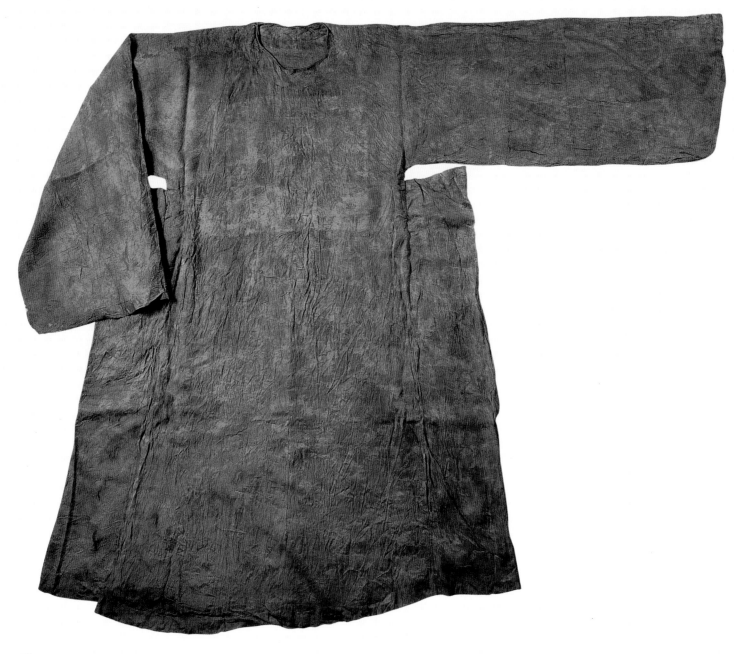

Fig. 2.4
Ming informal court coat *(pao)* for rank badges
(missing); late fifteenth or early sixteenth century.
Silk damask, length 160 cm. Myers collection,
Paris.

Bamboo mesh garments kept outer silk clothing from sticking to the body or being soaked with perspiration during humid summers, thus contributing to decorum practiced by Confucian Han Chinese society.

Fig. 2.5
Han Chinese undercoat; late nineteenth century. Bamboo and string, length 63 cm. Royal Ontario Museum, Toronto; gift of Mrs. William C. White. 972.210.1.

Robes and accessories based on imperial models honored a Han Chinese bride as "empress for the day." As these garments were the most important garments to be worn by many Chinese women, they were frequently depicted in portraits of matriarchs used in the cult of ancestor worship.

Fig. 2.6
Anonymous, posthumous portrait of a Chinese woman; nineteenth century in early eighteenth-century style. Hanging scroll: ink and colors on silk, 190.5 × 99 cm. Royal Ontario Museum, Toronto; George Crofts collection. 921.1.138.

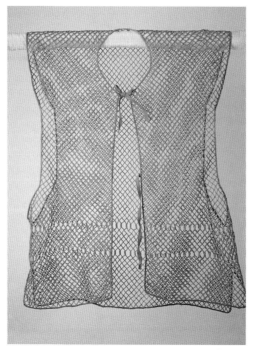

2.5

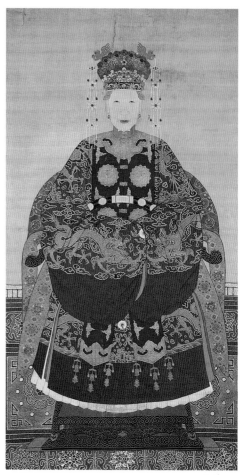

2.6

longpao), were among the most conservative garments in the Chinese wardrobe. Because of the Chinese custom that referred to the bride as "empress for the day," her wedding clothes imitated Ming court styles in their red color and dragon decoration. For many women, these robes were the most prestigious costumes they would ever wear. They are frequently depicted in posthumous portraits and were often used as burial shrouds. The less celebrated formal and semiformal coats worn domestically, called *ao*, were often influenced by Manchu styles, such as the curved overlap held with loops and toggles, but were nonetheless cut with wide, non-nomadic sleeves.

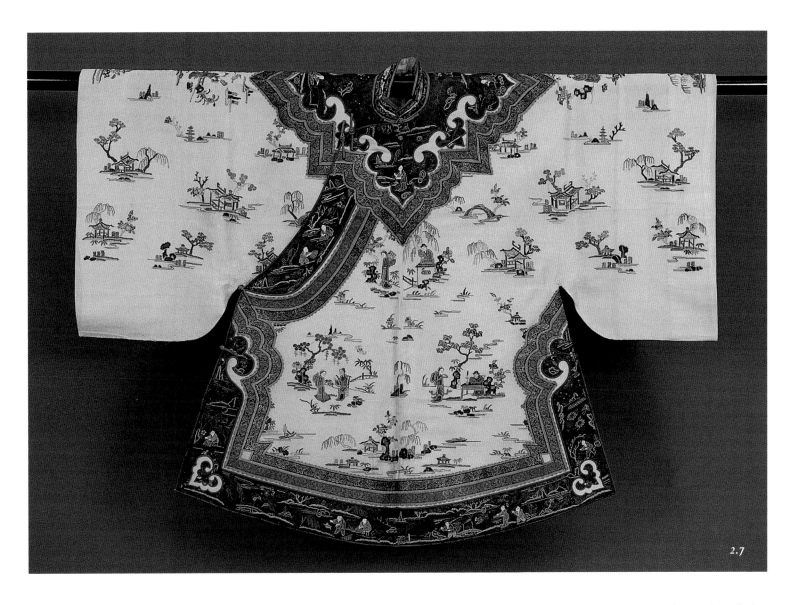

2.7

The shaped front overlap and loop-and-toggle fastenings are indistinguishable from Manchu clothes, but the shape of the sleeves characterizes cloth garment-making traditions in which conspicuous displays of woven cloth reflect wealth and status.

Fig. 2.7
Chinese woman's semiformal domestic coat *(ao)*; nineteenth century, third quarter. Embroidered silk gauze; .length 90 cm. Mactaggart collection, Edmonton.

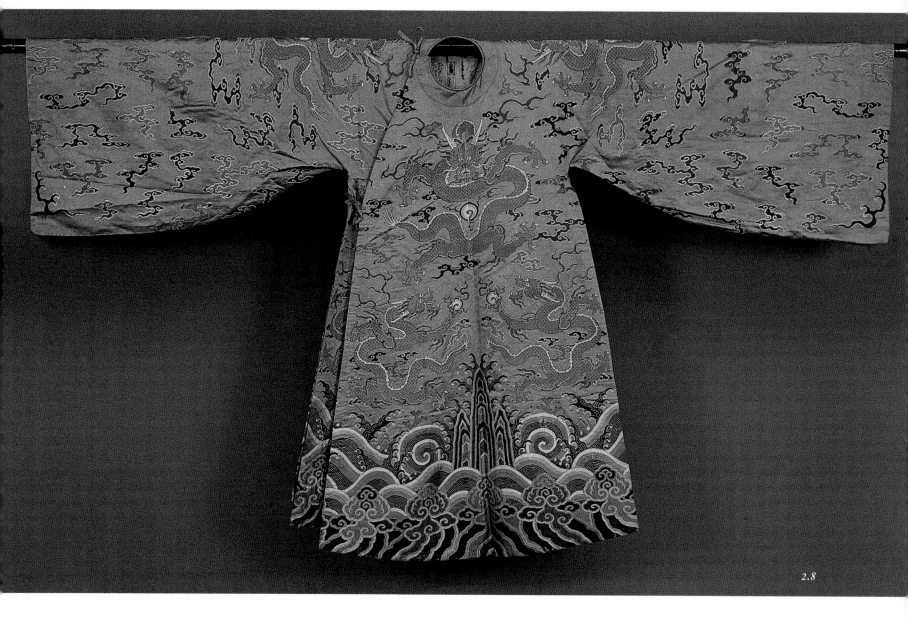

2.8

While the dragon patterns on this garment followed up-to-date Manchu court styles, the shape of the garment evoked traditional Ming dynasty fashions that had in turn restored ancient Han Chinese models.

Fig. 2.8
Actor's coat *(longpao)*; early to mid-eighteenth century. Brocaded silk satin, length 24.5 cm. Mactaggart collection, Edmonton.

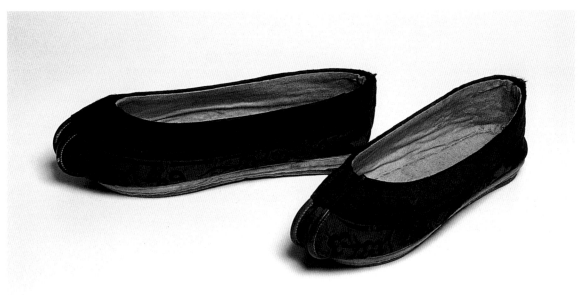

Costume used in the opera, a very popular entertainment for both Manchu and Chinese populations, reveals a similar conservativism. Many plays dated from the Yuan and Ming dynasties and often dealt with subjects that were even more ancient. The costumes assigned to many roles retained the *pao* and its full-cut sleeves to convey notions of authenticity. The Chinese custom of giving gifts of new clothes for the new year extended to pious donations of coats made to clothe temple images (see figure 0.3 in the introduction). Again, this practice was outside the Manchu costume regulations and tended to honor Ming dynasty styles even if the dragon decor that was often a feature of these garments followed the latest Qing court styles.

Traditional Chinese occupational footwear included straw sandals *(ju)* or wooden clogs *(ji)*. Lacquered versions of clogs and a rigid-soled slipper with

Depending on climate and season, traditional Han Chinese occupational footwear included lacquered wooden clogs and sandals. Urban wear featured various cloth slippers attached to rigid soles composed of layers of starched cloth, felt, or leather.

Fig. 2.9
Chinese man's shoes *(xie)*; late nineteenth century. Silk satin and velvet, wool felt, leather, and cotton thread, length 27 cm. Glenn Roberts collection, New York.

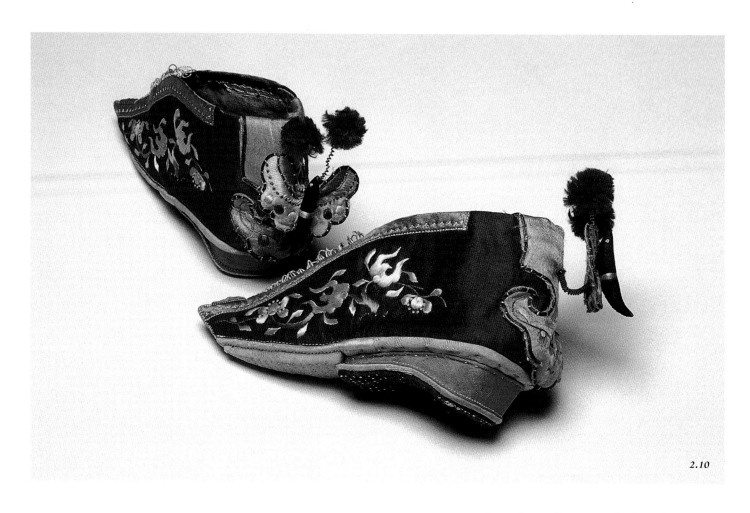

2.10

From the tenth century, the feet of upper-class Chinese urban women were bound with bandages in order to deform their growth and create a much-admired lotus bud shape. Tiny feet and tiny shoes conferred status and distinguished the Han Chinese ethnic group from others. Butterflies attached to metals springs would have been activated by every movement.

Fig. 2.10
Shoes *(xie)* for Chinese woman's bound feet; late nineteenth century. Embroidered silk satin, various silk ribbons, length 10.7 cm. Glenn Roberts collection, New York.

cloth uppers, called *xie,* were the footwear of urban courtiers. During the Northern and Southern dynasties (265–589) and the Sui (581–618) and Tang (618–907) dynasties, slippers with cloud-shaped, upturned toes helped carry the excessive skirt lengths fashionable at court. Variations of these slippers with more modest toe caps continued to be used at the Ming dynasty court and were worn domestically by Han Chinese men until the advent of western-style shoes at the beginning of the twentieth century.

Chinese women also wore slippers. Among the urban elite was the custom of binding a girl's feet to stunt growth and reshape them into an idealized lotus bud shape. The foot was covered with a tiny shoe that was often engineered to make the foot appear even smaller. Footbinding affected the way a woman walked, contributing to the erotic appeal of the tiny feet, but footbinding also symbolized woman's obedience to the Confucian virtues of discipline and modesty. While the Qing government found footbinding repellent and repeatedly issued edicts forbidding Manchu women and the wives of bannersmen from indulging in the practice, footbinding continued among Chinese women and by the end of the dynasty had spread to all strata of Chinese society.

Occupational headgear was based on a circular sunshade, usually plaited of straw or split bamboo, called *li.* The conical sunshade was adopted by the Manchu court as official summer attire. Chinese women's formal hats often imitated elaborate coiffures with numerous decorative hairpins. Men's formal hats were commonly rigid affairs resembling a bonnet, with stiffened streamers projecting perpendicularly at the back, possibly evoking a scarf tied at the back of the head over a high chignon.

NOMADIC COSTUME HERITAGE

Nomadic steppe peoples occupied an area between two garment-making traditions. To the south, sedentary populations developed weaving and used cloth as the basis of garment constructions. In the forested areas to the north, animal hides acquired by hunting or trapping provided raw materials for clothes. Both traditions reflect notions of economy and the optimum use of available raw materials. The physical dimensions of hides and cloth differ,

affecting approaches to garment constructions. Hide dimensions are limited to the size of the animal. Woven cloth is generally of unlimited length but of a fixed width that is determined by the type of weaving equipment employed. Although irregular in shape, hides have a definite symmetry and grain, which can be exploited to fashion garments from them. The rectilinear properties of cloth result in the straight seams and geometric shapes of cloth constructions.

Whenever the raw materials of one culture are adopted by another culture to make garments, concessions inevitably result. Often, construction principles of the original tradition are so strongly entrenched in a lifestyle or culture that principles of economy are sacrificed for matters of appearance. Whether it occurred through conquest or commerce, contact with the cloth traditions of the southern agrarian peoples affected northern garment constructions. When woven cloth was introduced with all its limitations and variables, garment construction on the steppe underwent some radical changes, but the memory of the hide tradition was never entirely eradicated. The use of irregular pieces of textile to fill in areas, extend sleeves, or alter the shape of a neck opening indiscriminately disrupts decorative patterns made for the original construction. This feature was regularly seen on nomadic garments and was typical of animal hide garment-making traditions, in which holes and weak places are regularly "filled in" with leather patches. Thus, when the Manchu moved from the steppe to the palaces of the Forbidden City, many of their national clothing traditions continued to be honored.

The constructions and shapes of Manchu garments reflect the animal hide garment-making traditions developed by the forest-dwelling, hunting and fishing nomads, whose descendants, the Evenk (formerly called Tungus) and the Even (also called Lamut), continue to people the easternmost part of Siberia. Most of these taiga-dwelling nomads kept reindeer for transport, but reindeer were also milked and ridden and their hides used to make clothing. These nomads' garments protected the body from scratches and scrapes in a forested environment. Coats were knee length and had long, relatively tight-fitting sleeves. They were worn belted and fastened with pairs of ties or loops and toggles to conserve body heat in winter and to militate against the depredations of mosquitoes and black flies in the summer.

Costumes included hoods and bonnets and moccasins made in one piece with leggings, trousers, and boots.

Coat Construction

The earliest surviving evidence for Evenk and Even costume dates only from the late nineteenth century, when European and American ethnologists mounted field collecting trips to Siberia. While the presence of western trade goods, such as glass beads and red and blue woolen cloth, reflect outside influences, the construction methods demonstrate the integrity of traditional animal hide garment-making technology. Some aspects of these surviving reindeer-herding nomadic costume, such as the short coats with flaring skirts, patterned fur mosaic decoration, and fitted hoods, are corroborated in eighteenth-century Chinese paintings depicting the peoples of the world that were commissioned by the Qianlong emperor. By examining the animal hide constructions of these taiga-dwelling nomads, we are better able to explain some of the features of historical Manchu garments.

Many Evenk and Even coats were constructed with waist seams and had flared skirts to facilitate walking or sitting astride reindeer. The fullness at the hem was created with additional pieces of hide. In some coats, a band of hide was gathered into the seam to form a flounce. In others, wedge-shaped gores were inserted at the back of the coat. Some of these gores were rectangular. In these cases, the upper edges of the insert were gathered to fit short horizontal slashes made at the back of the coat (see figures 2.11 and 2.12). Among the Even, a second garment made from a separate hide was suspended from the neck and tied around the waist, filling in the space between the front edges of the coat, which did not always meet. Most of these secondary garments extended the length of the coat and resembled aprons (see figures 2.13 and 2.14). The Evenk also retained this supplemental garment type, but some Evenk coat constructions included an asymmetrical overlap attached to the left coat front that closed over the chest and fastened securely at the neck and under the right arm. It is tempting to hypothesize that the asymmetrically closing coats, which are typical of horse-riding steppe nomads, resulted from the marrying of the apron and coat into a single garment.

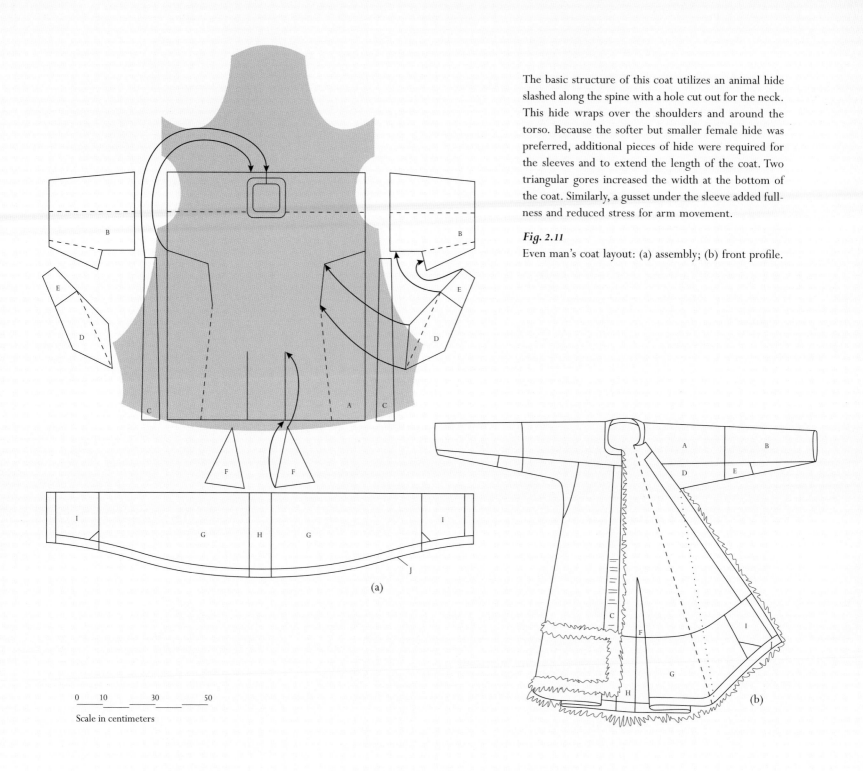

The basic structure of this coat utilizes an animal hide slashed along the spine with a hole cut out for the neck. This hide wraps over the shoulders and around the torso. Because the softer but smaller female hide was preferred, additional pieces of hide were required for the sleeves and to extend the length of the coat. Two triangular gores increased the width at the bottom of the coat. Similarly, a gusset under the sleeve added fullness and reduced stress for arm movement.

Fig. 2.11
Even man's coat layout: (a) assembly; (b) front profile.

0 10 30 50
Scale in centimeters

(a)

(b)

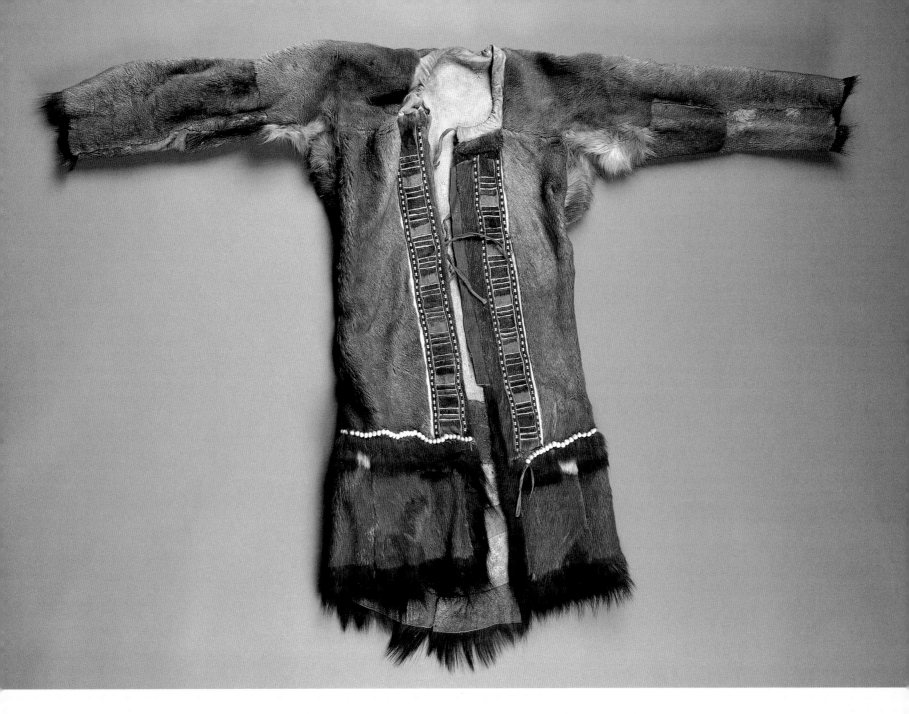

Fig. 2.12
Even man's coat from Markowa, Siberia; late nineteenth century. Reindeer hide, fur, beads, sinew, and wool cloth; length 92 cm. American Museum of Natural History, New York. Waldemar Bogoros collection. 1902-20 (70/5891A).

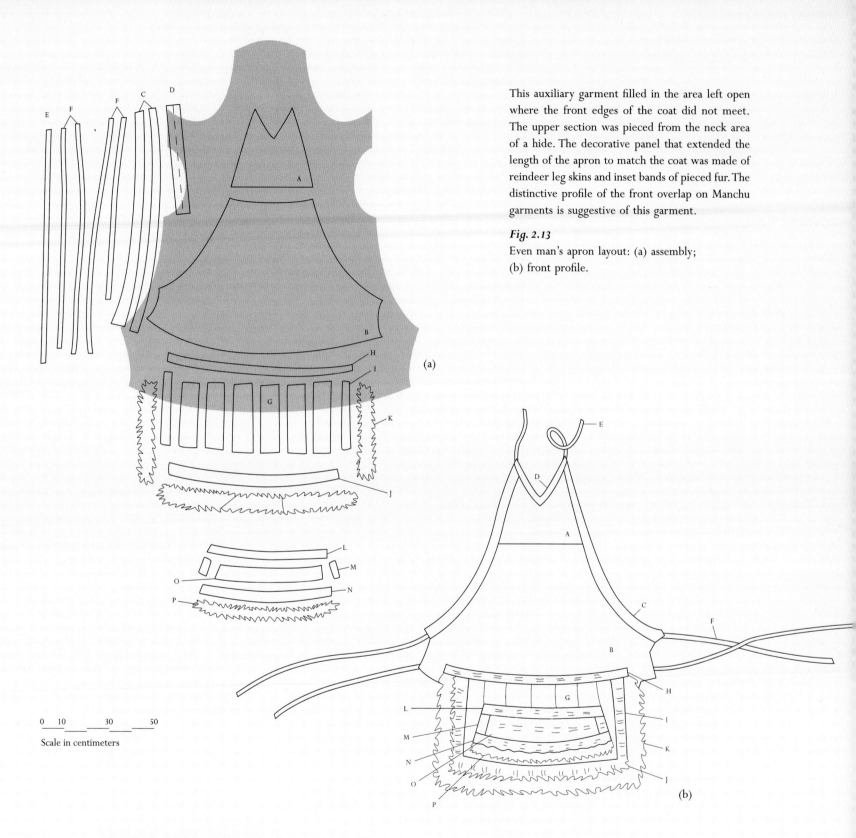

This auxiliary garment filled in the area left open where the front edges of the coat did not meet. The upper section was pieced from the neck area of a hide. The decorative panel that extended the length of the apron to match the coat was made of reindeer leg skins and inset bands of pieced fur. The distinctive profile of the front overlap on Manchu garments is suggestive of this garment.

Fig. 2.13
Even man's apron layout: (a) assembly;
(b) front profile.

(a)

(b)

0 10 30 50

Scale in centimeters

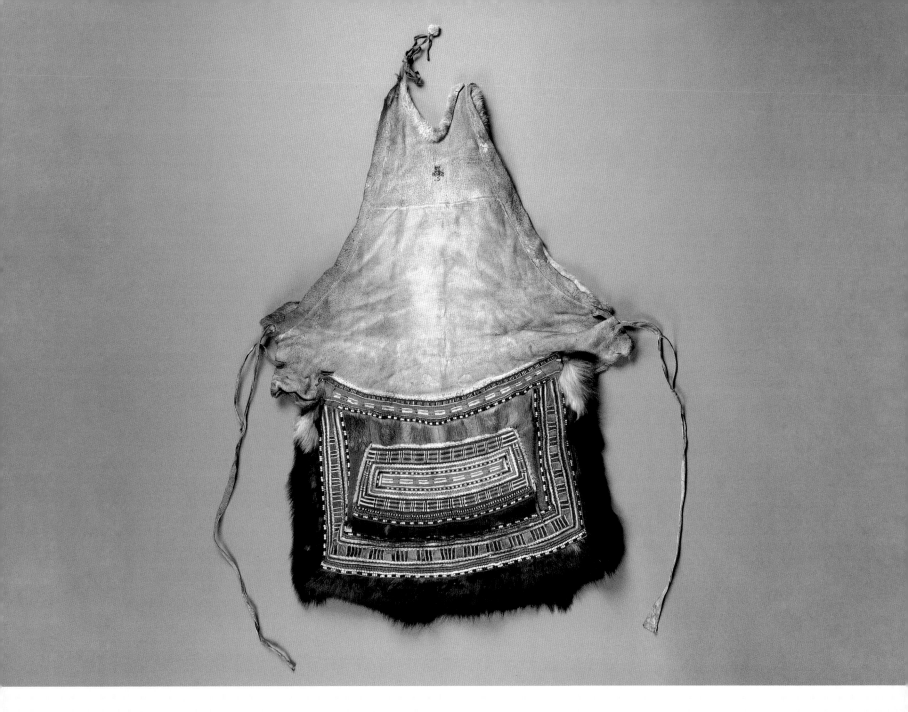

Fig. 2.14
Even man's apron from Markowa, Siberia; late
nineteenth century. Reindeer hide, fur, beads,
sinew, and wool cloth; length 85 cm. American
Museum of Natural History, New York. Waldemar
Bogoros collection. 1902-20 (70/5891C).

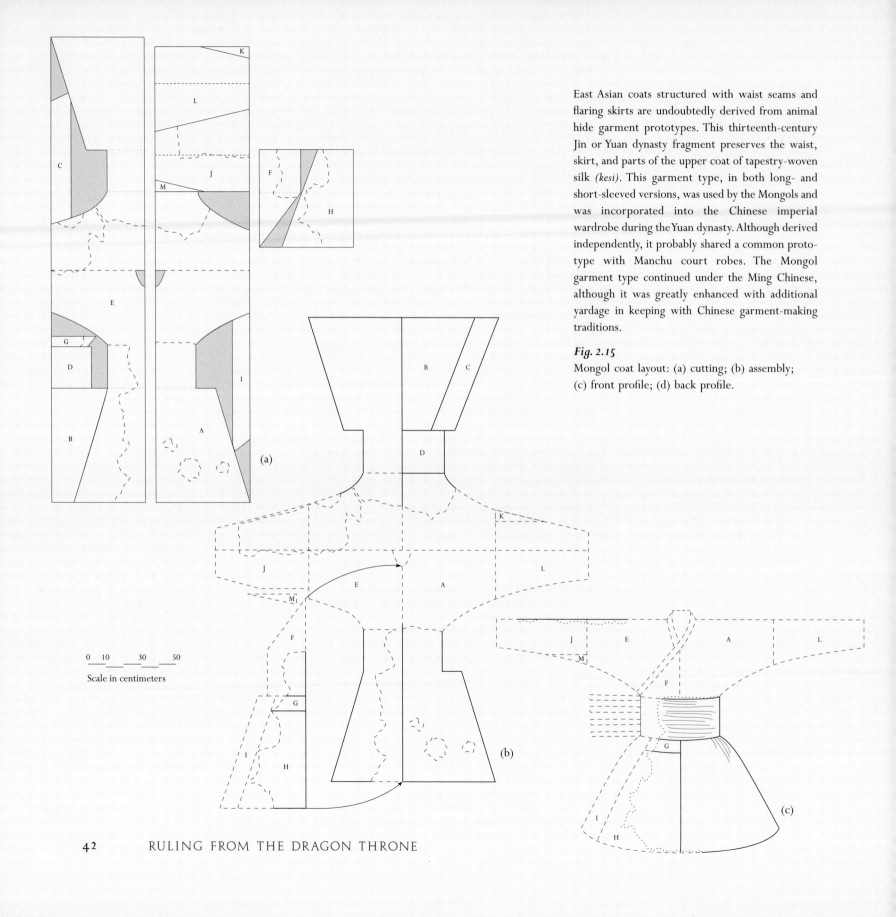

East Asian coats structured with waist seams and flaring skirts are undoubtedly derived from animal hide garment prototypes. This thirteenth-century Jin or Yuan dynasty fragment preserves the waist, skirt, and parts of the upper coat of tapestry-woven silk *(kesi)*. This garment type, in both long- and short-sleeved versions, was used by the Mongols and was incorporated into the Chinese imperial wardrobe during the Yuan dynasty. Although derived independently, it probably shared a common prototype with Manchu court robes. The Mongol garment type continued under the Ming Chinese, although it was greatly enhanced with additional yardage in keeping with Chinese garment-making traditions.

Fig. 2.15
Mongol coat layout: (a) cutting; (b) assembly; (c) front profile; (d) back profile.

Scale in centimeters

0 10 30 50

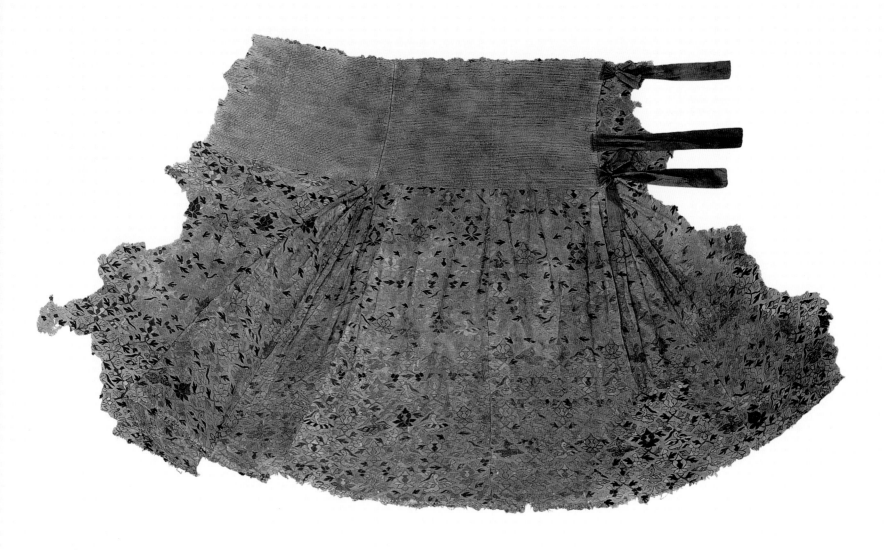

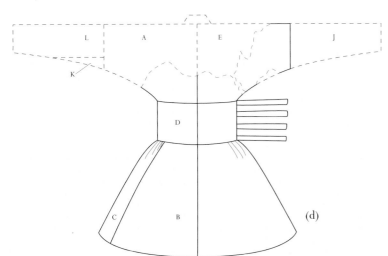

Fig. 2.16
Mongol coat fragments; thirteenth century. Tapestry-woven silk *(kesi)*; reconstructed length 125 cm. Jacqueline Simcox Ltd., London.

(d)

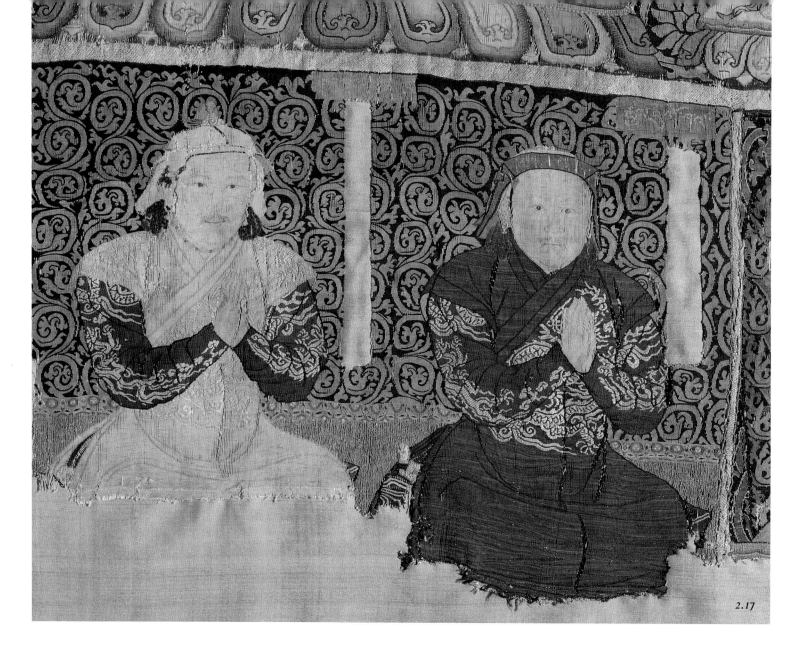

2.17

In this detail from a tapestry-woven religious picture showing Mongol garments from the fourteenth century, a short-sleeved surcoat marked with a dragon at the chest is worn over a long-sleeved robe with dragon designs organized in a quatrefoil yoke and band pattern.

Fig. 2.17

Anonymous, detail of the Vajrabhairava mandala: imperial portrait of Tugh Temur, who ruled 1328–1332 as the Yuan dynasty Wenzong emperor, and his brother Qoshila, who briefly ruled in 1328 as the Mingzong emperor; 1330–1332. Tapestry-woven silk and gilded paper *(kesi);* 245.5 × 209 cm. The Metropolitan Museum of Art, New York. Purchase, Lila Acheson Wallace Gift, 1992. 1992.54.

Many Manchu coats close asymmetrically; in fact, it is the curved shape of the front overlap and the loop-and-toggle closures that helped identify Qing dynasty garments as Manchu. A similar asymmetrical front overlap, but angling in a straight line from the center front neck to the right underarm, marked Mongol garments dating from the thirteenth and fourteenth centuries. Waist seams occur on several types of Mongol coats, particularly one type that bore decoration related to rank and status arranged in a quatrefoil yoke and band of ornament that ran horizontally midway down the skirts. This form was adapted by the founder of the Ming dynasty and continued to be a major garment type for dragon-patterned robes throughout the dynasty. When made of cloth acquired from plains-dwelling peoples, horsemen's coats were often quilted or faced with fur for added warmth. Although there are no known surviving items of Manchu clothing before the mid-seventeenth century, we know that by that time Manchu occupational dress made of cloth resembled Mongol-style horse-riding attire. The Manchu had also adopted the Mongol use of special hat ornaments and *zhu* (ceremonial necklaces) based on Buddhist rosaries to indicate rank.

Horsemen's coats were designed for movement and a life outdoors. The close-fitting upper body with its long, tapered sleeves and belted waist helped conserve body heat while giving free arm movement for riding or for conducting military operations from horseback. The lower part of the coat was slashed or vented to prevent it from bunching at the waist when the rider was seated in the saddle. Long, tight sleeves prevented the wind from blowing up the arm and were often cut generously long so they could be pulled down to cover the hand. Flaring sleeve extensions, such as the characteristic Manchu horse hoof cuff *(matixiu),* offered further protection for the back of the hand in the absence of gloves and mitts.

The overlap of the left front extension to the right side seam characteristic of Manchu and Manchu-influenced coats is the most eastern variant of methods of closing the coat tightly at the neck. Toggle buttons and loops that secured the overlap derived from hide traditions. The curved shape of the flap echoes the contour of an animal hide, not the straight lines characteristic of rectilinear woven cloth.

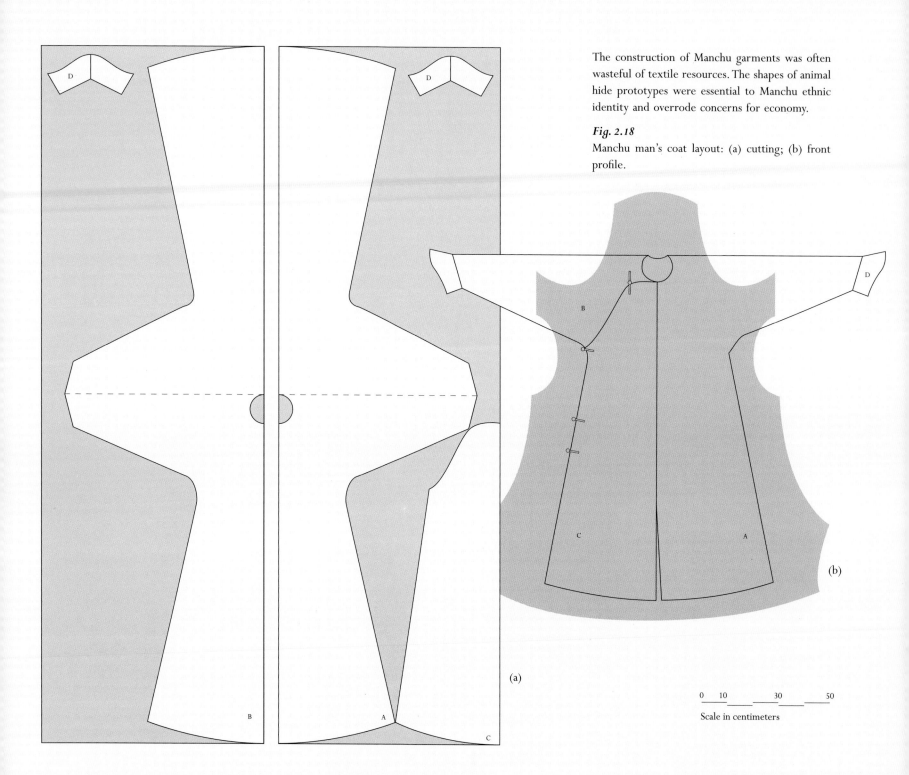

The construction of Manchu garments was often wasteful of textile resources. The shapes of animal hide prototypes were essential to Manchu ethnic identity and overrode concerns for economy.

Fig. 2.18
Manchu man's coat layout: (a) cutting; (b) front profile.

(a)

(b)

```
0    10         30         50
```
Scale in centimeters

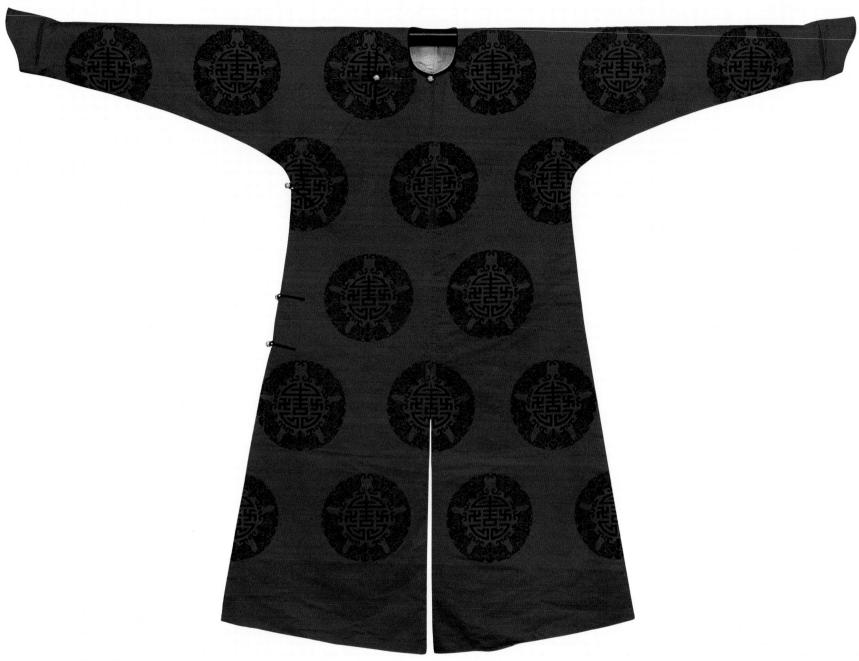

Fig. 2.19
Manchu man's coat *(neitao);* nineteenth century,
fourth quarter. Cut and voided silk velvet; length
132 cm. Mactaggart collection, Edmonton.

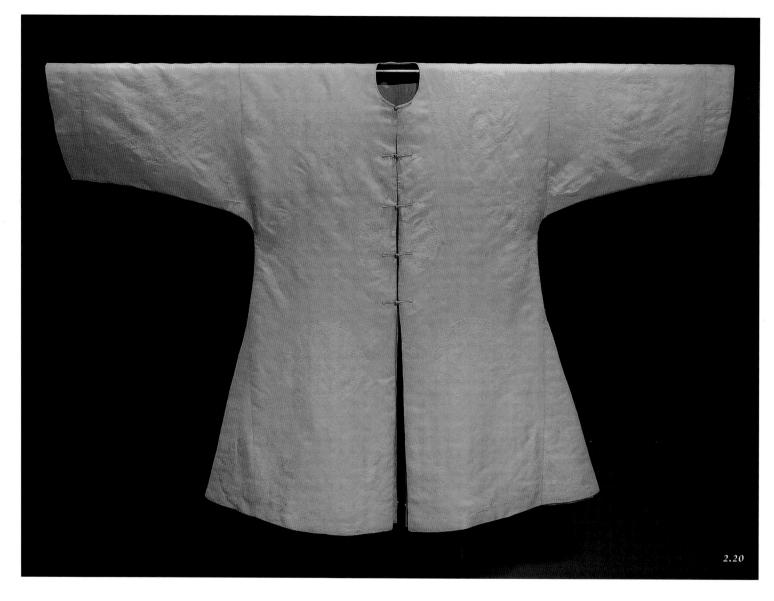

2.20

Surcoats served a functional role, for example, as added insulation; they also served a decorative role, as a contrasting color or an indicator of rank. This surcoat, called *huang magua* (yellow riding jacket), originally identified the highest-ranking ministers and officers of the imperial bodyguard.

Fig. 2.20
Manchu man's surcoat *(magua)*; eighteenth century, last half. Silk damask; length 87 cm. Jon Eric Riis collection, Atlanta.

Surcoats and Sleeveless Coats

Surcoats, called *magua,* worn over functional coats were characteristic of nomadic costume. These auxiliary short-sleeved garments added an additional layer of insulation, but more often they transformed the appearance of functional coats when made of contrasting colors or materials. Frequently, they bore ornament or patterns that indicated an individual's status or rank.

Vests or sleeveless coats (the shorter versions are called *majia* or *kanjian* and longer ones are named *gualan*) were another nomadic garment type. This garment was widely distributed among steppe nomads and inhabitants of the Tibetan plateau but did not occur among taiga hunters and trappers. This evidence suggests that the garment type evolved on the steppe as an auxiliary garment suited to camp-based and herding activities. Sleeveless coats were always worn over other garments.

Superficially, many sleeveless coat types used during the Qing dynasty appear similar to Han Chinese coat constructions, only made without sleeves. However, this does not explain the prevalence of sloping shoulder seams, for in all east Asian cloth traditions, narrow widths of fabric are sewn longitudinally to form coats without shoulder seams. Rather, the construction of the sleeveless coat follows a strategy seen in Even and Evenk coats, where one hide was used for the back. It had a hole cut out for the neck and was slashed from the neck hole to the top edge of the hide. When this hide was brought over the shoulders it extended to the top of the chest. The hide was secured at the neck, and a second hide, which served as a kind of plastron at the front, was secured at the sides and top of the chest. The overlap of the two hides provided additional warmth and protection for the front of the body and would have been particularly effective shields against the wind for a horseman. Surviving Qing dynasty examples made of cloth preserve this means of closure. Other construction strategies for the front opening were also used. Some opened down the center front and were held closed with loop-and-toggle fastenings; others were made with an overlap with a curved top line like a coat and held at the neck, right clavicle, and right side with loop-and-toggle fastenings. Nearly all versions have a minimum of side seams that produce deep vents even when the garment is extended full length.

This construction followed an animal hide construction strategy. It used a shaped piece of cloth for the back, which wrapped over the shoulders; another shaped piece covered the chest.

Fig. 2.21
Manchu sleeveless short coat layout: (a) cutting; (b) front profile.

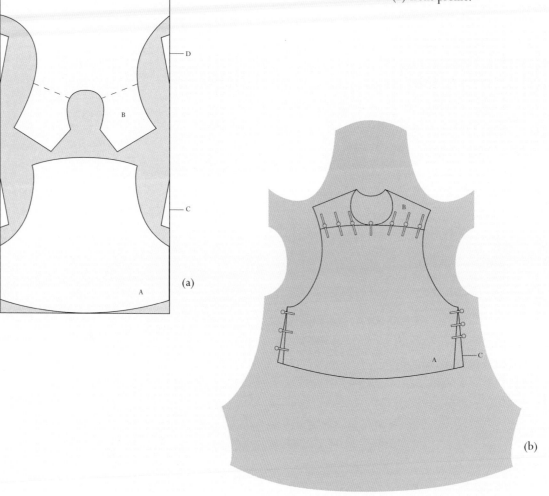

(a)

(b)

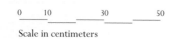

Scale in centimeters

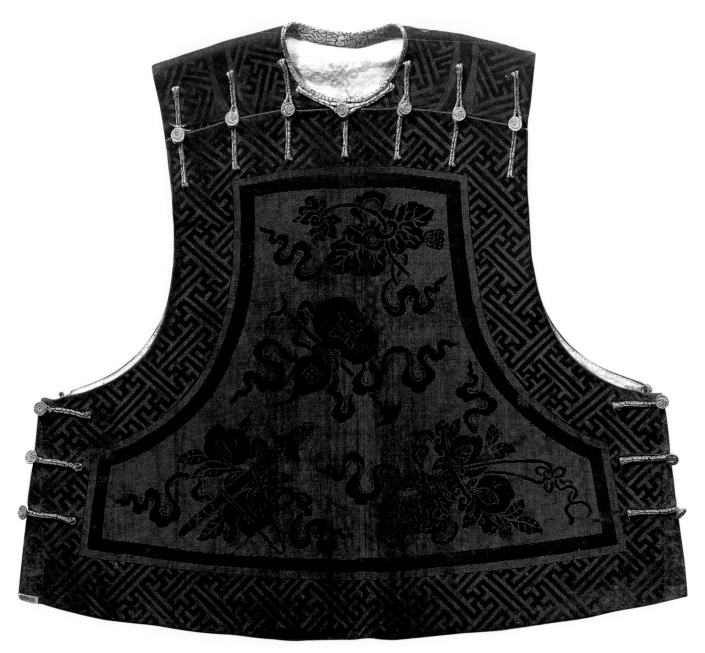

Fig. 2.22
Manchu or Chinese man's sleeveless short coat;
nineteenth century, fourth quarter. Solid cut and
uncut silk velvet; length 68 cm. Royal Ontario
Museum, Toronto. 958 × 103.

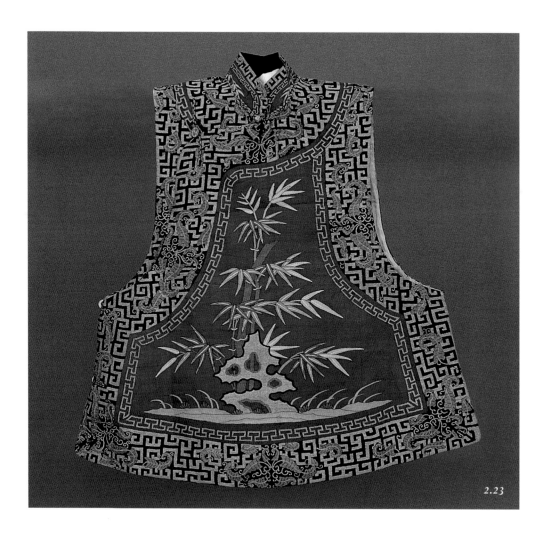

2.23

Manchu women wore sleeveless overgarments in a variety of lengths. By the end of the dynasty, Han Chinese men had adopted the short version of the vest for informal wear, but Han women tended to shun this overtly nationalistic garment.

Fig. 2.23
Manchu woman's short vest *(majia* or *kanjian)*; early twentieth century. Tapestry-woven silk *(kesi)*; length 73 cm. Mactaggart collection, Edmonton.

Leg Coverings

Trousers provided a horseman's legs with protection from the elements and from rubbing against the horse's flanks. Leg coverings probably evolved from animal hides, as suggested by Evenk costume, where legging and moccasin were frequently combined into one. These stockinglike garments were worn with boots and pieced hide trousers that resembled shorts. On the steppes, leggings made of cloth were provided with ties for attachment to a belt. A second pair of ties held the legging closely at the ankle. Tubular constructions in cloth sewn to a waistband made a more convenient garment, merging loincloth and leggings to create true trousers. All are called *ku* in Chinese.

Steppe nomads wore a separate skirtlike pair of aprons over their leg coverings. Paired aprons added additional bulk, extending the line of the coat

2.24

from shoulder to ground, which in sedentary societies like the Han Chinese was often associated with formality and ceremony. In a steppe environment, aprons also added bulk and were worn for ceremonial occasions, but on a practical level they would not have hindered the movements of the wearer should the need arise to make a hasty getaway on horseback. The more eastern variants of this garment were characterized by two identical parts. By the thirteenth century these auxiliary garments were incorporated into the skirts of some Mongol coats, and by the seventeenth century some Manchu coats reveal a similar combining of garments. Many Manchu coats preserved a panel below the waist to which the apronlike skirts were attached. This panel suggests the lower edge or peplum of a belted coat.

Han Chinese women and men wore both leggings and trousers. Leggings attached to a belt and worn tightly bound at the ankle preserved nomadic horse-rider leg coverings, which had been adapted by the Chinese as early as the fourth century B.C.E.

Fig. 2.24
Chinese woman's leggings *(ku)*; about 1900. Silk damask; length 79 cm. Royal Ontario Museum, Toronto. Gift of Mrs. William C. White. 972. 163.16AB.

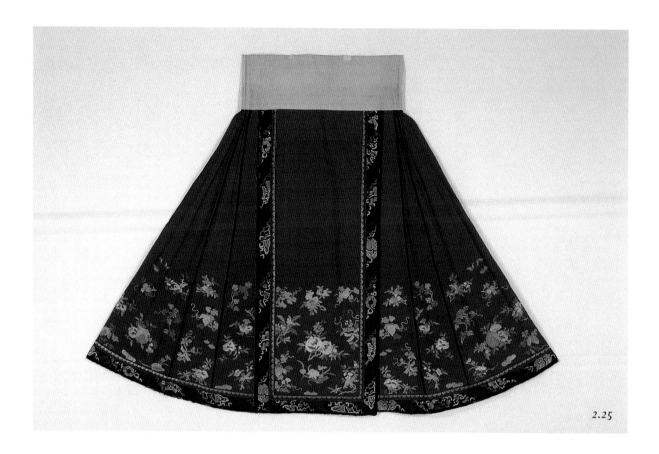

2.25

Chinese paired aprons worn to conceal trousers or leggings were borrowed from nomadic herder traditions. They created the more impressive bulk associated with formality. Only the lower section, exposed below a three-quarter-length coat worn with it, was decorated.

Fig. 2.25
Woman's paired aprons *(qun)*; mid-nineteenth century. Tapestry-woven silk *(kesi)*; length 96.5 cm. Association pour l'Etudes et la Documentation des Textiles d'Asie collection, Paris. A.E.D.T.A. no. 1165.

Ku (leggings) and *qun* (skirtlike paired aprons) were present in the Chinese wardrobe beginning with the end of the Bronze Age. Official Chinese histories record that in 307 B.C.E. the king of the small state of Jao (435–230 B.C.E.) introduced mounted archers into his army. Jao was one of many city-states that rose to prominence following the collapse of Zhou dynasty military power in 771 B.C.E. and the further disintegration of Zhou political and moral authority over the next three hundred years. During the so-called Warring States period (475–221 B.C.E.), the Jao state, occupying what is present-day Shanxi Province between the Huang (Yellow) River to the south and the steppe to the north, battled with other states for ascendancy. By adopting a nomadic method of warfare, Jao permanently changed the face of war on the central Chinese plains by replacing war chariots and their individual princely combatants with disciplined units of fast-striking cavalry. Not only did the Jao ruler adopt horse-riding archers, but also he went so far as to insist that nomadic-style trousers and short coats be worn

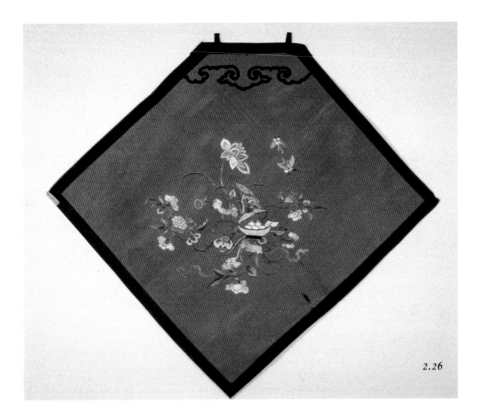

2.26

at his court, his reason being that the Chinese-style coat was too voluminous and clumsy to be practical. Jao's costume regulation did not survive the weight of Chinese court practice established by the Zhou kings, but nomadic costume became widespread as basic military and occupational clothing throughout the empire.

At the time of the Qing conquest, Chinese of both sexes and of all classes wore trousers and leggings. During the Qing dynasty, standard Chinese female attire consisted of a full-sleeved, three-quarter-length coat worn over trousers with a pair of aprons that concealed the woman's trousers on more formal occasions. This costume was used both for formal, quasi-official functions and for domestic wear.

From at least the time of the Southern Song dynasty (1127–1279), the Chinese form of these nomadic aprons consisted of two identical pleated parts. By the Ming period and continuing throughout the Qing dynasty, each part consisted of a straight panel and a section consisting of five to twelve

This undergarment was adapted from the bib aprons used to fill in the area at the fronts of north Asian hide coats.

Fig. 2.26
Chinese woman's bodice *(doudou)*; nineteenth century, fourth quarter. Embroidered silk satin; length 30.5 cm. Royal Ontario Museum, Toronto. Gift of Mrs. David Meltzer. 960.62.3.

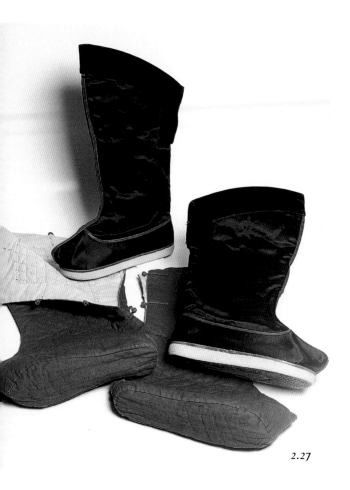

2.27

Rigid-soled boots permitted archers to stand in the stirrups while riding, greatly increasing the effectiveness of mounted attack. Court boots made of luxury materials only preserved the outward form of functional footwear. This pair was fitted with cotton covers to protect them in storage.

Fig. 2.27
Manchu man's court boots *(maxie)*; about 1900. Silk satin, leather, layers of cotton and paper, gesso; length 31 cm. Glenn Roberts collection, New York.

angled gores or pleated widths of cloth. These panels were arranged at the center front and back with the gored or pleated sections flaring gracefully at the sides. Decoration was commonly concentrated across the lower section, which remained exposed under the coat worn with it.

Undergarments, Footwear, and Headgear

The Chinese woman's traditional underbodice, called *doudou,* was a square of fabric hung from the neck by one corner and fastened around the back at its widest diagonal. *Doudou* are related to the bib- and apronlike secondary garments developed by the Even to fill in the space at the front of the coat. This same bodice or front apron is also found among other ethnic groups in southern and southwestern China, such as the Miao. This congruence reflects the northern origins of the Miao as recorded in Chinese histories.

Boots, called *maxie* (literally, "horse boots"), were used both for riding and for camp-based herding on foot. Boots also developed from the hide tradition, combining hide leggings or stockings with either a moccasin-type sole, which wraps around the foot, or a more rigid layered sole, which stops at the edge of the foot. The soft moccasin type was more typical of the extreme eastern part of Siberia, while the rigid-sole type was more common on the steppe itself from Manchuria to central Asia. The latter evolved to meet the demands of riding with stirrups: rigid-soled boots permitted archers to stand in the stirrups while riding, greatly increasing the effectiveness of mounted attack.

Hoods, called *guo,* were worn as separate outer garments. These possibly were derived from close-fitting head coverings fashioned from the hides of actual animal heads, a form found repeatedly in circumpolar areas. On the eastern steppe, the typical form, close fitting at the crown and elongated at the back and sides with a fastening under the chin, covered the head as well as protected the ears and back of the neck. Its form was characterized by a vertical seam that ran from the forehead to the back of the neck, joining identical halves.

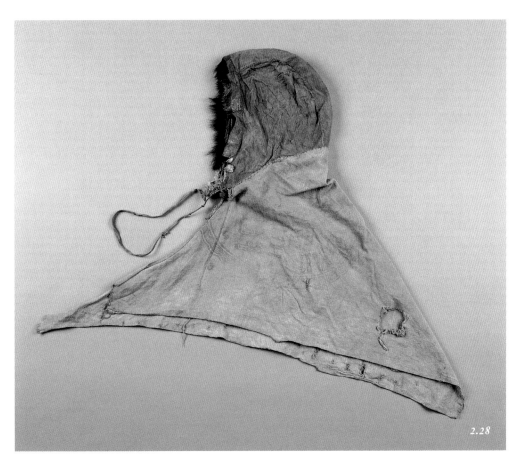

2.28

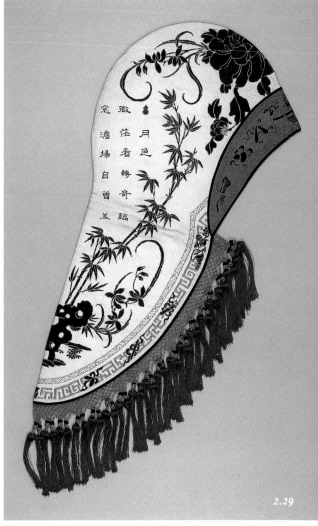

2.29

In the summer, close-fitting hoods protected the head and neck of herder/hunters from the depredations of mosquitoes and flies. In the winter, the hoods retained body heat and added protection from inclement weather.

Fig. 2.28
Even man's summer bonnet from Markowa, Siberia; late nineteenth century. Reindeer hide, fur, sinew, and cotton cloth; length 48 cm. American Museum of Natural History, New York. Waldemar Bogoros collection. 1902-20 (70/5776 D).

This garment was termed a "wind bonnet" (fengguo), probably referring to its original function in northern Asia.

Fig. 2.29
Chinese woman's hood (fengguo); nineteenth century, fourth quarter. Embroidered silk satin; length 77.5 cm. Museum of Fine Arts, Boston. Helen and Alice Colburn Fund. 32.41.

原靖逆將軍三
等義烈公工部
尚書納穆扎爾
我懷賢勞命將往
代正值黑水猖獗
鼠輩以二百衆隘
萬賊中因緣狗節
勇濟以忠
乾隆庚辰春
御題

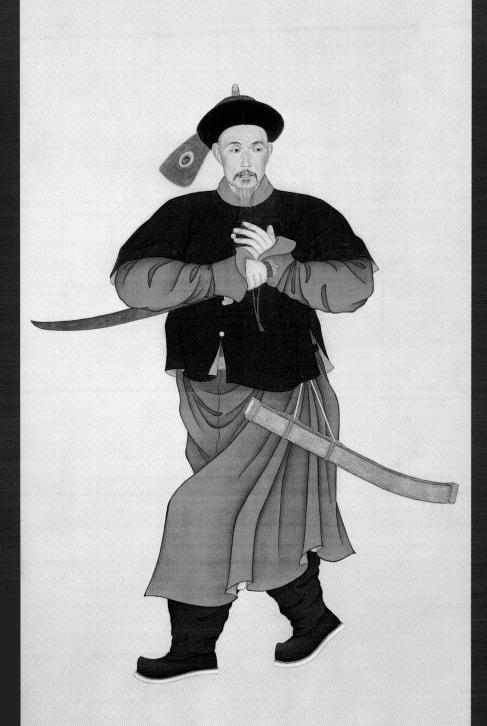

3.1

3
MANCHU GARMENTS

The Manchu wardrobe included various styles: informal functional costume, such as riding coats, trousers, and boots; and formal ritual attire, which included ceremonial robes and capelike collars. By the time of conquest, these formal garments were made of Chinese dragon-patterned silks.

INFORMAL WEAR

Male functional coats, called *neitao,* were midcalf-length with a shaped overlap at the front held with loops and toggles at the neck, clavicle, and under the right arm. They had long, fitted sleeves ending with flared cuffs; the skirts were vented at the center front and back (see figure 2.19 in chapter 2). The bottom of the front overlap of the riding coat version of this garment, called *xingshang,* was cut shorter than the front panel it covered. The hem of the shorter flap was held with loops and toggles to keep it from blowing in the wind. Coats were belted tightly at the waist with a card-woven silk sash, called *dai,* which was secured with adjustable hook-and-loop closures.

Boots and layered, close-fitting garments characterized Manchu costume.

Fig. 3.1
Anonymous, portrait of Namjar, one of fifty officers who pacified Tibet by imperial command; dated to 1760. Hanging scroll: ink and color on paper; 184.5 × 94.6 cm. Royal Ontario Museum, Toronto. 925x84.4.

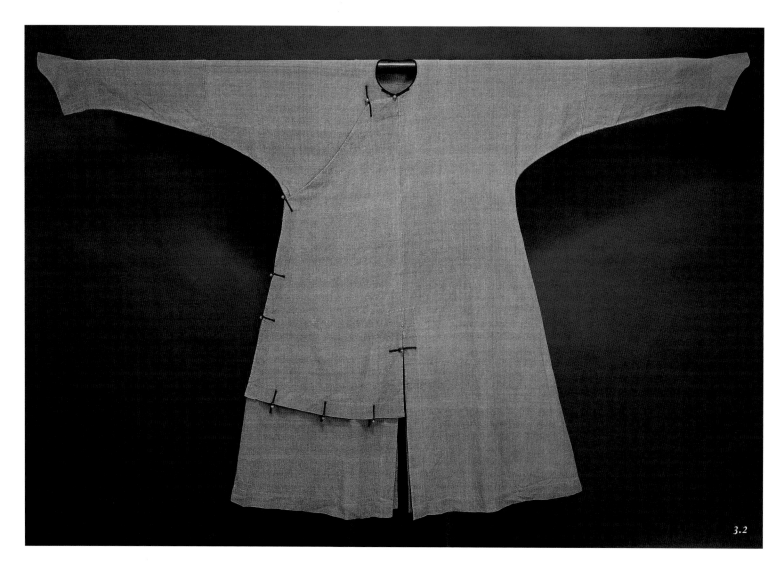

3.2

The front overlap on riding coats was cut short and held in place with loop-and-toggle fastenings to keep it in place while riding.

Fig. 3.2
Manchu man's informal riding coat *(xingshang);* nineteenth century, third quarter. Silk gauze; length 138 cm. Jon Eric Riis collection, Atlanta.

The riding coat was often worn with a waist-length or knee-length surcoat. These surcoats had long sleeves without cuffs and opened down the center front. Like the coat beneath, they closed with loops and toggles and were vented to the waist at the center back and side seams. The longer versions were called *waitao;* the shorter surcoats were called *magua* (see figure 2.20 in chapter 2). Normally these auxiliary garments were made of dark-colored fabrics, but when bannersmen attended court, their *magua* were made of colored fabrics appropriate to the wearer's banner affiliation.

During the winter, upper-ranking Manchu wore a fur-faced, long surcoat called *duanzhao*. These flamboyant nomadic garments contrasted sharply with Chinese tastes, which favored the use of fur as linings that remained largely unseen. Manchu soldiers also wore a hip-length sleeveless coat called *gua*. These usually opened at the center front and were given extra padding and quilted to serve as a kind of body armor.

Men's legs were covered with trousers or leggings *(ku),* which were tucked into boots. Manchu boots, called *maxie* (literally, "horse boots"), were originally made of leather, but during the Qing period boots worn at court were made of black silk satin. Leather piping reinforced the front and back seams. The edges of the thick platform soles, which were made of layers of stiffened cotton or paper over a leather sole on the bottom, were whitened with gesso (see figure 2.27 in chapter 2).

Hats were worn on all public occasions by members of the Qing court, Manchu bannersmen, and eventually by most urban males (see figure 1.1 in chapter 1). A Manchu man's headgear was based on a close-fitting cap with rounded crown and an upturned, separately attached brim faced with fur. Originally, the brim probably turned down for protection. In addition to appropriate hats for court functions (see discussion of court hats on page 76), hats were always worn when going out of the house and in the house when attending formal family gatherings.

Similarly, a costume was considered incomplete without a collar. Like hats, a collar was worn on all public occasions. Collars for formal court occasions were called *piling* (see discussion of court collars on page 70); those for semiformal court use as well as other public occasions were called *lingtou*. For court use, the stiffened round collar of the *lingtou* was faced with various furs, graded by rank—sable being reserved for the emperor and his consort. For domestic wear, the collar could be faced with plush velvet or satin, depending on the season.

Female informal costume consisted of many of the same elements used by men. The generic term *qipao* (literally, "banner gown") was used for female costume, and more specific vocabulary applied to individual garments. The male *neitao* was cut floor-length and renamed *chenyi*. Its long sleeves were not always finished with flaring cuffs, and the skirts were vented

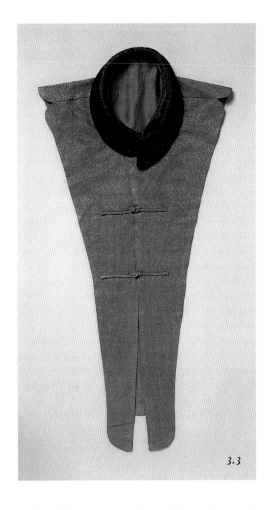

3.3

In the cloth garment-making tradition, lining and neck bands kept luxury fabrics clean. In the Chinese tradition, no costume was considered complete without a collar, thus the Manchu adopted separate collars for formal and semi-fomal attire. In winter, these were fur-faced or made of plush; in summer, they were satin.

Fig. 3.3
Manchu man's or woman's semiformal collar *(lingtou)* for winter; late nineteenth century. Plush and silk damask; width at shoulder 31.8 cm. Ruth Chandler Williamson Art Gallery, Scripps College, Claremont, California. SC763.

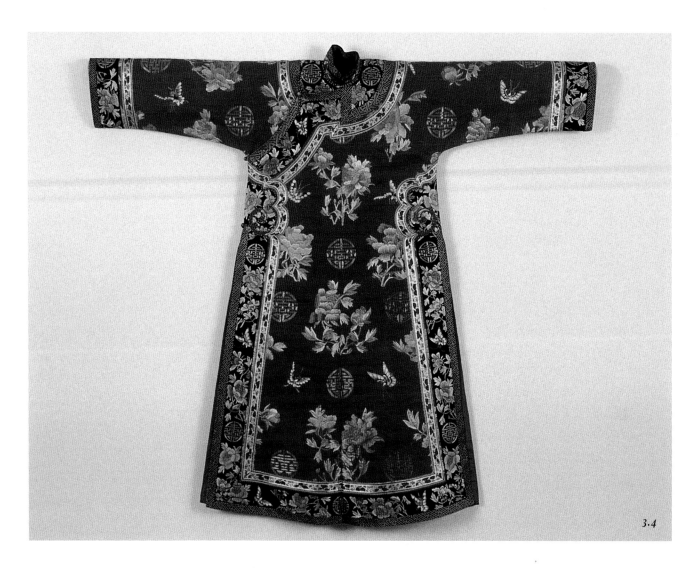

Originally, the skirts of Manchu women's robes were left unsewn along the side seams to facilitate walking. During the Qing dynasty this feature was often exploited as a matter of fashion. Here, the side vents open to the waist, allowing the contrasting colors of undergarments to show.

Fig. 3.4
Manchu woman's domestic semiformal robe *(changyi)*; early twentieth century. Embroidered silk gauze; length 142 cm. Mactaggart collection, Edmonton.

only at the sides. When the side slits reached to the area under the arm, the garment was called *changyi.* Women wore the *chenyi* and *changyi* unbelted. Women's wardrobes also included full-length surcoats *(waitao)* and short surcoats *(magua)* as well as short vests *(kanjian* or *majia)* and full-length versions of the sleeveless coat or vest *(gualan).* Manchu women's court hats resembled the fur-faced, unturned brim hats worn by men; domestically their hats resembled elaborate coiffures. Structures of shaped fabric, called *jiazitou,* or floss silk–wrapped frameworks, called *dianza,* held jeweled ornaments. Women's formal collars were identical to men's collars. Domestically a long

patterned ribbon was placed around the neck, one end draped over the front of the robe, the other tucked into the neck opening.

There are only painted depictions to show what seventeenth-century versions of informal Manchu garments looked like. Even after the mid-eighteenth century these relatively plain garments rarely survived. Most examples in museum collections date from the second half of the nineteenth century or the early twentieth century.

FORMAL COURT WEAR

Manchu formal or ceremonial attire was named *chaofu* (literally, "court costume"). Once installed in Beijing, the Manchu restricted the use of formal dress to the most important court functions. These centered around the cycle of annual state sacrifices conducted by the emperor to ensure the well-being of the empire, the emperor's birthday celebrations, and the grand audiences held a total of thirty-nine times a year, at which courtiers paid homage to the emperor seated on the Dragon Throne. Because of its ceremonial use and ethnic significance, *chaofu* was the most conservative of Manchu costume introduced into China, preserving features distinctive to Manchu native costume worn prior to the conquest. The costume included robes, overcoats, hat, and accessories. *Chaofu* is most commonly depicted in Qing period posthumous or ancestor portraits, reflecting the highest level of court status attained by the wearer. For that reason *chaofu* was used as a burial shroud for those honored to wear it; consequently it is the rarest type of costume surviving in collections.

Although it was a single garment, the male version of the court coat (*chaopao*) visually consisted of three units. The upper part was a riding coat, of which only the lower sleeves and cuffs were visible. After the 1730s the lower sleeves with horse hoof cuffs (*matixiu*) were made of materials that contrasted markedly with the rest of the coat. Typically they were constructed of blue or black fabric, which was either ribbed or patterned with sets of woven or embroidered parallel bands. These suggested long, tight-fitting nomadic sleeves that extended over the hand but that could be pushed up the arm in a series of parallel folds when the hand was engaged. Over

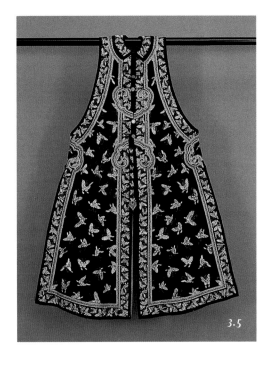

3.5

While men wore hip- and knee-length vests, only Manchu women wore full-length vests.

Fig. 3.5
Manchu woman's domestic long vest (*gualan*); late nineteenth century. Embroidered silk satin; length 147 cm. Mactaggart collection, Edmonton.

the riding coat was a short-sleeved, hip-length surcoat similar to the *magua*. Such auxiliary decorative garments, worn over the more practical attire for formal occasions, had been a feature of nomadic costume in central and eastern Asia since the twelfth century.

The third component was a pair of aprons, similar to the pair of pleated aprons worn informally by Chinese women. The aprons were arranged to overlap at the sides; the small tab at the lower right of the coat, called *ren,* was undoubtedly the vestige of some form of closure or tie. The survival of a mid-eighteenth century two-part *chaopao* skirt attached to a waistband, which is now in the collection of the Victoria and Albert Museum, offers evidence that the Manchu robe and aprons may have remained separate garment components until after the conquest.

Toward the end of the Qing dynasty, when court regulations were no longer strictly enforced, lower-ranking courtiers frequently wore separate *chaopao* aprons over ordinary coats, under the surcoat bearing their insignia of rank, which, according to the scholar of Chinese costume Schuyler Cammann, saved the expense of having a special court coat made.

All *chaofu* are decorated with dragon patterns. On male robes these patterned areas contrast with areas of plain silk. A quatrefoil yoke at the neck extends to the waist at the chest and back and to the elbow at each shoulder. A horizontal band of ornament at the hips marks the hem of the original belted surcoat. A second horizontal band of dragon patterns mark the midpoint of the apron's skirt. The placement, crowding of the pattern, and arbitrary cutting of decorative motifs resulted from adapting fabric designed for a flowing Ming garment to the more restricted forms derived from animal hide traditions.

As vassals of the Ming court, the leaders of the Manchu tribes received both bolts of silk and dragon coats as diplomatic gifts in return for tribute. The bolts of presentation silks were in turn made up in formal Manchu-style garments or *chaopao;* or, as Cammann has argued, Manchu *chaopao* may have resulted when actual Ming coats were cut down (see figure 3.10). By the time of conquest, the tradition of silk Manchu *chaopao* decorated with discrete areas of dragon patterns was so firmly established that its form was considered inviolable. Throughout the dynasty the disposition of designs

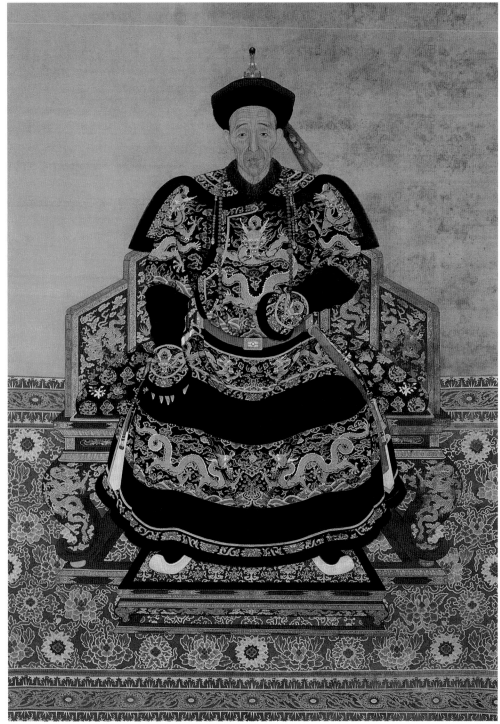

Boggoda, prince of the blood, first rank, was grandson of Hongtaiji, the second Manchu emperor, and inheritor of one of the large estates assigned to Manchu leaders at the time of the conquest.

Fig. 3.6
Anonymous, portrait of Boggoda, Prince Zhuang (1650–1723); eighteenth century or later. Hanging scroll: ink and color on silk; image only 215.7 × 152.9 cm. Arthur M. Sackler Gallery, Smithsonian Institution, Washington D.C. Smithsonian Collections Acquisitions Program and partial gift of Richard G. Pritzlaff. S 1991.78.

The male version of the Qing formal court coat (*chaopao*) was the most conservative of all Manchu garments and preserved vestiges of three garments (a hypothetical reconstruction shows how a short-sleeved surcoat and pair of long aprons add substance to the basic long-sleeved riding coat). When cut from fabrics originally designed for Ming dynasty court robes, excess fabric was cut away to create the trapezoidal shapes of animal hides that had originally been used to make Manchu garments. Cut-away parts, which were decorated with dragon patterns, were pieced together and fashioned into cuffs and a band at the hem of the riding jacket. Here, three different fabrics have been used to construct this garment.

Fig. 3.7
Manchu man's formal court robe layout:
(a) cutting; (b) assembly; (c) front profile.

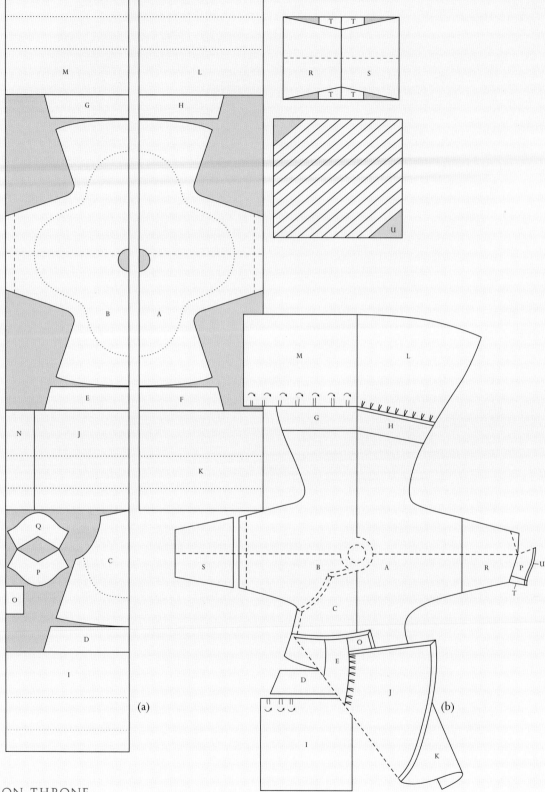

(a)

(b)

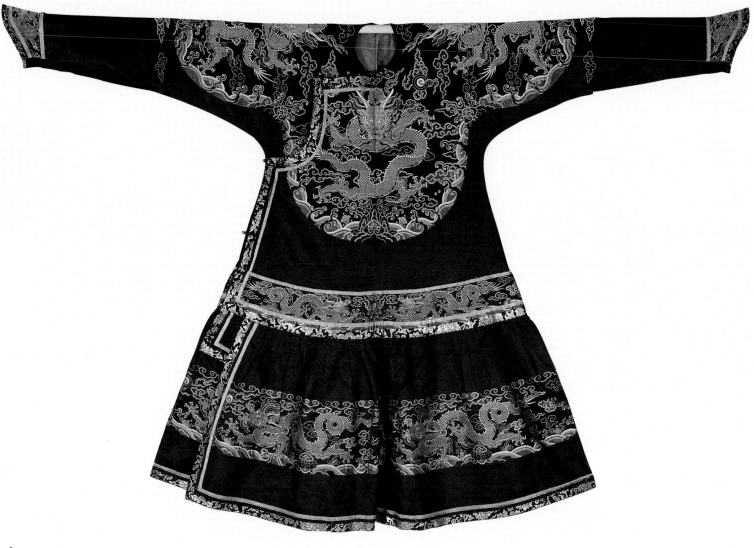

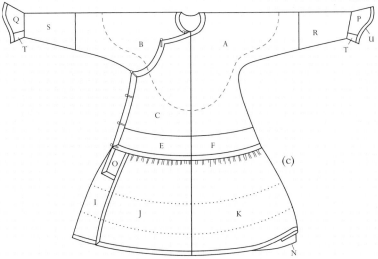

Fig. 3.8
Manchu man's formal court robe *(chaopao)*; late seventeenth or early eighteenth century. Brocaded silk damask; length 143 cm. Myers collection, Paris.

The structure of both men's and women's formal court robes *(chaopao)* suggests a costume consisting of several layers. The various components become evident in this deconstruction.

Fig. 3.9
Hypothetical origin of formal court robes *(chaopao)*:
(a) for men—riding coat, surcoat, paired aprons;
(b) for women—long coat, surcoat, long overvest.

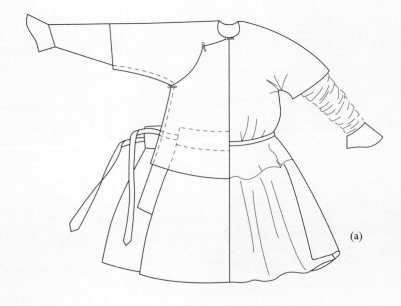

(a)

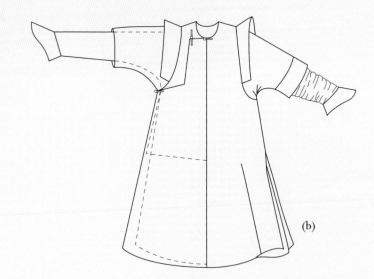

(b)

0 10 30 50

Scale in centimeters

continued with only minor changes in style or placement of pattern areas. Being made of fine silk, the *chaopao* was suitable only for ceremonial wear, yet in its construction it embodied the practical functions for which the garments it was based on had been designed to meet.

Women's Court Attire

Although the form of most surviving Manchu women's formal court attire is debased and the importance of the original construction largely misunderstood, this court attire reflected features similar to those of male attire. The form was also based on layered garments: a long-sleeved, full-length coat (*chaopao*) with a full-length sleeveless coat (*gualan*) worn over it. Probably by the time of conquest—and certainly by the mid-eighteenth century, when court costume was regulated by edict—these two garments had merged into a single coat. Applied bindings and the flaring projections at the shoulders preserved the outline of the earlier sleeveless coat.

By the mid-eighteenth century, the coat sleeves had been styled like those of male *chaopao*—with lower sleeves of ribbed or banded fabric and horse hoof cuffs. At the same time, another separate full-length sleeveless coat, called *chaogua*, was added to high-ranking women's formal wardrobe. Worn over *chaopao*, it opened down the front and was vented at the back.

The *chaopao* would appear to have been added in response to ancient Chinese court traditions that were under review at the beginning of the eighteenth century. Ranking women at the Ming dynasty court wore a vest-like tabard called *xiapei*. Its decoration conveyed information about rank and status. During the Qing dynasty, Chinese women continued to wear a *xiapei* that had evolved into a knee-length, front-opening garment. The *xiapei* was constructed with angled shoulder seams and was used to display insignia of rank like its Ming dynasty court precedent. To accommodate the very wide Ming-style sleeves on Chinese women's formal coats (*ao*), the side seams were left open and front and back sections were held together with straps.

Manchu women also wore a full-length apron called *chaoqun* under the court coat. Only the lower edges were exposed at the hem of the *chaopao*. This wraparound garment consisted of two parts, each formed from up to ten angled panels and attached to a waistband. These angled panels were

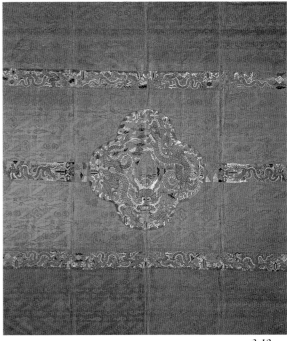

3.10

Although here the coat lengths have been seamed to form a panel, uncut bolts of cloth were presented to the Manchu leaders by the Ming emperors.

Fig. 3.10
Panel composed of four lengths of an uncut court robe; early seventeenth century. Embroidered solid cut and uncut silk velvet, embroidered with floss silk and metal- and silk-wrapped threads; 313 × 272 cm. Royal Ontario Museum, Toronto. Gift of Mrs. Edgar J. Stone. 956.67.2.

arranged in slightly overlapping pleats. This garment probably derived from the same prototypes that originally added bulk to men's functional attire for formal occasions and had evolved into the lower sections of the male *chaopao*. With its decoration concentrated only along the lower sections of the pleats it also resembled the paired aprons worn by Chinese women since the Song dynasty (960–1279); see figure 2.25 in chapter 2.

Collars

Both male and female *chaofu* were worn with a separate triangular collar called *piling*. The costume was considered incomplete without it. These collars flared over the shoulders at the back. The shape and form of this flaring tippet resembled a separate hood, which when opened along the top of the crown would lie flat across the shoulders. If the *piling* does indeed derive from a hood form, then it is related to the larger family of steppe garments with back collars, which convert into hoods, rather than to the Chinese yoke, or "cloud collars" *(yunjian)*. In late seventeenth century paintings and in surviving *piling* from the mid-eighteenth century, the Manchu form had lost all vestiges of tabs or fringes, which might once have served to tie the top edges together.

Necklaces

Manchu ceremonial dress included a court necklace called *chaozhu*. The form was derived from a Buddhist rosary. It consists of 108 beads divided into four sets of 27 by larger spacers called *futou* (Buddha heads). A long pendant extended down the wearer's back, acting as a counterweight. Three smaller pendants attached to the necklace were called *shuzhu* (counting strings); each had eight *jinianer* (memory beads). When men wore *chaozhu,* one counting string was placed on the wearer's right side and two on the left. Women's *chaozhu* were worn with the counting strings reversed. Men wore a single strand of beads with a long pendant at the back of the neck. Women frequently used three strands; two worn draped over each shoulder crossing over the chest and back, a third worn over the head. Originally these counting strings had been used to keep tally of prayers. The single string at the right kept track of individual circuits, while the other two kept

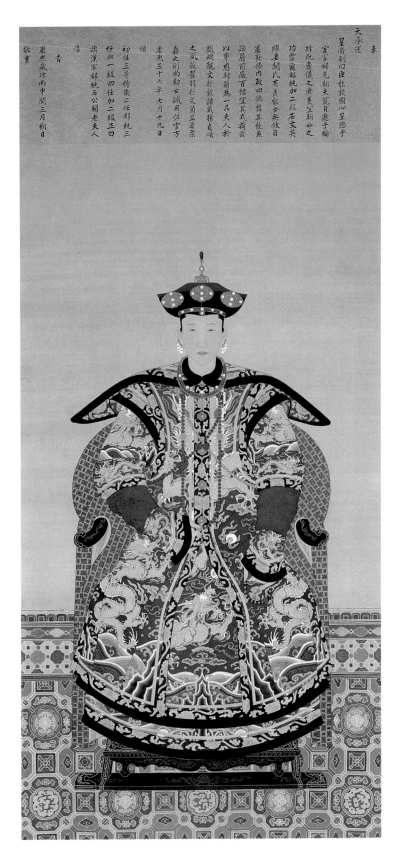

The bold dragon patterns on this Manchu woman's matching formal court garments—robe, vest, *piling*, and underskirt—were typical of the flamboyant late–Ming dynasty textile designs favored by the Manchu.

Fig. 3.11
Anonymous, a portrait of the Lady Guan (mid-seventeenth to early eighteenth century); early eighteenth century or later copy, inscription dated to 1716. Hanging scroll: ink and color on silk; image only 211.7 × 113.8 cm. Arthur M. Sackler Gallery, Smithsonian Institution, Washington D.C. Smithsonian Collections Acquisitions Program and partial gift of Richard G. Pritzlaff. S 1991.121.

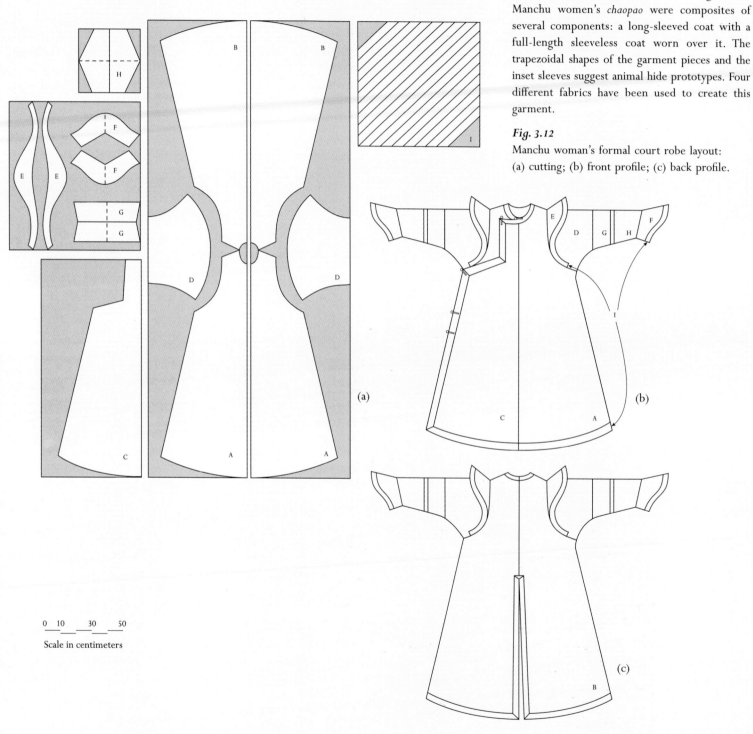

Like the male version of this formal garment, Manchu women's *chaopao* were composites of several components: a long-sleeved coat with a full-length sleeveless coat worn over it. The trapezoidal shapes of the garment pieces and the inset sleeves suggest animal hide prototypes. Four different fabrics have been used to create this garment.

Fig. 3.12
Manchu woman's formal court robe layout:
(a) cutting; (b) front profile; (c) back profile.

(a)

(b)

(c)

0 10 30 50
Scale in centimeters

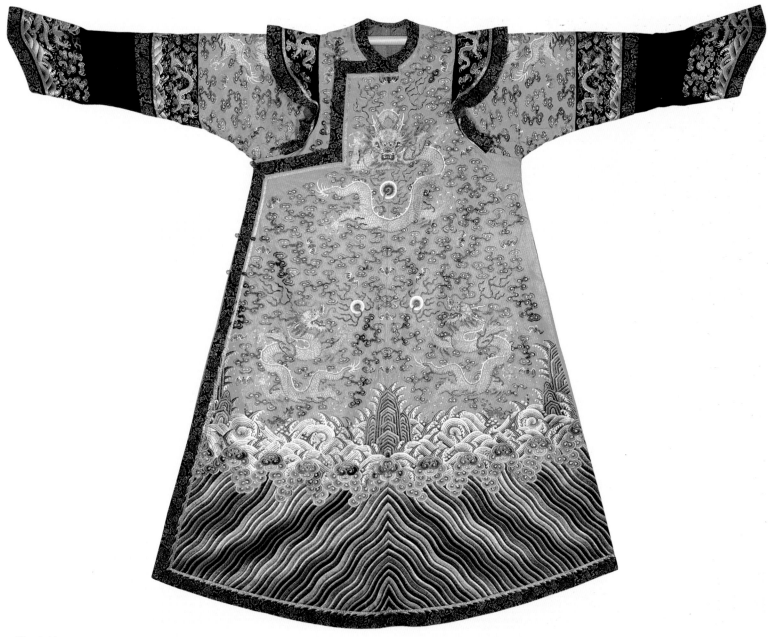

Fig. 3.13
Manchu woman's formal court robe *(chaopao)*;
mid-eighteenth century. Embroidered silk satin;
length 144 cm. Museum fur Ostasiatische Kunst,
Koln.

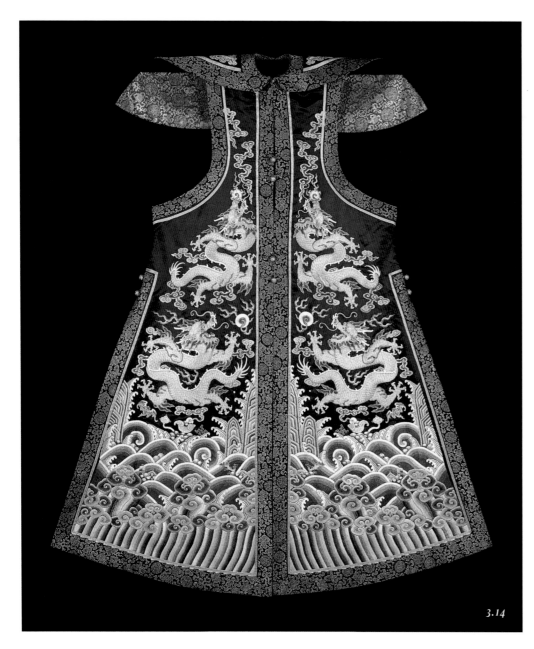

3.14

Vests that retained angled shoulder seams and deeply cut-out armholes typical of animal hide constructions were among the most archaic of Manchu female garments.

Fig. 3.14
Manchu woman's formal court sleeveless coat *(chaogua);* mid-eighteenth century. Embroidered silk satin; length 140 cm. Museum of Art, University of Oregon, Eugene. Murray Warner Collection of Oriental Art. MWCH45:45.

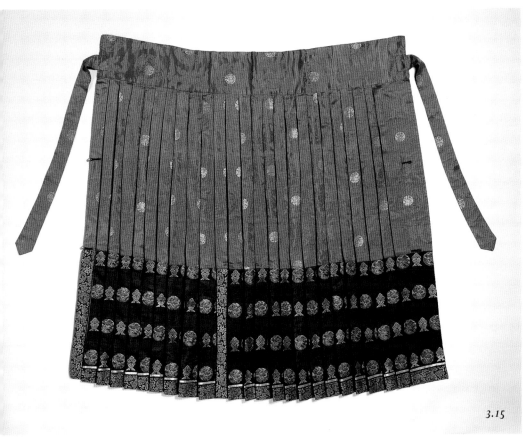

3.15

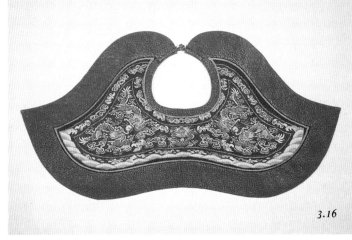

3.16

Technically an undergarment, this element of female court attire rarely survived.

Fig. 3.15
Manchu woman's formal court paired aprons *(chao-qun)*; nineteenth century, fourth quarter. Brocaded silk damask; length 89 cm. Petterson Museum of International Culture, Claremont, California. Gift of Miss Margaret Angeil. 93.15.11.

The shape of this capelet suggests a hood opened flat along the top seam.

Fig. 3.16
Manchu man's or woman's formal court collar *(pi-ling)*; nineteenth century, fourth quarter. Tapestry woven silk *(kesi)*; width 60 cm. Royal Ontario Museum, Toronto. Gift of Mrs. M. Brown. 958.5.

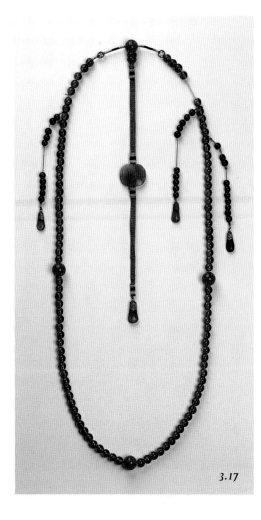

3.17

Manchu court necklaces *(chaozhu)* were based on a Buddhist rosary. The long pendant extended down the wearer's back and acted as a counterweight. Three smaller pendants attached to the necklace were called "counting strings" *(shuzhu)*, each with eight memory beads, and were originally used to keep tally of prayers. Men wore the *chaozhu* with one counting string on the right and two on the left; for women, the counting strings were reversed.

Fig. 3.17
Manchu court necklace *(chaozhu)*; probably nineteenth century. Amber, jadite, rose quartz; approximate length 65 cm. Beverley Jackson collection, Santa Barbara.

track of tens and hundreds of circuits. The first mention of the rosary as part of the official Manchu costume was a decree dated to 1664 stating that "counting beads" were to be worn by civil and military officials down to the fourth rank. (For a discussion of rank, see page 116.) This has suggested to some scholars that the introduction of the rosary was linked to the visit of the Dalai Lama in 1648. However, the Mongols also used this accessory and may have introduced it to their Manchu neighbors before the conquest.

Upper-ranking Manchu women also wore a torquelike collar called *lingyue*. Generally, this accessory was made of gold or gilt metal and inlaid with coral and pearls. Colored ribbons hanging at the back were coordinated with the wearer's rank.

Hats and Hat Ornaments

Hats were indispensable parts of formal Manchu dress and were worn on all public occasions, which included all court ceremonies and audiences, all authorized functions of Qing government officials, and most formal social occasions. Two years after the conquest, the Qing court decreed two types of headgear. The original Manchu fur-trimmed hat with upturned brim and a crown covered with red-dyed yak hair or horsehair was worn during the cold half of the year. The summer, or "cool," hat—a conical sunshade of finely woven bamboo strips covered with silk gauze and fitted with a stiffened sweatband—was used from spring through early autumn. It was based on a traditional Chinese hat shape called *li*. Like its winter equivalent, it was originally decorated with horsehair. By the mid-eighteenth century, a fringe of red floss silk was prescribed for formal occasions. At the same time, for semiformal occasions a fringe of plied red silk cords or red-dyed yak hair replaced floss silk.

Both categories of hat had jeweled finials that conveyed information about rank and status. The emperor's hat finials were made of pearls—a tall, three-tiered arrangement of fifteen pearls set in gold for the most formal occasions and a single large "Eastern pearl" for semiformal wear. "Eastern pearls" are freshwater pearls from the Sungari, Yalu, and Amur rivers in Manchuria. Because of their association with the Manchu homeland and great rarity in

large sizes, they were used as hat ornaments only by members of the imperial clan. Other male members of the imperial family were entitled to fewer pearls in shorter tiered arrangements and a ruby or other red jewel for semiformal wear.

When courtiers wore a tall, slender, faceted hat ornament on ritual occasions, the hat was called *chaoguan* (court hat). On other occasions, a round jewel was used, changing the designation to *jiguan* (festive hat). The earliest regulation concerning the types of hat jewels is dated to 1632. In this law, different colored stones indicated the four grades of civil and military officials. The highest officials used ruby or another red-colored stone; the second rank, sapphire; the third rank, rock crystal; and the fourth rank used gilt metal. The regulations were reworked in 1645 to incorporate the imperial bureaucracy, which was divided into nine ranks. In 1727, the regulations were further revised, dividing the colored stones into crystalline and opaque versions and then adding a smaller round jewel for use on semiformal court occasions.

Men's hats also carried embellishments that indicated merit. Plumes of peacock tail feathers, called *lingzhi,* were graded by the number of "eyes": triple-eyed plumes were the most distinguished, followed by double- and single-eyed plumes. The plume consisted of a bundle of peacock tail feathers tightly wired in layers to reveal the prescribed number of "eyes" surrounded by a sheath with long black filaments of pheasant feathers or black horsehair. *Lingzhi* were inserted into a tube of jade (or a glass imitation of jade), which was attached under the finial at the crown of the court hat. Originally, the right to wear the *lingzhi* was only conferred by the emperor in recognition for some meritorious service. Later in the dynasty, officials could obtain the right to *lingzhi* by making suitable gifts to high-ranking court officials. Pairs of sable tails, called *diaowei,* marked active military service.

Winter-style court hats for imperial women had fur-faced brims. Their summer hats, unlike the conical bamboo summer hats for men, were identical to their winter hats except that black satin replaced the fur facing on the upturned brim. The most formal style hats, for the empress and principal

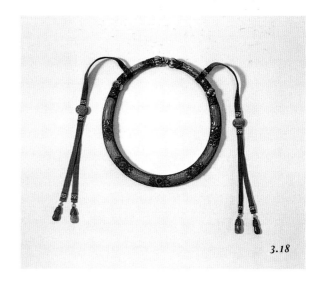

3.18

Like *chaozhu*, most Manchu jewelry had been adopted from Mongols and incorporated into Qing costume prior to the conquest.

Fig. 3.18
Manchu woman's court torque *(lingyue);* probably nineteenth century. Gilt silver metal with remains of kingfisher feather inset with coral, trimmed with rose quartz, nephrite, and pearls; length with tapes 30 cm. Royal Ontario Museum, Toronto. Gift of Mrs. Edgar J. Stone. 975.332.1.

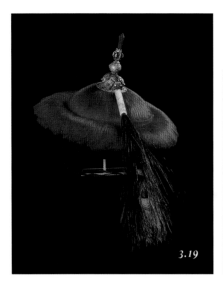

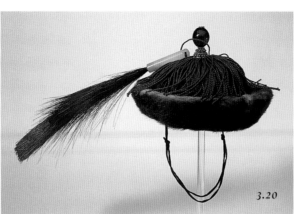

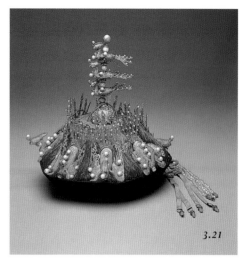

The Manchu used a summer court hat based on a Chinese-style sunshade and another for winter based on a nomadic cap with upturned brim. Rank was indicated by the type of fur, color, and shape of the hat finial and accessories such as peacock feather plumes *(lingzhi)*.

Fig. 3.19
Manchu man's formal court hat *(chaoguan)* for summer; late nineteenth century. Bamboo, silk gauze, floss silk, glass, gilt metal, cotton, and feather; height 24 cm, diameter 34 cm. Museum of Art, University of Oregon, Eugene. Murray Warner Collection of Oriental Art. MWCH65:18.

Fig. 3.20
Manchu man's court hat *(jiguan)* for winter; nineteenth century, second half. Silk satin, sable, silk cord, glass, gilt metal, jadite, and feather; height 16 cm, diameter 26 cm. Royal Ontario Museum, Toronto. 922.4.26.

Fig. 3.21
Winter formal court hat *(chaoguan)* for empress; eighteenth century, second half. Fox (?), floss silk, gold, pearls, silk, coral, height 26 cm. National Palace Museum, Taiwan, Republic of China.

consorts, were embellished with finials composed of three gold filigree phoenixes arranged in tiers and decorated with pearls. Other jewel-encrusted gold filigree phoenixes decorated the crowns of these imperial hats. Lower-ranking consorts were assigned fewer phoenixes, and the hats of imperial princesses were decorated with filigree golden pheasants. The court hats of Manchu noblewomen resembled those of their husbands but had circular plaques inlaid with kingfisher feathers and set with semi-precious jewels in place of the filigree birds worn by imperial women (see figure 3.11).

Other Court Accessories

The court sash used by men was called *chaodai*. It was a narrow, card-woven silk strap, color coordinated to the wearer's rank. *Chaodai* were trimmed with four gilt metal or jeweled plaques that also reflected rank. Two of the belt plaques were fitted with rings from which accessories were suspended and which hung at the sides when worn. These accessories included pairs of drawstring purses; cases for a knife, chopsticks, and flint; and a pair of kerchiefs. The kerchiefs, evocative of the pairs of similar cloths used for Chinese ritual dress since the Han dynasty, were tapered and pointed for formal wear and narrow and finished with a straight end for other occasions. Attaching one's personal effects to a belt with cords was a horseman's solution for convenience and security. The display of the Qing *chaodai* made a clear reference

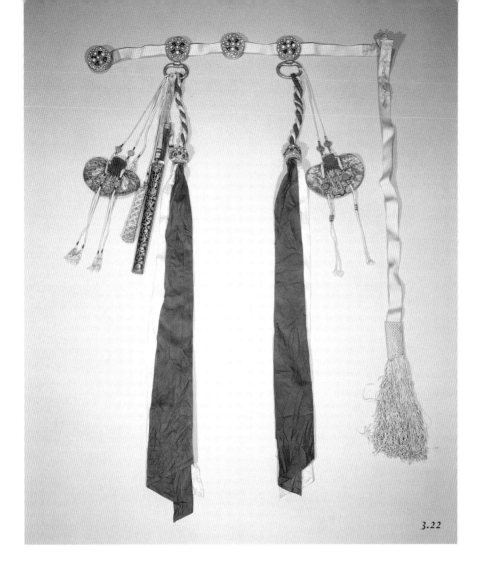

3.22

Men's court coats were belted tight around the waist. The color of the card-woven silk belt and the jewels that ornamented the four plaques were determined by rank. Ceremonial kerchiefs, a pair of purses, a dagger, and flint hung at the sides. For the state sacrifices, the purses were plain; for other court ceremonies, these purses were embroidered.

Fig. 3.22
Manchu man's court belt *(chaodai)*, first type; nineteenth century, first half. Silk, gold, pearls, red glass, embroidered satin, various silk cords; length of belt 124 cm. National Palace Museum, Taiwan, Republic of China.

to the nomadic origins of the Manchu. As a further indication of their military origins, men also wore an archer's ring made of jade or other semiprecious stone on one thumb. Originally, such an accessory was a functional device used to hold the bowstring while an archer's index and middle finger steadied the arrow.

The *chaodai* and *chaozhu* for the emperor were further coordinated to the specific court ritual at which he officiated. Generally, the silk ribbons and bands used by the emperor were yellow. However, for ceremonies at the Altar of Heaven these accessories were blue, as were his ritual clothes; they were red for rites at the Altar of the Sun and pale blue at the Altar of the Moon.

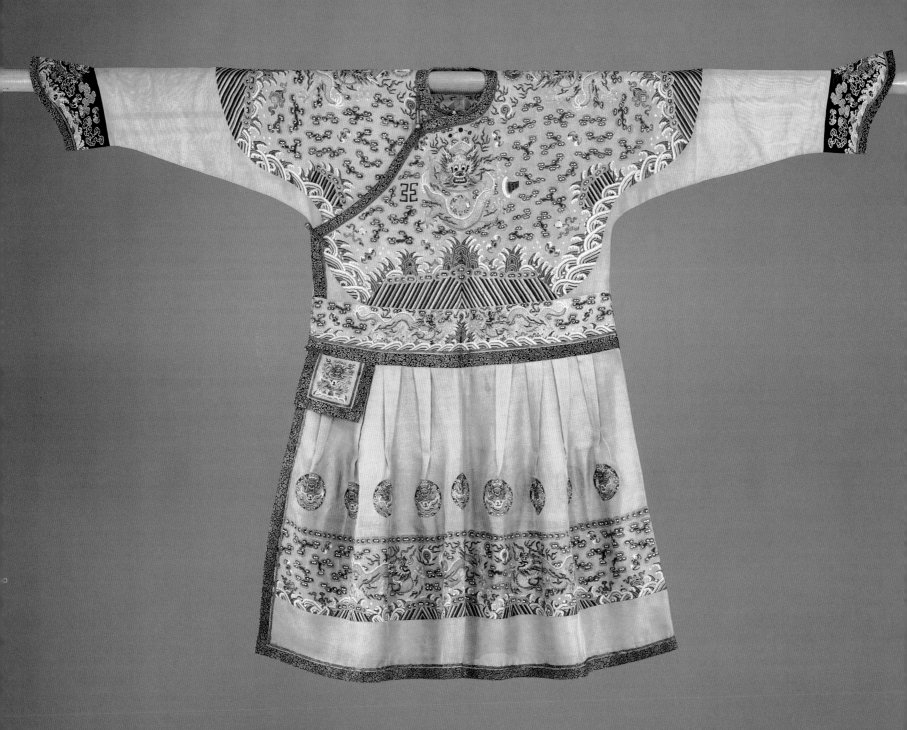

IN SERVICE OF THE DRAGON THRONE

The Chinese emperor's position was based on the Confucian ideal of the family and the sense of order that arose from appropriate behavior among family members. Within the basic social unit, the family, the highest respect was paid to the male head of household. In turn, he performed rituals and religious ceremonies on behalf of his kin. By extension the village elder performed a parallel function within the community, as did the local magistrates within the prefecture. The emperor fulfilled the same position for the whole human world. He was "Father and Mother," supreme magistrate and supreme priest on behalf of "all under heaven."

As emperors, the Manchu embraced the Confucian notion that court apparel defined and sustained the elite who were responsible for good government on earth and harmony in heaven. Ritual and ceremonial clothing were regarded as absolutely necessary to maintaining the proper hierarchical order in society. From a Confucian perspective, proper clothing ensured that virtue (li) would be recognized and praised, so that the base elements of society would not encroach upon their superiors. As the Han dynasty historian Ban Gu (d. 92 C.E.) noted: "[T]he ancients used clothing for the

The most formal Qing court garments were based on preconquest Manchu attire that evolved from animal hide garment-making traditions.

Fig. 4.1
Emperor's formal court robe *(chaopao)*, probably made for the Tongzhi emperor; nineteenth century, third quarter. Embroidered silk gauze; length 115 cm. The Metropolitan Museum of Art, New York. Rogers Fund, 1945. 45.37.

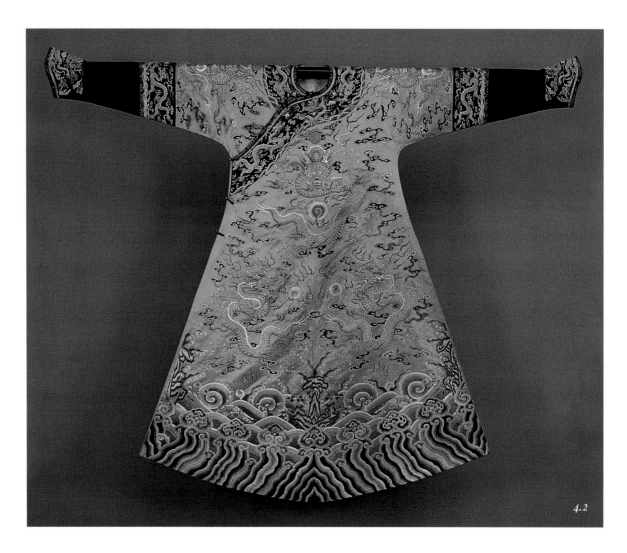

4.2

This shade of yellow was called *xiangse* (incense color) and was conferred by the emperor as a special honor. The placement of the skirt vents at the side seams and the addition of a band of ornament between the sleeve extension and the body of the coat distinguished women's court garments.

Fig. 4.2
Manchu woman's semiformal court robe *(jifu)*, probably for imperial consort; eighteenth century, second quarter. Embroidered silk satin; length 135 cm. Mactaggart collection, Edmonton.

purpose of distinguishing between the noble and the common and to illustrate virtue so as to encourage the imitation of good example." Thus, proper clothing contributed to the harmony in the sociopolitical-religious order and bore testimony to the civilizing authority of the state.

Like every dynasty before them, the Qing enacted sumptuary legislation to regulate the official wardrobe. The Qing declared a new dynastic color to legitimize their rule in accordance with the *wuxing* (Five Phases system). *Wuxing* was associated with the ancient yin-yang philosophy. In it, the five elements of the universe—earth, fire, water, metal, and wood—had a direct correspondence to seasons, directions, musical scales, and colors. The sequence of black, blue, red, yellow, white was viewed as the natural

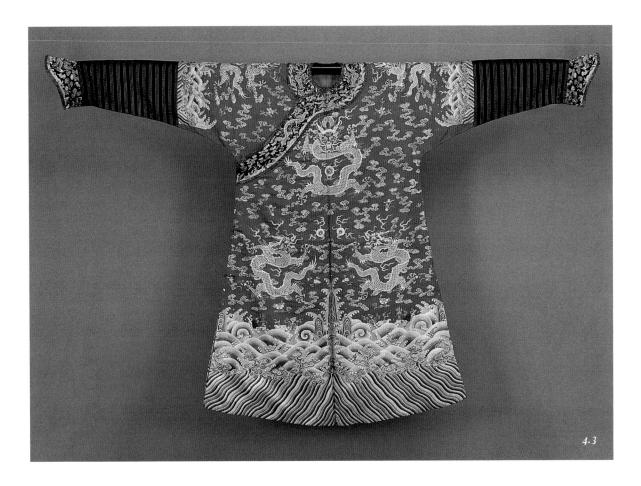

4.3

succession of colors. Red, the official color of the Ming dynasty, was replaced by yellow, reflecting the belief that the element earth overcomes fire. Qing court clothing was thus harmonized with yellow. With the exception of rituals that required red robes, the Qing largely avoided the Ming dynastic color.

Yellow had additional significance in traditional China. Since at least the time of the Jin dynasty (1115–1234) and possibly dating back to the time of the Gaozu emperor (618–626) of the Tang dynasty (618–906), wearing yellow robes had been the prerogative of the emperor, serving to link him to the mythical founder of Chinese civilization, Huangdi (the Yellow emperor). Some of the earliest Qing edicts enshrined this ancient imperial precedent

This brown color referred to as *qiuxiangse* (tawny incense) was reserved for imperial princes and other nobles.

Fig. 4.3
Manchu man's semiformal court robe *(jifu)*; nineteenth century, second quarter. Embroidered silk twill; length 141 cm. Mactaggart collection, Edmonton.

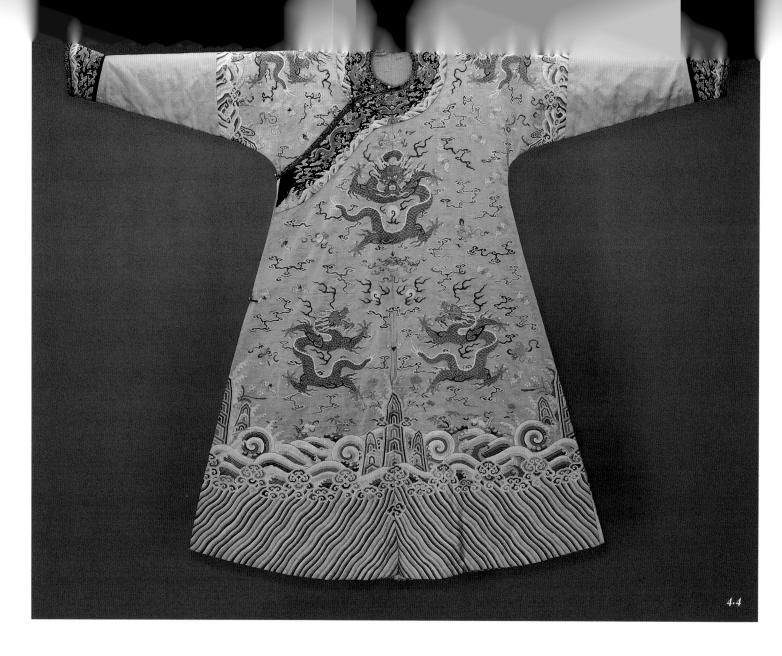

4.4

The arrangement of iconography and styling of semiformal court attire was not formalized until the mid-eighteenth century.

Fig. 4.4
Emperor's semiformal court robe *(jifu),* probably made for the Qianlong emperor; eighteenth century, third quarter. Tapestry-woven silk *(kesi);* length 152.1 cm. Museum of Fine Arts, Boston. William S. Bigelow collection. 11.3983.

by reserving *minghuang* (brilliant yellow) for the emperor and his consort. The heir apparent and his consort used *xinghuang* (apricot yellow), usually orange in tone; the emperor's other sons used *jinhuang* (golden yellow), also in the orange range but duller in tone than *xinghuang*. Imperial consorts and some ranks of imperial princesses wore *xiangse* (incense color), a greenish-yellow color, and other members of the imperial clan used *qiuxiangse* (tawny incense), which actually ranged from brown to plum tones. Manchu nobles to the rank of third-degree prince used blue; all others were assigned black. These colors referred to the background colors of the garments themselves. In reality, these color restrictions applied only to garments actually worn at court. But many of the surviving Qing ceremonial and celebratory garments were undoubtedly made for purposes other than court wear. Without documentation or other circumstantial evidence, it is now almost impossible to identify the rank of the wearer of a garment by its color alone.

THE EMPEROR'S ROLES

In addition to purely ritualistic activities in which the emperor sat upon the Dragon Throne wearing yellow *chaopao* to receive the homage of his family and courtiers as a demonstration of the centrality of the emperor, the institution of emperorship was defined by five functions: sacral, administrative, scholarly, martial, and private.

Sacral Role: The Emperor as Son of Heaven

The emperor was mediator between the world and the higher powers. He prayed and offered sacrifices to ensure that everything would go well, or continue to go as it should. As Heaven's Son he was the central officiant at the great ritual sacrifices that occurred at the turn of the seasons and at other strategic moments during the calendar year. Most of these sacrifices were performed at the altars in the suburbs beyond the walls of the capital. The colors of ceremonial attire used by the celebrants engaged in rituals honoring the Supreme Ancestor, heaven, earth, the sun and moon, agriculture, and sericulture followed ancient Chinese precedent. Conceptually, this role was the most prestigious, hence only the most formal attire was appropriate.

Administrative Function:
The Emperor as Supreme Magistrate

As head of state and supreme magistrate, the emperor's role was preeminently secular. Affairs of state were less formal than the ritual functions of the emperor. They were conducted through daily audiences with courtiers and family members. For these audiences, the emperor's clothing reflected political authority and control. Because these court events were concerned with hierarchy, all courtiers wore garments to indicate rank.

Scholarly Role: The Emperor as Supreme Man of Letters

As the supreme man of letters (*wenren,* literally, "man of culture"), the emperor was expected to have a working knowledge of Confucian canonical texts and the orthodox commentaries. As a patron of arts and scholarship, the emperor commissioned new artworks and sponsored scholarly works, such as the compilation of encyclopedias. In this role, the emperor was expected to emulate the understated elegance of the *wenren* who modeled himself on Confucius, as noted in the *Analects:*

> The superior man did not use a deep purple, or a puce color, in the ornaments of his dress. Even in his undress, he did not wear anything of a red or reddish color. In warm weather, he had a single garment either of coarse or fine texture, but he wore it displayed over an inner garment. Over lamb's fur, he wore a garment of black; over fawn's fur, one of white, and over fox fur one of yellow.

Manchu-style informal garments made of appropriate fabrics were used for these informal activities.

Martial Role: The Emperor as Supreme Commander

The emperor was also commander in chief of the army. As conquerors, the Qing were particularly sensitive to their martial heritage. During the early part of the dynasty, when power was being consolidated, the emperor was present in person on the battlefield. Until the mid-eighteenth century, a gathering of the banner troops in the capital occurred every three years. By extension, hunts in the hills north of the Great Wall were viewed as a means of maintaining military preparedness.

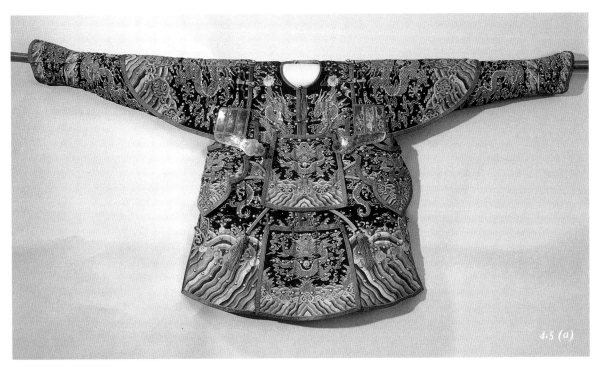

4.5 (a)

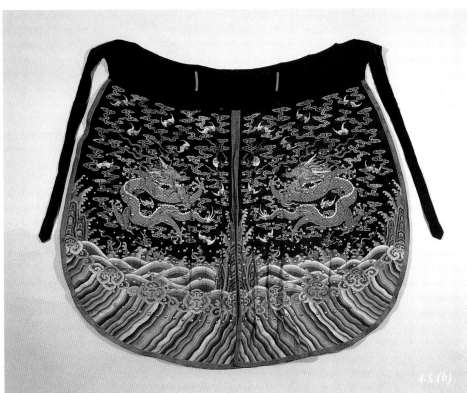

4.5 (b)

In the role as commander in chief, the Qing emperors donned elaborate suits of dress armor that were indebted to Ming dynasty prototypes.

Fig. 4.5
Suit of ceremonial armor, probably made for the Qianlong emperor: (a) sleeveless coat plus separate sleeves, epaulets, underarm guards, and two flaps and (b) chaps attached to waistbank; eighteenth century, third quarter. Tapestry-woven silk *(kesi)* over brigandine plates; length of jacket 78 cm, length of chaps 88 cm. Myers collection, Paris.

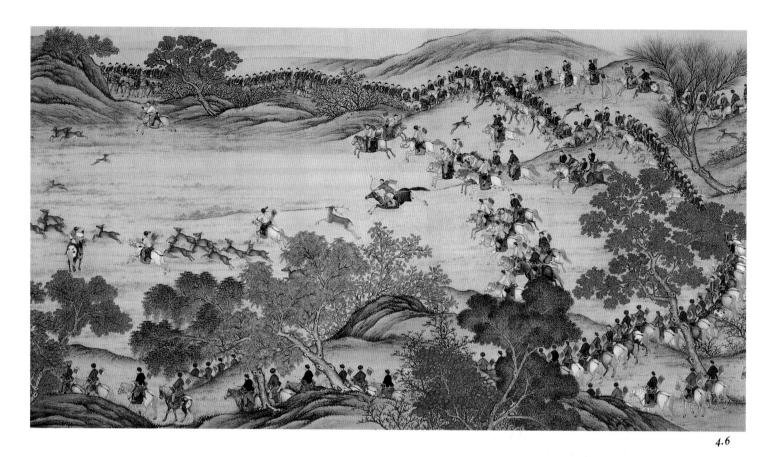

4.6

Traditionally, hunts provided Manchu society with opportunities to build tribal solidarity and hone military skills.

Fig. 4.6
Lan Shining (Giuseppe Castiglione, 1688–1766), Mulan, detail of fourth scroll: the Qianlong emperor hunts deer (Mulan, a district north of Rehe [Jehol], was the site of the imperial autumn hunts); mid-eighteenth century. Hand scroll: ink and color on silk; 49.5 × 159.1 cm. Musée National des Arts Asiatiques—Guimet, Paris. EO 3568.4.

Surviving evidence suggests that Manchu military uniforms were identical with riding costume. Dress or parade armor did not appear until after the conquest. Suits of brigandine armor covered with luxury silks and gilt brass fittings were used for ceremonial armor by the guards at the Forbidden City or for the emperor's own attire; this style was adopted from Ming dynasty prototypes.

Private Life: The Emperor as Son and Paterfamilias

Even within the privacy of the inner court, the emperor as the most prominent son, grandson, husband, and head of family and clan in the empire served as an example to his people. Paintings suggest the Manchu emperors may have worn Chinese clothing for some private family events, although there are scholars who urge caution when considering what level of reality such depictions of emperors wearing foreign attire actually convey.

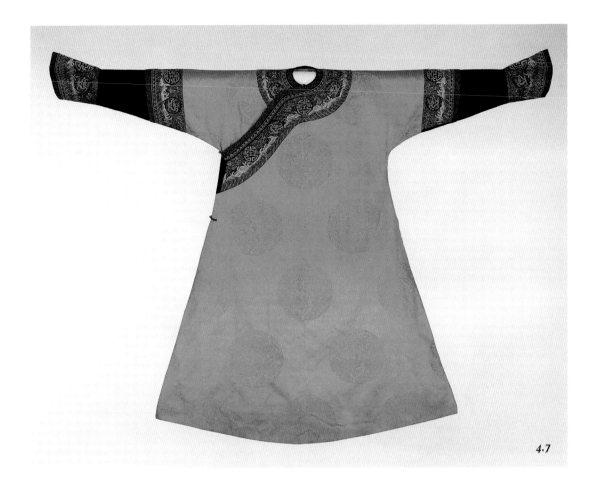

4.7

EXPANDING THE MANCHU WARDROBE

Initially, the Qing imperial court regulated formal attire made of dragon-patterned silks, keeping tight rein on prescribed colors and patterns. By the end of the seventeenth century, as the silk-producing regions of central China came under government control, officials were given greater access to the factories and workshops that produced goods for the court. Qing imperial management of the officially appointed court silk factories, called *jizaoju*, of which there were three—Suzhou, Hangzhou, and Nanjing—plus a silk workshop *(jiranju)* in Beijing, allowed the sale of excess production privately. While this management system, which had been established in the fourteenth century by the Yuan dynasty and continued under the Ming dynasty, helped stimulate the silk industry as a whole, it also sowed the seed of abuse of garment types and imagery that distinguished entitlement and

Both men and women were assigned informal court attire. The differences between male and female types of this coat are the placement of the skirt vents (front and back for men; at the sides for women) and the additional band of decoration at the top of the sleeve extension that only women wore. Partly because it was relatively plain, the article rarely survived.

Fig. 4.7
Woman's informal court robe *(changfu),* probably made for an empress of the emperor Guangxu; nineteenth century, third quarter. Silk damask; length 137 cm. Santa Barbara Museum of Art. Lent by Miss Helen P. Janhke in memory of J. Fyle Edberg and Paul Foote. L1999.3.3.

privilege. The first edicts specifically related to the designs and uses of court attire were issued at the end of the seventeenth century during the reign of the Kangxi emperor.

While formal and informal modes of dress had been appropriate for the Manchu emperors prior to the conquest, they did not constitute a sufficiently diversified wardrobe to meet the needs of the emperor of China. Ascending the Dragon Throne obliged Manchu rulers to rethink and to expand the official wardrobe. Throughout the first century of Manchu rule, the official clothing underwent profound changes to bring it in line with state doctrine. As requirements for court rituals and ceremonies became more regimented to distinguish and elevate them from the court's administrative functions, the wearing of garments that comprised Manchu formal attire became more restricted.

During the transition to Manchu rule during the seventeenth century, Ming dynasty iconography, as well as Ming styles of ornamenting costume, continued largely unchanged. In part this can be explained by the fact that, beginning in 1522, Manchu leaders as vassals of the Chinese emperor received gifts of coveted dragon-patterned coats and coat yardages from the Ming court (see figure 3.10 in chapter 3). These gifts were transformed from the flowing robes of urban courtiers into more functional nomadic coats. After the 1644 conquest, other Ming garment types and decorative patterns that survived in the imperial stores of the Ming dynasty or were supplied by the former imperial factories and workshops were readily adopted by new Qing dynasty elite. By the end of the third quarter of the seventeenth century, the expanded Qing wardrobe included several types of semiformal garments, including those decorated with dragon patterns that had not been part of the Manchu national dress before the conquest.

Since the Han dynasty, dragons had decorated objects used by the imperial household as well as objects used by those representing imperial authority. However, their appearance on garments can only be documented from the Tang dynasty (618–907), when in 694 Empress Wu (684–705) presented robes to court officials above the third rank with patterns on them appropriate to the status of the recipient. Princes received robes with deer or coiled dragons. The dragons are described in these records as having three

claws. A painting from the central Asian site of Dunhuang depicts the emperor of the Xixia kingdom, a Tibetan dynasty (1032–1227), wearing a coat with dragon roundels. The oldest surviving dragon robe fragment dates from the late tenth or eleventh century and is attributed to the Liao dynasty (907–1125). It, like the Xixia emperor's robe, is ornamented with dragon roundels. From the time of the Liao dynasty, dragon robes *(longpao)* were associated with the imperial court and specifically with the person of the emperor. While the emperors of the succeeding Yuan and Ming dynasties wore dragon robes, it was the practice of regulating entitlement and granting the privilege of wearing *longpao* to others that imbued these garments with prestige and made them so desirable.

Although the Manchu leaders were dependent on limited supplies of these much-coveted dragon-patterned fabrics from the Ming court, nevertheless in 1636 Hongtaiji, in imitation of Chinese imperial practice, decreed that only the emperor and his immediate family could wear yellow robes with the five-clawed dragon called *long*. Lesser nobles were obliged to use the four-clawed *mang* dragon as legislated in 1667, unless granted the privilege of wearing the imperial symbol. During the first century of Manchu rule, despite an ever-increasing number of individuals entitled to wear dragon-patterned robes, the Qing court remained vigilant regarding the abuse of this privilege. Museums and private collections contain early Qing robes with one claw of each *long* dragon unpicked to make it a *mang*.

Dragon Robe Designs

Under the Manchu, full-length dragon robes were styled like riding coats with long sleeves with flaring cuffs and a front overlap held with loops and toggles. Men's coats were vented at the front and back; women's robes retained side vents. Four Ming dynasty dragon robe decorative designs—roundel, quatrefoil yoke and band, amalgamated, and integrated—were used by the Manchu conquerors with only minor changes.

Roundel Design

The most ancient design featured concentrated dragon patterns organized as roundels on a plain or self-patterned field. Although both roundels and

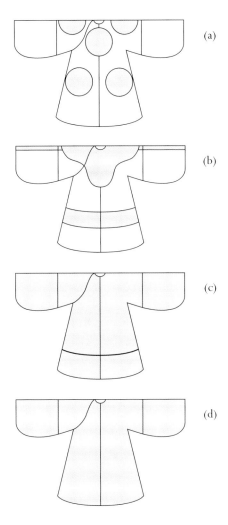

Fig. 4.8
The four styles of Ming dynasty ornament:
(a) roundels; (b) quatrefoil yoke and band;
(c) amalgamated; and (d) integrated.

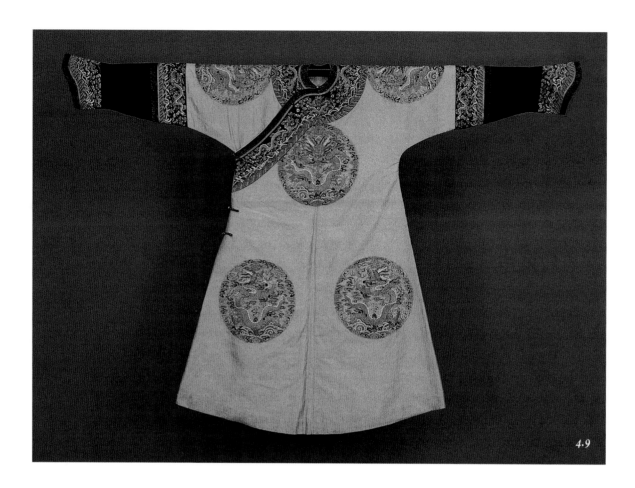

4.9

In the 1759 edicts, the empress and ranking impe-rial consorts were assigned three styles of semiformal court robes. The first has an all-over integrated pattern of dragons within a cosmic uni-verse; the second type has eight dragon roundels and a plain field above a wave motif border; the third variation has only the eight roundels. Those robes with bright yellow grounds were reserved for the empress and dowager empress.

Fig. 4.9
Imperial consort's semiformal court robe *(jifu)*, third style; late eighteenth century. Embroidered silk satin; length 148 cm. Mactaggart collection, Edmonton.

dragon patterns on garments had been popular since the Tang dynasty, the earliest example of dragon roundels used on a robe dates from the Liao dynasty. The Ming court used variants with eight, ten, and twelve roundels. The Manchu favored the eight-roundel variant for robes and surcoats, which denoted semiformal court wear, and by the mid-eighteenth century was restricted to the female wardrobe (see figure 4.26). A variation with four roundels was retained for high-ranking male court surcoats (see figure 4.25).

Quatrefoil Yoke and Band Design

Another old dragon robe pattern, the quatrefoil yoke and band pattern, was used by the Ming dynasty. It had been inherited from the nomadic Jin dynasty (1115–1234) through the Mongol Yuan dynasty (1279–1368). It is characterized by discrete zones of ornament contrasted with areas that remained unpatterned (see figure 3.10 in chapter 3). Dense patterns at the

quatrefoil yoke and across the tops of the sleeves focused attention on the head, creating a horizontal frame from which the rest of the voluminous coat flowed. The band at the knees emphasized the expanse of the skirts and would have enhanced their graceful motion without cutting the sweep of the garment to the floor. The Mongol convention of placing a dragon at the center front and back and looping the bodies over the shoulders continued during the Ming, and it was in this form that the design was transmitted to the Manchu. Billows and prism-shaped rocks symbolizing a cosmic landscape define the lower edge of the yoke zone; clouds fill the spaces above. In the skirt bands, smaller dragons run and twist against clouds with mountain and billow borders below. The quatrefoil yoke and band designs gave the Manchu *chaopao* its distinctive pattern, and under the Qing this configuration was reserved exclusively for the most formal court attire. Outside of the court, some garments used by Chinese brides and robes presented to temple images preserved this conservative convention into the early twentieth century.

Amalgamated Design

At the end of the sixteenth century, Ming pattern designers began to discard the distinction between zones of decoration and areas of self-patterned fabric. Rather, the entire coat was treated as a decorative surface. The mountain and billow borders of the quatrefoil yoke moved to the top edge of the horizontal band at the knees; those of the lower edge of the horizontal band moved to the hem of the coat: the decorative and patterned areas of the robe were amalgamated. This form was already established at the Wanli emperor's court (1573–1619), as evidenced by various garments recovered from that emperor's tomb, which was excavated in the 1950s.

Integrated Design

Further experimentation occurred during the early seventeenth century. In the fourth design, called the integrated pattern, distinctions between the zones of decoration for the upper and lower garment were discarded. A single mountain and billow border was placed at the hem of the coat, while the rest of the garment functioned as the sky above against which dragons were displayed. Initially, the main dragons remained looped over the shoulders,

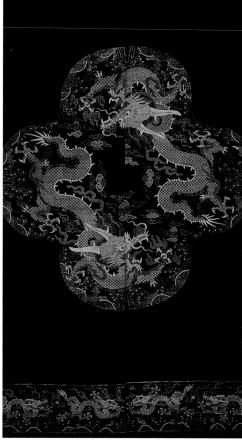

4.10

Imperial iconography included dragons within a cosmic landscape indicated by waves with billows crashing against a rocklike mountain and clouds above. Here, the same imagery is organized in two discrete zones: a quatrefoil yoke with the dragons wrapping around the shoulders and bands with the dragons running through the clouds.

Fig. 4.10
Panel from an unmade Manchu man's formal court coat *(chaopao)*; late seventeenth century. Brocaded figured silk gauze; 209 × 119 cm. Association pour l'Etudes et la Documentation des Textiles d'Asie collection, Paris. A.E.D.T.A. no. 3604.

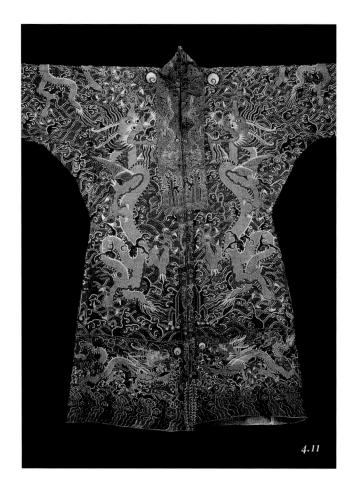

4.11

The two separate zones of ornament seen in the yoke and band schema here abut, keeping a distinction between upper body and lower body decoration. The quatrefoil yoke completely disappears.

Fig. 4.11
Ming dynasty *longpao* remade into Tibetan man's robe *(chupa)*; late sixteenth or early seventeenth century. Embroidered silk gauze; length 142 cm. Jobrenco Limited, trustee, Hall Collection Trust, Hong Kong.

while the smaller dragons, liberated from their horizontal bands, were given more prominence on the lower skirts. Later, the position of the decorative elements was modified to focus more attention on the principal ornament. Dragon bodies were uncoiled from the shoulder and extended full length down the front and back of the coat.

The Manchu liked the two newer design variants, with their extravagant, luxurious decorative effects for semiformal festive dress, but preferred the completely integrated dragon patterns. A magnificent needlework coat in the Royal Ontario Museum collection is solidly couched with gold-wrapped threads with accents in colored floss silk—satin stitch, and it has two large dragons surrounded by sixteen smaller dragons. The coat, acquired in Beijing in the second decade of the twentieth century, has survived without its original cuffs and has undergone at least two alterations. In its present condition, the skirts are vented at the sides, therefore it was identified by Helen Fernald

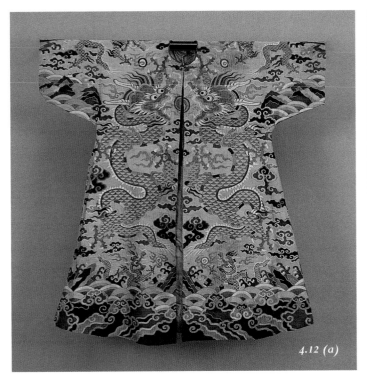

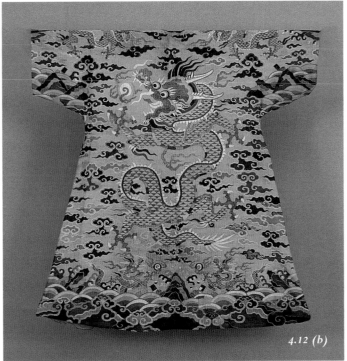

4.12 (a) 4.12 (b)

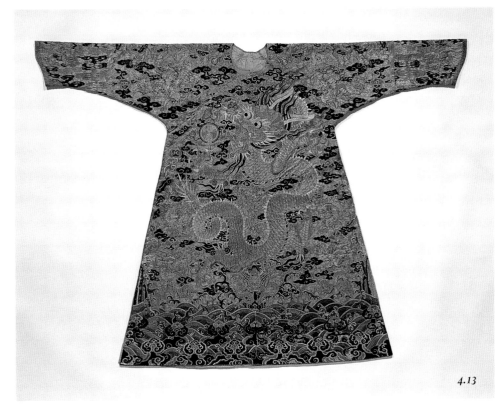

4.13

The distinction between upper and lower body decoration is eliminated in favor of using the entire garment surface for an integrated pattern of dragons within a cosmic landscape.

Fig. 4.12
Ming dynasty *longpao* surcoat remade into Tibetan man's robe *(chupa):* (a) front and (b) back; early seventeenth century. Tapestry-woven silk *(kesi);* length 142 cm. Mactaggart collection, Edmonton.

The surface of this coat is solidly embroidered with lavish amounts of couched gold-wrapped threads and with accents of colored floss silk–satin stitch. This flamboyant style was a late Ming dynasty innovation that was favored by the Manchu conquerors.

Fig. 4.13
Manchu man's semiformal court robe *(jifu),* possibly for the Kangxi emperor; seventeenth century, third quarter. Embroidered silk tabby; length 138 cm. Royal Ontario Museum, Toronto. George Crofts collection, gift of the Robert Simpson Company. 919.6.21.

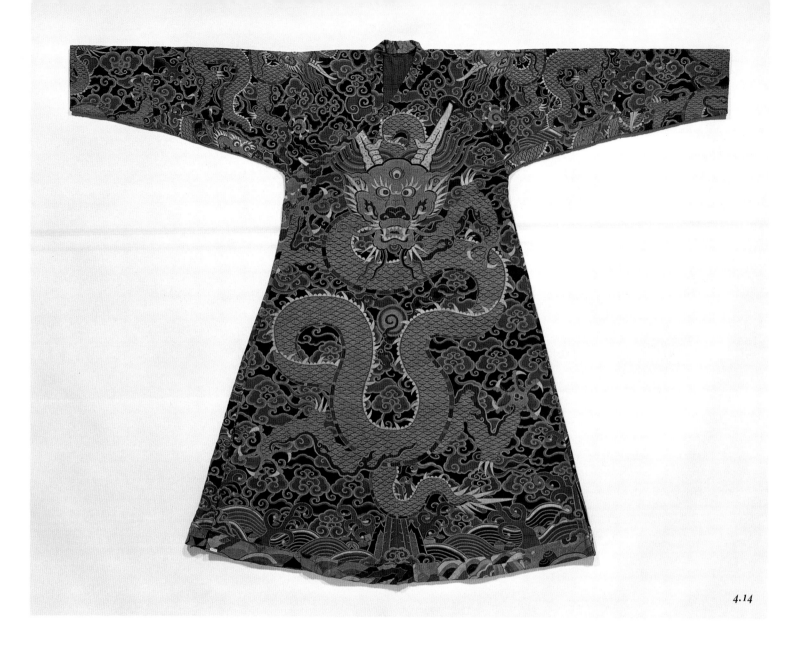

4.14

Unlike most court robes that are seamed at the center front and back, this early Qing robe was designed and woven in one piece. It included a second, separate warp that formed the overlap at the front. A paired warp thread at the center formed the finishing edges of the original center front and back vents. In its present form, the vents were sewn shut and the fabric under the front overlap was used to extend the sleeves and fill in the area under the arms.

Fig. 4.14

Manchu semiformal court robe *(jifu)* remade into Tibetan man's robe *(chupa)*; late seventeenth century. Tapestry-woven silk *(kesi)*; length 137 cm. Royal Ontario Museum, Toronto. 974.368.

as a consort's coat (Fernald, *Chinese Court Costumes,* 22). However, originally the vents were placed at the front and back in male fashion, making it a coat appropriate for a very exalted Manchu noble, possibly even the Kangxi emperor himself.

Further development is illustrated by a late-seventeenth-century tapestry-woven silk and gold-wrapped thread coat in the Royal Ontario Museum collection. Like the previous example, it has two principal dragons. A secondary dragon has been added at each shoulder, extending down the sleeve. Four dragons radiating from the neck opening became the favored configuration for the Manchu. The coat shown in figure 4.14 has been recut in Tibetan style although it was designed and woven to meet the construction requirements of a Manchu coat. It was made with an overlap closing to the right and deep vents in the skirts at the center front and back. In its present form, the cuffs have been discarded, and material from the inner flap has been pieced to extend the sleeves and fill in the areas under the arms. This coat and another almost identical to it may have been sent as yardages to Tibet after the Manchu court established diplomatic and spiritual relations with the Dalai Lama in 1648, or they may have been remodeled from a Manchu-style coat sent to Tibet during the first quarter of the eighteenth century, after robes patterned with large-scale dragons had gone out of fashion.

RATIONALIZING THE MANCHU WARDROBE

In 1748, the Qianlong emperor commissioned a review of all previous costume regulations enacted during the reigns of the first three Qing emperors. These rulers had formulated the conceptual framework for court attire and, through the *Neiwufu* (Office of the Imperial Household), had been involved with aesthetic and stylistic issues. The Qianlong review culminated in the promulgation of a comprehensive set of costume edicts in 1759. The *Huangchao liqi tushi* (Illustrated precedents for the ritual paraphernalia of the [Qing] imperial court) classified all the clothing and accessories used by the court from emperor to the lowest functionary. It reiterated the rights of the conqueror as a check against increasing pressures to restore native Chinese costume. The reasons are eloquently summarized in the 1759 Qianlong preface:

We, accordingly, have followed the old traditions of Our dynasty, and have not dared to change them fearing that later men would hold Us responsible for this, and criticize Us regarding the robes and hats; and thus We would offend Our ancestors. This We certainly should not do. Moreover, as for the Northern Wei, the Liao and the Jin, as well as the Yuan, all of which changed to Chinese robes and hats, they all died out within one generation [of abandoning their native dress]. Those of Our sons and grandsons who would take Our will as their will shall certainly not be deceived by idle talk. In this way the continuing Mandate of Our dynasty will receive the protections of Heaven for ten thousand years. Do not change Our traditions or reject them. Beware! Take warning!

Ostensibly the *Huangchao liqi tushi* was concerned with preserving Manchu-style clothing and, with it, Manchu identity. However, there were other reasons to enact new costume legislation beyond this official rationale. During the first century after the conquest, Qing wardrobe requirements had expanded far beyond the ritual clothing that had been specifically mentioned in earlier sumptuary legislation. The proliferation of patterns and garment types among Manchu nobility and Han Chinese offi-cials resulted in an abuse of imagery originally controlled by entitlement or through imperial prerogative. Also, the position and role of the Qing emperor had been revised. Beginning with the Kangxi emperor and continuing under his son, the Yongzheng emperor, the image of the Qing emperor was linked more firmly to the ideals of the Chinese imperial model.

Although largely undocumented, the result of this shift in official thinking can be observed in the surviving garments. By the early decades of the eighteenth century, Manchu court clothes were deliberately redesigned, adjusting them to meet Chinese, rather than Manchu, aesthetics. Chinese tastes preferred garments to have distinct, often contrasting borders at the hem, around the neck, and at the edges of the sleeves. Constructing clothes from cloth requires cutting fabric, weakening the woven material and necessitating a hem or facing to guard against fraying. From earliest times, Chinese called attention to these areas by using an external facing to cover, or enclose, the cut edges. By the Shang dynasty, these external facings often featured densely patterned fabrics different from the more loosely patterned

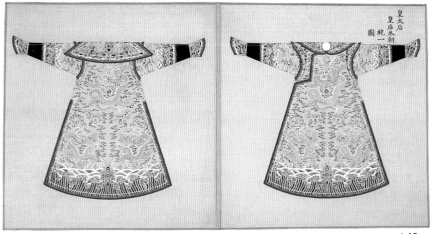

4.15

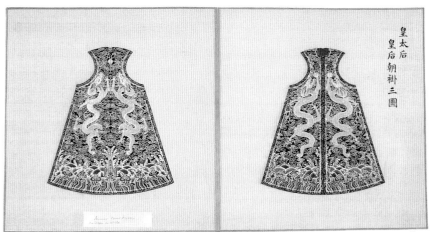

4.16

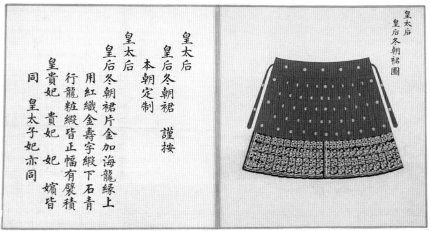

4.17

The folios shown here are from a set made for presentation to the Qianlong emperor. Originally there were eighteen volumes with more than 6,000 illustrations. They served as the models for a woodcut-illustrated edition that was circulated in 1766.

Fig. 4.15
Anonymous, *Huangchao liqi tushi* (Illustrated precedents for the ritual paraphernalia of the [Qing] imperial court), woman's formal court coat *(chaopao),* first style; mid-eighteenth century. Presentation folio: ink and color on silk; 40.5 × 81.2 cm. Mactaggart collection, Edmonton.

Fig. 4.16
Anonymous, *Huangchao liqi tushi* (Illustrated precedents for the ritual paraphernalia of the [Qing] imperial court), woman's court vest *(chaogua),* third style; mid-eighteenth century. Presentation folio: ink and color on silk; 40.5 × 81.2 cm. Mactaggart collection, Edmonton.

Fig. 4.17
Anonymous, *Huangchao liqi tushi* (Illustrated precedents for the ritual paraphernalia of the [Qing] imperial court), woman's court aprons *(chaoqun);* mid-eighteenth century. Presentation folio: ink and color on silk; 40.5 × 81.2 cm. Mactaggart collection, Edmonton.

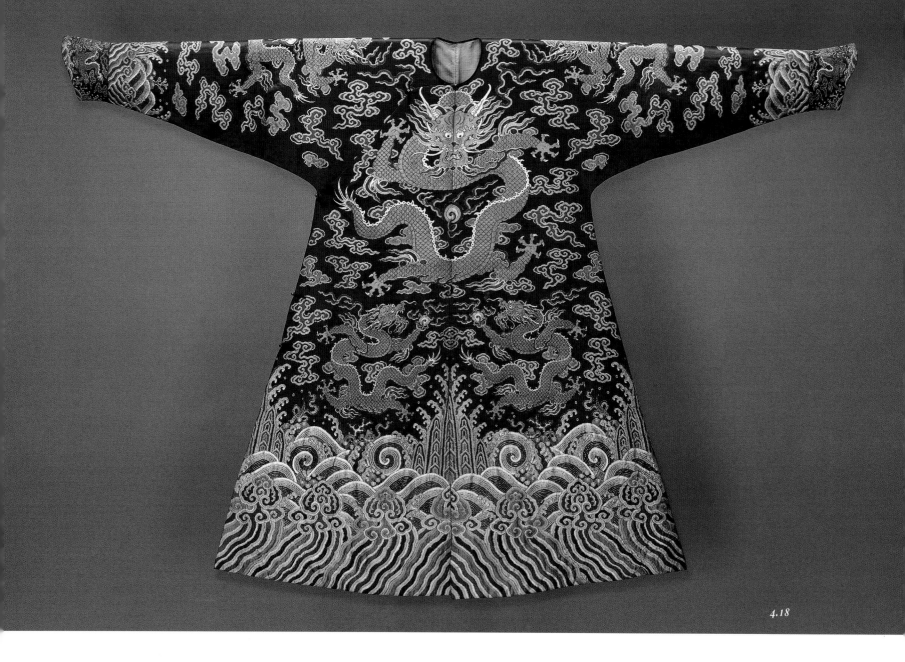

4.18

In its earliest manifestation, the Manchu semi-formal court coat was made of a single fabric, including cuffs and sleeve extensions.

Fig. 4.18
Manchu man's semiformal court robe *(jifu);* eighteenth century, first quarter. Brocaded silk satin; length 137.2 cm. Museum of Fine Arts, Boston. The James Fund. 02.53.

ground fabrics of the garments themselves. By the late imperial period, the Chinese valued the integrity of pictorial imagery; Manchu or Tibetan practice that pieced, patched, or otherwise rearranged elements of a pattern looked crude and unrefined. The fact that Manchu coats were worn tightly belted at the waist with a sash that by the mid-eighteenth century bore the name *jifudai,* thus cutting a large single dragon design in half, probably accounts for the decision, which occurred during the reign of the Kangxi emperor, to separate dragon patterns into two zones. The four larger dragons were confined to the upper part of the coat. Pairs of smaller, confronted dragons were placed on the coat skirts at the front and back, with a fifth smaller dragon placed out of sight on the panel that was under the front overlap. This unseen dragon brought the total to nine, a number associated in ancient Daoist numerology with infinity and notions of heaven.

These changes in scale and placement of the principal ornament resulted in changes elsewhere. The lower border of a satin robe now in the Boston Museum of Fine Arts collection, patterned with supplemental colored floss silk, gold-wrapped threads, and strips of gilt paper, took on added prominence as it advanced upward from the hem to fill the void (see figure 4.18). By the early years of the eighteenth century, the *lishui* (standing water), which was indicated by parallel sets of wave bands, became a prominent feature of Qing dragon coat imagery. This, along with other construction and design changes, such as the reduction of the mountain symbols to four (at the center front and back and sides of the skirt) and changes in scale of individual components like the cloud, formed to integrate them better with the dragons, marking the transformation of Ming ideas to purely Qing dynasty ones.

These changes to semiformal court wear coincided with structural changes the Kangxi emperor made to the imperial government. In 1679, he announced a special examination to revitalize the Hanlin Academy, a move that enabled him to win the support of the Han Chinese gentry, establish the emperor as the head of a Confucian state, and secure the brightest and best educated in the land to fill government office. Meanwhile he retained the Collegium of Princes, originally a council of Manchu tribal leaders that had been established at the outset of the dynasty, as advisors and from whose

ranks heads of the government ministries were appointed. Hongtaiji had copied the Ming government model and named six boards, or ministries, to conduct the Qing administration. They included the Boards of Civil Appointments (bureaucratic appointments and sanctions, including the sale of offices); Revenue (tax audits and accounts, state welfare, and monopolies and provincial revenues); Rites (imperial rituals, diplomatic relations with central Asian tribes, and the state examination system); War (supervision of the Green Standard armies and defense); Justice (drafting laws, supervision of provincial judges, and acting as appeals court); and Works (roads, water conservation, and flood control). While he retained high-ranking Manchu to head each of these ministries, he curbed the power of the Manchu nobility by dividing the posts of president and vice president of each board evenly between Manchu and Chinese bureaucrats and reining in the power of members of the imperial family by declaring them ineligible for high ministerial positions. He altered the *Neiwufu,* staffing it with bannersmen and Chinese bond servants, who derived status wholly from attachment to the person of the emperor and whose loyalty was also directed to the emperor. The members of this corps became his intimates and confidential advisors.

The efforts of the Kangxi, Yongzheng, and Qianlong courts balanced Manchu and Han Chinese interests to create a new semiformal garment that replaced the *longpao.* Refinements instituted during the 1720s were made at the expense of the dragon decoration. First, the dragons in the two zones, although differentiated into front-facing (standing) dragons and profile (walking) dragons, were made roughly the same size. Second, increasing attention was paid to secondary motifs. The wave and mountain border increased in depth, reaching to midcalf. Cloud forms evolved from large scattered motifs to more uniform densities of smaller ribbonlike forms. A plethora of auspicious signs and incidental good luck symbols appeared. Third, this garment's construction began to feature multiple fabrics, as seen in the early-eighteenth-century embroidered satin robe now in the collection of the Musée des Arts Asiatiques in Nice, France (see figure 4.20).

The ground fabric supported the principal decoration. The sleeves were made of pleated fabric or fabrics with woven stripes that imitated sets of par-

allel wrinkles from a pushed-up sleeve. A third fabric, usually black or blue, was patterned to complement the ground fabric and was applied as external facings at the neck and top edge of the overlap and at the cuffs. After the 1730s, all court coat edges were bound with yet another patterned fabric. These edgings were invariably black or dark blue in satin weaves with supplementary gold thread weft patterns, reflecting a feature first introduced to imperial clothes during the twelfth century under the Jin dynasty emperors.

The multiple fabric construction was already favored by the court in the 1730s, as is demonstrated by the group of robes from the tombs of the brother of the Qianlong emperor, Prince Quo Jinwang, who died in 1738, and two of his consorts. These robes were reportedly plundered in the 1930s and are now in the collections of the Nelson-Atkins Museum of Art, the Minneapolis Institute of Arts, and the Metropolitan Museum of Art in New York.

Some features, like the shaped overlap at the front and the sleeve extensions with horse hoof cuffs, continued to emphasize Manchu shapes and construction details. But overall, the restyling reflected Chinese tastes, and the changing aesthetics concerning imperial garments reflected other actions taken by the *Neiwufu* to redefine the image of the emperor from barbarian chieftain to the emperor of the Confucian-based Chinese state. The semiformal coat that had previously borne the name *longpao* was renamed *jifu* (literally, "auspicious attire or coat"), undoubtedly a reference to the name that appeared in the *Zhouli* (Rituals of [the] Zhou [dynasty]). The changes to sleeve constructions, borders, and bindings were also applied to *chaofu*. These alterations were incorporated into the illustrated imperial edicts promulgated by the Qianlong emperor in 1759.

THE MEANING OF JIFU

The *jifu* garment was among the clearest statements of Manchu intentions concerning the political and social functions of costume. The use of costume to further political aims is very ancient in China; but few garments in its long history have managed to demonstrate these intentions as clearly as

Dragon Ornament Arrangement

Fig. 4.19

The character *jing*, meaning "well," depicts two pairs of beams marking a wellhead (a). This form was envisioned by Confucian philosophers as the most equitable means of land division. Ideally, eight farmers occupied the outer fields and shared in the farming of the central field for the lord (b). In effect, they created two rings of defense protecting the inner field (c). Manchu court coat decoration (d) reflected these notions of centrality and power.

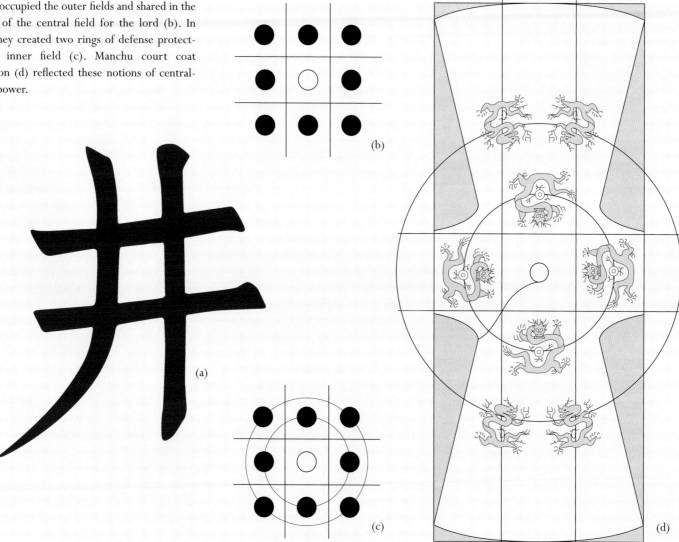

(a)

(b)

(c)

(d)

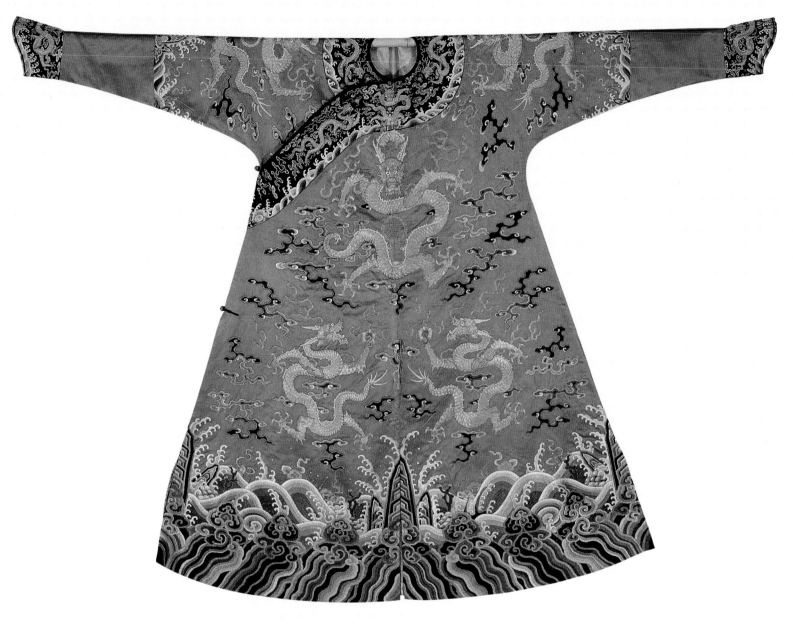

During the second quarter of the eighteenth century, the styling of semiformal court attire began to change with the addition of neck facings, cuffs, and sleeve extensions in fabrics that differed from the body of the coat. In addition, the earlier distinction in size between the dragons on the upper part of the coat and those on the skirts has largely been eliminated.

Fig. 4.20
Manchu man's semiformal court robe *(jifu)*; eighteenth century, second quarter. Embroidered silk satin; length 139 cm. Musée des Arts Asiatiques, Nice. Acquired with assistance of FRAM. 98.5.

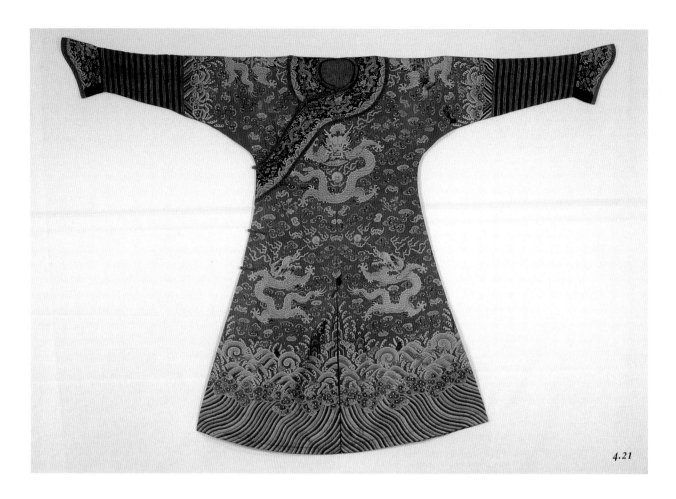

4.21

With Manchu semiformal robes during the eigh-
teenth century, the flaring skirts of the robe were
emphasized by having the garment cut close to the
chest. During the nineteenth century, robes were
generally cut wider at the chest.

Fig. 4.21
Manchu man's semiformal court robe *(jifu);* nine-
teenth century, first quarter. Embroidered silk
gauze; length 139 cm. Association pour l'Etudes et
la Documentation des Textiles d'Asie collection,
Paris. A.E.D.T.A. no. 2077.

semiformal coats of the middle and late Qing dynasty, such as the embroidered
silk gauze robe in the A.E.D.T.A. collection in Paris, shown in figure 4.21.

Four dragons radiating from the neck opening to the chest, back, and
shoulders pointed to the cardinal points of the compass when a courtier was
aligned with the axial arrangements of the Forbidden City. Four more drag-
ons on the skirts—two at the front and two at the back—indicated the
intervening directions of the compass. A ninth dragon that remained unseen
was placed on the inner flap. This protective arrangement referred to the
centrally controlled ideal land division called the *jingtien* (well-field) system.
The name *jingtien* was derived from the character for wellhead—a pair of
horizontal lines crossing a pair of verticals. This system marked off nine
sections; it symbolized the idealized relationship between farmers who actu-
ally worked the field and the lord who owned the land. Eight farmers were
envisioned as tending each of the fields around the perimeter. All partici-

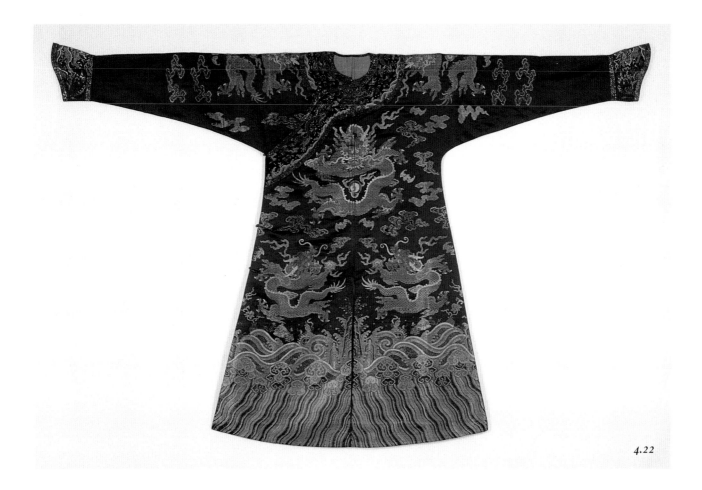

pated in the work necessary to farm the central field. The eight fields protected the ninth by encircling it. Those sharing contiguous borders with the central field, if viewed as occupying the cardinal points of the compass, established the harmonious balance implied by the *wuxing* system. These four created a ring of power and provided the first line of defense from external threat. The other four fields, occupying the secondary points of the compass and sharing no border with the central field, created a second ring of power.

The *jifu* also functioned as a schematic diagram of the universe. The lower border of diagonal bands and rounded billows were water, representing the universal ocean that surrounds the earth. At the four axes of the coat, the cardinal points, rose prism-shaped rocks symbolizing the earth mountain. Above was the cloud-filled firmament against which dragons, the symbols of imperial authority, coil and twist. The symbolism was complete only when the coat was worn. The human body became the world's axis: the neck

While this style of dragon robe imitated early eighteenth century designs, the hardened and lifeless dragon forms reflect the political decline of Qing authority at the end of the dynasty.

Fig. 4.22
Manchu man's semiformal court robe *(jifu);* nineteenth century, fourth quarter. Brocaded silk satin; length 135 cm. Association pour l'Etudes et la Documentation des Textiles d'Asie collection, Paris. A.E.D.T.A. no. 2230.

opening, the gate of heaven or apex of the universe, separated the material world of the coat from the realm of the spiritual represented by the wearer's head.

Women's semiformal coats were differentiated from male *jifu* by the placement of vents at the sides rather than at the front and back and by the addition of an extra band matching the neck and overlap facings between the body of the coat and the sleeve extension. Higher-ranking members of the imperial harem were assigned variations on the more ancient design, with eight dragon roundels on plain fabric, in addition to the standard integrated dragon in cosmic landscape design. After 1759, garments with eight dragon roundels were restricted to women's semiformal garments (see figure 4.9).

Conceptually the Qing wardrobe did not change again after 1759. The Qianlong regulations were reissued regularly throughout the remainder of the dynasty. The new decorative schema drawn from Chinese ideals and applied to court clothing eventually influenced domestic wear. By the nineteenth century, other than garment shape there was little to differentiate between Manchu and Chinese clothing. The ever more hardened and lifeless forms of nineteenth-century dragon-patterned coats reflected the broader effects of dynastic decline. Waning imperial authority in the face of foreign threats and growing demands for foreign trade, as well as the demands of an increasingly wealthy middle class, challenged control from the center. Laxer quality controls and diminished financial resources affected workmanship. The symbolic integrity of dragon motifs was crowded by an ever-increasing emphasis on minor decorative elements and good luck motifs.

THE TWELVE SYMBOLS OF ANCIENT IMPERIAL AUTHORITY

The 1759 edicts codifying Qing court attire exalted the emperor's own formal and semiformal coats above all others with the addition of the Twelve Symbols of Ancient Imperial Authority. These had been superimposed on basic decorative schema of his robes as they had evolved during the early eighteenth century. The Twelve Symbols can be traced to Han dynasty precedent and are related to the sacral roles and ritual obligations of the emperor.

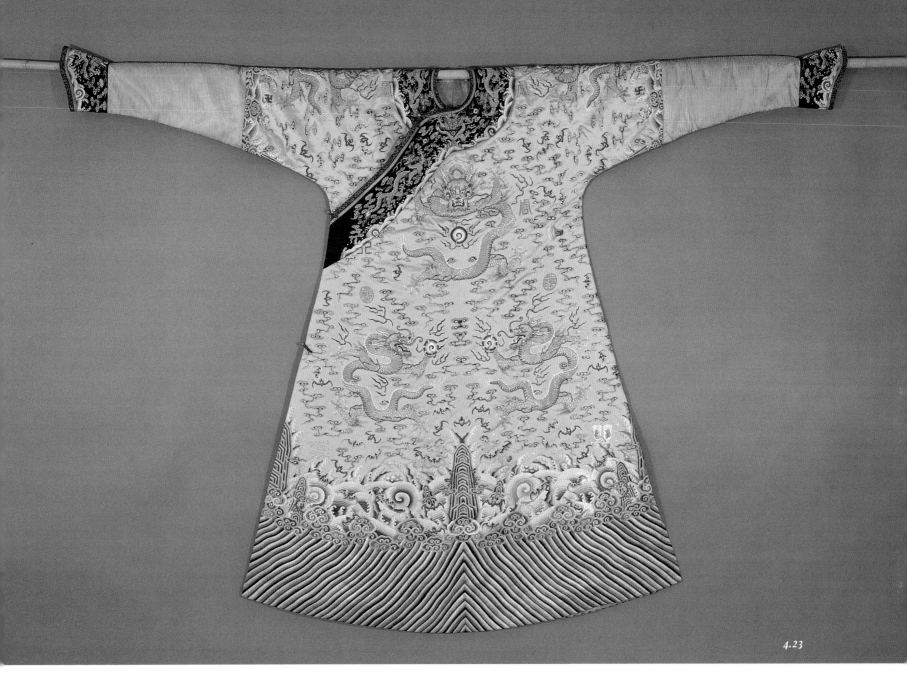

Manchu court coat decoration reflected notions of centrality and power. The dragon imagery set within a schematic diagram of the universe placed the wearer at the center of imperial rule. The addition of the Twelve Symbols of Ancient Imperial Authority on the emperor's coats reflected his wide-reaching power.

Fig. 4.23
Twelve Symbol semiformal robe *(jifu)*, probably made for the Qianlong emperor; eighteenth century, third quarter. Embroidered silk satin; length 138 cm. Myers collection, Paris.

Arrangement of Twelve Symbols

The Twelve Symbols of Ancient Imperial Authority were arranged on Manchu imperial coats in three groups, located at the neck, waist, and at knee level.

The first four symbols around the neck opening refer to the celestial and terrestrial orders to which the emperor made sacrifices during the year. These sacrifices were conducted at four imperial altars, which were aligned with the cardinal points of the compass and located outside the walls of the capital.

At waist level in the front are the *fu* (represented as a pair of mirror-image square hooked lines) and an ax head; in corresponding positions at the back are a pair of long dragons and the flowery creature (usually shown as a golden pheasant). These symbols relate to the four major astronomical events of the year. The *fu* character, sometimes translated as "symbol of distinction," can also be a linked homophone character for "return," a term used in connection with the winter solstice, when days begin to grow longer. In plan the paired dragons are placed diametrically opposite the *fu* symbol. They reflect the polarity of increasing and decreasing light and dark that change at the summer solstice. The ax head and flowery creature are located equidistant from the markers of the sol-stices. The ax, traditionally the symbol of the emperor's power over life and death, occupies the position of the autumn equinox. In ancient times, all executions were postponed until the autumn. The flowery creature marks the spring equinox and was linked to the constellation the Chinese called Red Bird, which appeared in the late spring.

At knee level are the temple cups, aquatic grass, grains of millet, and flames. These correlate with four elements addressed in Daoist notion of *wuxing* (Five Phases system): metal, water, wood, and fire. In plan view these symbols align with the four above. Temple cups are immediately below the ax head associated with the autumn equinox. Aquatic grass aligns with the *fu* symbol and represents the element water that is in ascendancy during the winter solstice. Similarly, grains of millet symbolizing wood and the spring season align with the flowery creature and its association with the spring equinox. The flames representing fire are aligned with the pair of dragons that mark the summer solstice. The rock symbolizing earth, the last of the five elements, on the back of the robe at the nape of the neck is the center of the plan, reflecting the organization of the Chinese compass.

Fig. 4.24
Diagram of Twelve Symbol semiformal robe with details from Fig. 4.23 (clockwise, top left): flames, pair of dragons, sun, constellation, ax head, temple cups, aquatic grass, *fu* characters, moon, rock, flowery creature, plate of millet.

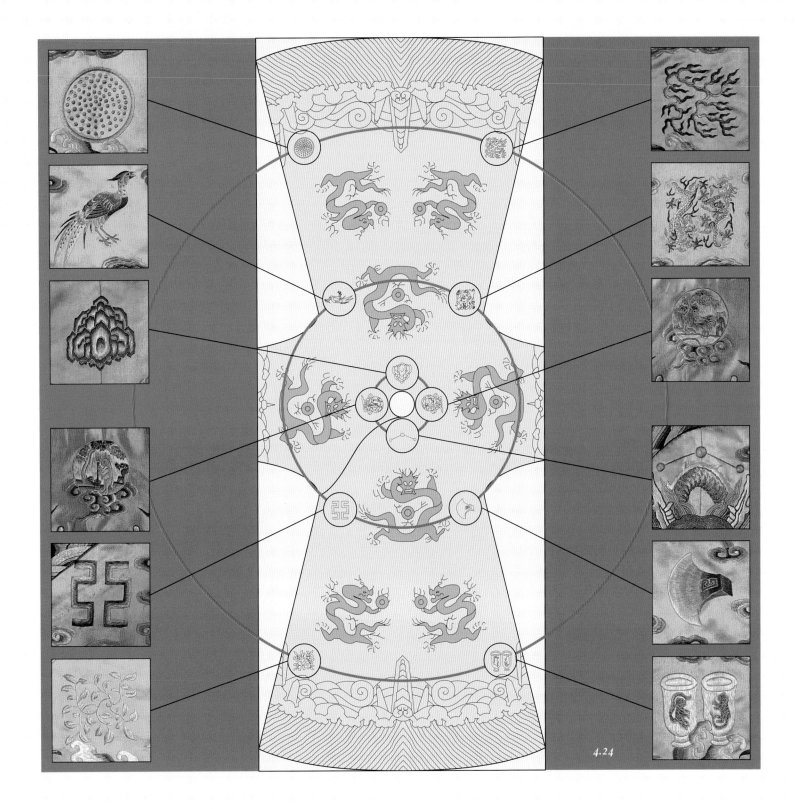

4.24

These symbols had been used on the official clothing of each succeeding dynasty. They were boldly displayed on the coats of the Ming emperors but were conspicuously absent from the official dress of the Manchu emperors until 1759. Scholars have speculated that such blatantly Chinese symbols were alien to Manchu ideals. They cite the resounding rejection by the Shunzhi emperor to the suggestion by a Chinese official that the new emperor assume the traditional Chinese ceremonial hat and robes with the Twelve Symbols when officiating at the great annual sacrifices.

By reclaiming the imperial use of the ancient Chinese symbols, the Qianlong emperor asserted the mandate of the Manchu imperial clan and the Qing intention of embracing the traditional role of rulers of the Chinese empire as expressed in the *Shujing* (Book of historical records), which was compiled from the last centuries of the Zhou dynasty (probably sixth century B.C.E.) to the fourth century C.E.. It quotes the legendary founding emperor of the pre-Shang dynasty (c. 1600–1027 B.C.E.) Shun as saying the following:

> [My] ministers constitute my legs and arms, my ears and eyes. I wish to help and support my people; you give effect to my wishes. I wish to spread the influence [of my government] through the four quarters; you are my agents. I wish to see the emblematic figures of the ancients—the sun, the moon, the stars, the mountain, the dragon, and the flowery fowl, which are depicted [on the upper garment]; the temple-cup, the aquatic grass, the flames, the grains of rice, the hatchet, and the symbols of distinction, which are embroidered [on the lower garment: I wish to see] all these displayed with the five colors, so as to form the [official robes]; it is your duty to adjust them clearly.

On the Qing robes, the symbols were placed at the neck opening, at waist level, and just above the wave border. The schematic arrangement of the Twelve Symbols is illustrated in figure 4.24.

While some scholars interpret these stylistic and technical features as the debasement of Manchu ideals, this reading ignores the long and complex interaction between nomadic conqueror and Chinese empire. The sinification of the Manchu had actually begun during the fifteenth century, when these tribal warriors became tributaries of Ming dynasty emperors. Their longevity as rulers of China was due in large part to their policies of accommodation to and adaptation of Chinese principles.

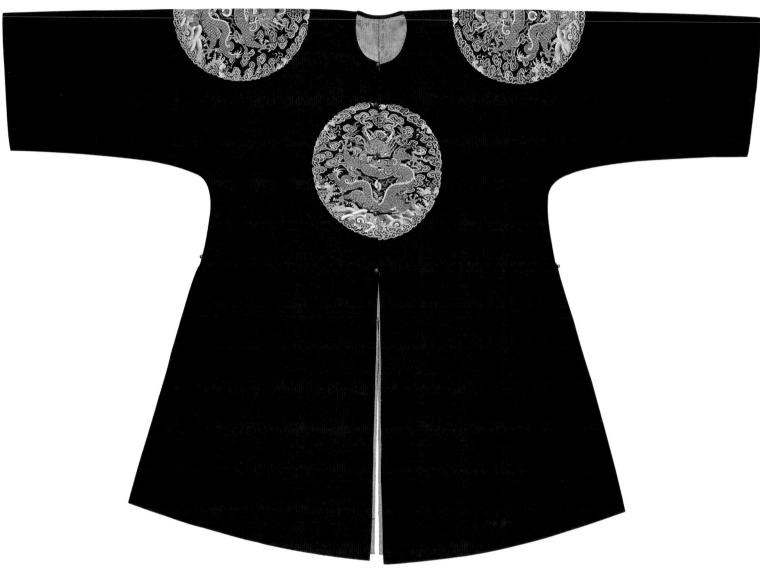

The emperor's court surcoat was emblazoned with four *long* dragon roundels.

Fig. 4.25
Emperor's court surcoat *(gunfu),* probably made for the Qianlong emperor; eighteenth century, second quarter. Tapestry-woven silk *(kesi);* length 100 cm. Petterson Museum of International Culture, Claremont, California. 86.63.2.

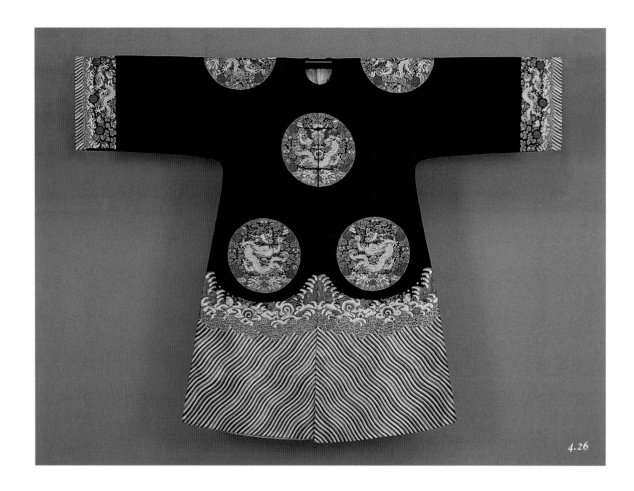

4.26

The surcoats worn by imperial women were decorated with eight *long* dragon roundels. The empress and dowager empress had two types. One, like this example, had wave motifs at the hem and lower sleeves. The second type lacked the wave motifs. Lesser-ranking consorts wore only the second type of surcoat.

Fig. 4.26
Empress's surcoat *(longgua);* nineteenth century, fourth quarter. Embroidered silk twill; length 149 cm. Mactaggart collection, Edmonton.

COURT SURCOATS: GUNFU AND BUFU

After 1759, all members of the imperial court, from the emperor to the lowest appointed official, were required to wear a surcoat over their semiformal coats. This plain, dark-colored unbelted coat was made of two lengths of cloth and was fashioned with uncuffed, elbow-length sleeves. It closed at the center front and was vented at the sides and back. Such ornamental short-sleeved garments were part of the nomadic heritage brought from the steppe.

This coat was always worn with other garments. For men, the coat was midcalf length, leaving the long, cuffed sleeves and decorated hem of the *jifu* exposed. Manchu women, in contrast, wore full-length surcoats. The domestic surcoats worn by Han Chinese women imitated those of their husbands and were also midcalf length. Coats for the emperor were designated as *gunfu;* those for ranking members of the imperial family were termed *longgua;* those for others bore the name *bufu.*

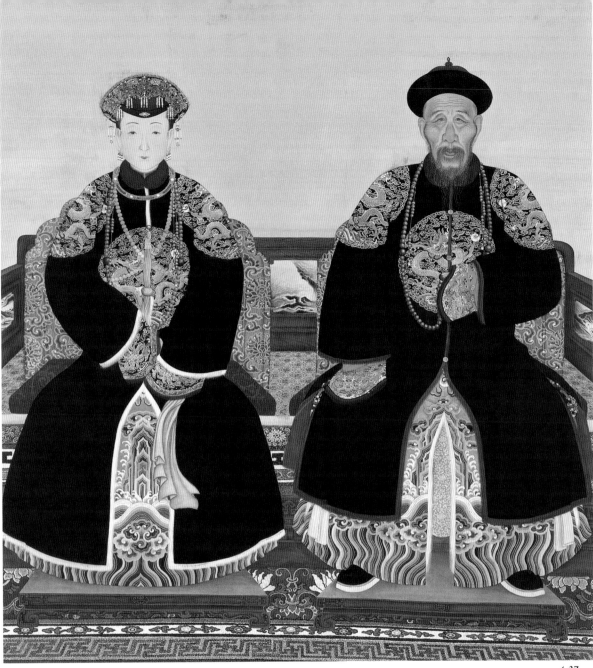

4.27

Yinti, fourteenth son of the Kangxi emperor, held the title of prince of the blood of the second rank. He is shown wearing a *jifu* with the *jinhuang* (golden yellow) color appropriate to his rank. Yinti's wife's robe is *xiangse* (incense color), possibly indicating special favor of the Qing court. Their surcoats with four roundels each with a profile *long* dragon convey their imperial status.

Fig. 4.27
Anonymous, portrait of Yinti (Prince Xun, 1688–1755) and wife; eighteenth century, second half. Hanging scroll: ink and color on silk; 187.6 × 161.8 cm. Arthur M. Sackler Gallery, Smithsonian Institution, Washington D.C. Smithsonian Collections Acquisitions Program and partial gift of Richard G. Pritzlaff. S1991.88.

Elevation of this particular garment to the rank of court attire achieved several ends. The measure acted as a social leveler, requiring all, regardless of means, to appear at court in similar garb. The simple construction and dark color made it ideal for displaying the badges with pictorial insignia that marked court rank. The Qing adopted the Ming dynasty system of insignia badges to differentiate noble ranks from civil officials and military officers in 1652. While this action followed a Chinese precedent, it was in fact linked to the Mongol Yuan dynasty practice of wearing decorated surcoats and to their predecessors, the Jurched, who ruled northern China in the twelfth century under the Jin dynasty.

THE SYSTEM OF RANKING

The imperial court consisted of twelve grades of nobles and nine each of civil and military officials. Each was assigned its own *buzi* (rank or insignia badge), which was worn in pairs—one was attached to the back of the *bufu*, the other was divided in half vertically at the chest of the coat. The first eight ranks of nobles at court (so-called princes of the blood) were assigned dragon badges. Distinctions were made first by the type of dragon, then by the shape of the badge. The five-clawed dragons called *long* marked the rank badges of the emperor and his immediate family. These outranked the four-clawed dragons called *mang,* which were assigned to courtiers from the ranks of princes of the blood of the third through the eighth rank.

Round or circular shapes had heavenly associations. Historically, the altars for worshiping Shang Di, the supreme deity, were set on circular terraced platforms. Lesser deities were worshiped at altars set on square platforms. These notions of the superiority, centrality, and heavenliness embodied in the round shape and the inferiority, peripheral nature, and earthliness of the square informed the court ranking system. The emperor and the heir apparent, as well as the first two ranks of princes of the blood (who would have included the emperor's sons, brothers, and uncles), used *long* roundels. Princes of the blood of the third and fourth rank (including the emperor's brothers-in-law and ranking clansmen) used *mang* roundels. Coats with four roundels outranked those with only two. Front-facing dragons outranked

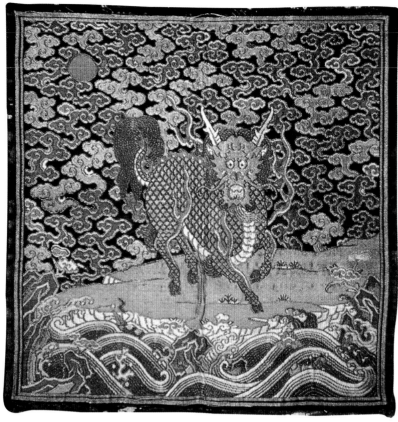

4.28

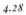

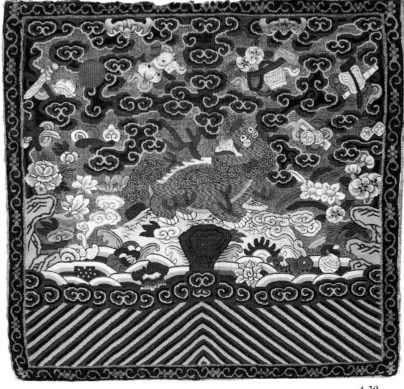

4.29

Fig. 4.28
Insignia badge *(buzi): qilin* for first-rank military officer; eighteenth century, third quarter. Brocaded silk satin; 26 × 25.5 cm. Jobrenco Limited, trustee, Hall Collection Trust, Hong Kong.

Fig. 4.29
Insignia badge *(buzi):* lion for second-rank military officer; nineteenth century, third quarter. Tapestry-woven silk *(kesi);* 26 × 25.5 cm. Jon Eric Riis collection, Atlanta.

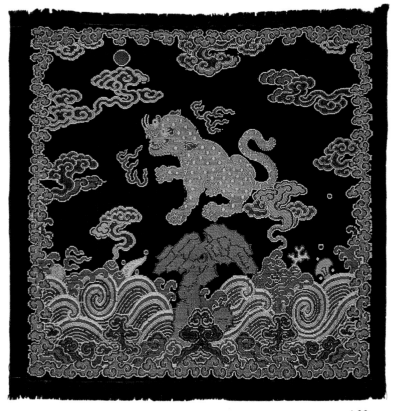

4.30

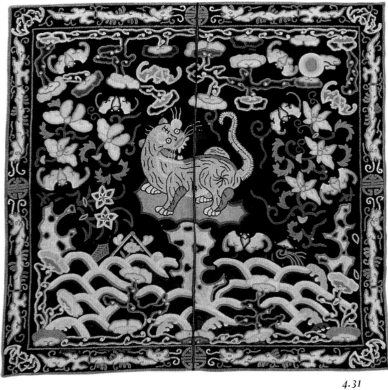

4.31

Fig. 4.31
Insignia badge *(buzi):* tiger for fourth-rank military officer; nineteenth century, third quarter. Embroidered silk satin; 26.5 × 26.2 cm. Jon Eric Riis collection, Atlanta.

Fig. 4.30
Insignia badge *(buzi):* leopard for third-rank military officer; eighteenth century, fourth quarter. Brocaded silk satin; 26.6 × 26.2 cm. Art Institute of Chicago. Oriental Department Sundry Fund Trust. 1947.540.

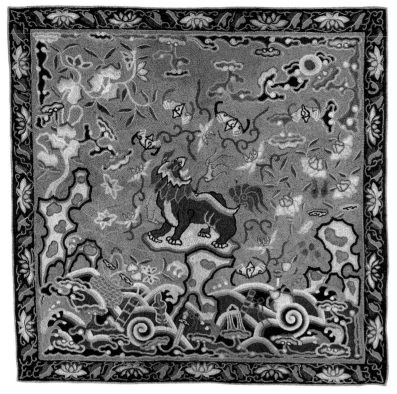

4.32

Fig. 4.32
Insignia badge *(buzi):* bear for fifth-rank military officer; nineteenth century, second quarter. Embroidered silk satin; 25.5 × 26 cm. Jon Eric Riis collection, Atlanta.

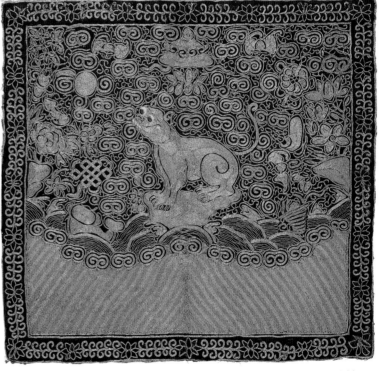

4.33

Fig. 4.33
Insignia badge *(buzi):* panther for sixth- and also seventh-rank military officers; late nineteenth or early twentieth century. Embroidered silk satin; 26 × 26.4 cm. Jon Eric Riis collection, Atlanta.

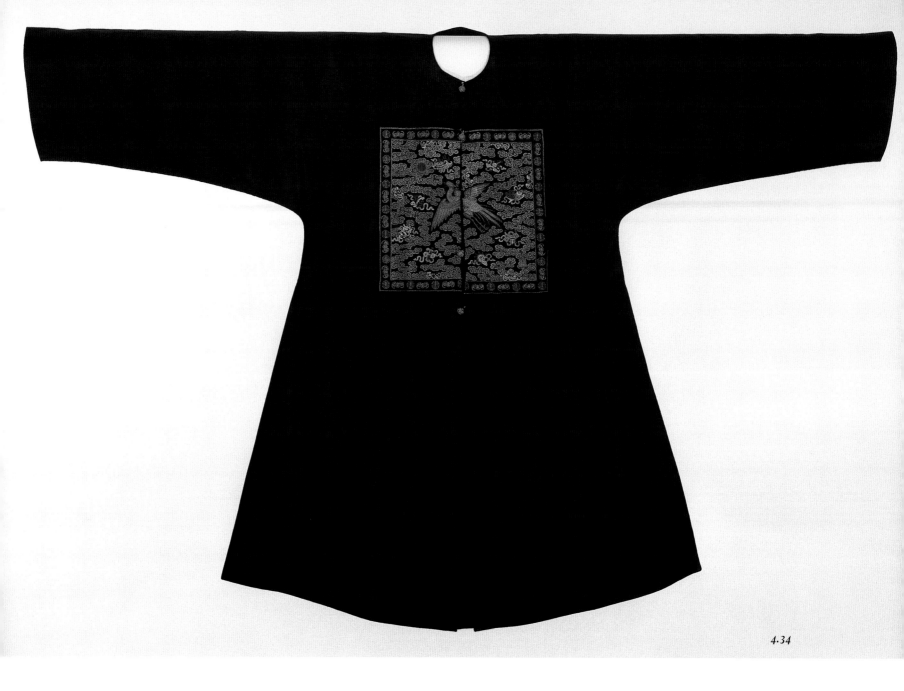

Fig. 4.34
Court surcoat *(bufu)* with golden pheasant *buzi* for
second-rank civil official; nineteenth century, last
quarter. Embroidered silk damask; length 115.7 cm.
Santa Barbara Museum of Art. Gift of Mrs. Ruth
Ann Guibara. 1988.21.

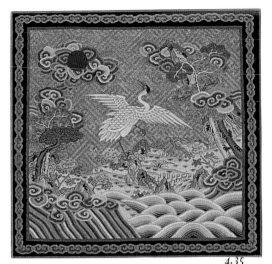

Fig. 4.35
Insignia badge *(buzi):* crane for first-rank civil official; eighteenth century, last quarter. Tapestry-woven silk *(kesi);* 21 × 21.7 cm. Mactaggart collection, Edmonton.

4.35

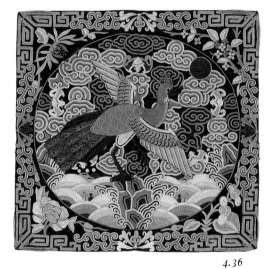

Fig. 4.36
Insignia badge *(buzi):* peacock for third-rank civil official; late nineteenth or early twentieth century. Embroidered silk satin; 21.5 × 22.8 cm. Judith Rutherford collection, Sydney, Australia.

4.36

Fig. 4.37
Insignia badge *(buzi):* goose for fourth-rank civil official; late nineteenth or early twentieth century. Embroidered silk satin; 22.5 × 25 cm. Textile Museum of Canada, Toronto, Canada. Gift of Thomas Kalman. T86.0419.

4.37

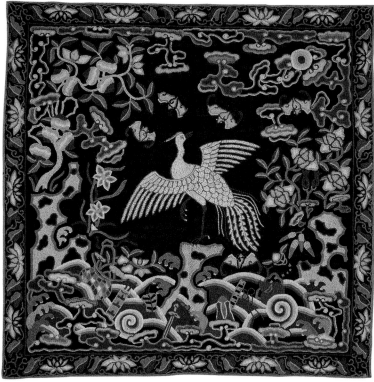

4.38

Fig. 4.38
Insignia badge *(buzi):* silver pheasant for fifth-rank
civil official; nineteenth century, second quarter.
Embroidered silk satin; 30.5 × 31.6 cm. Jon Eric
Riis collection, Atlanta.

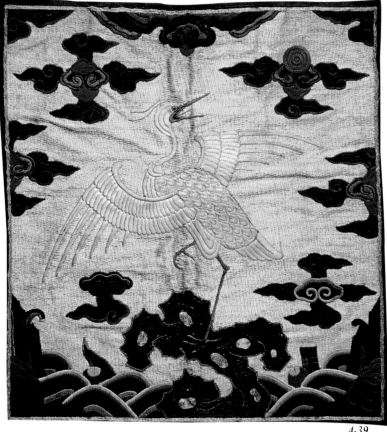

4.39

Fig. 4.39
Insignia badge *(buzi):* egret for sixth-rank civil offi-
cial; eighteenth century, first quarter. Embroidered
silk satin; 31 × 32.5 cm. Jobrenco Limited, trustee,
Hall Collection Trust, Hong Kong.

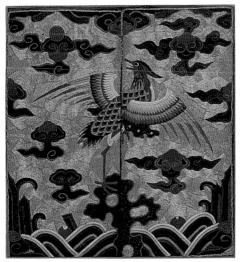

Fig. 4.40
Insignia badge *(buzi):* Mandarin duck for seventh-rank civil official; late seventeenth century. Embroidered silk tabby, 31 × 30 cm. Mactaggart collection, Edmonton.

4.40

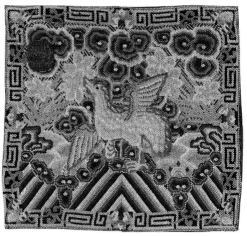

Fig. 4.41
Insignia badge *(buzi):* quail for eighth-rank civil official; late nineteenth or early twentieth century. Embroidery on silk mesh; 20.3 × 22.2 cm. Judith Rutherford collection, Sydney, Australia.

4.41

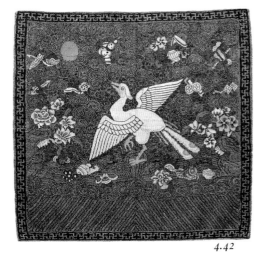

Fig. 4.42
Insignia badge *(buzi):* flycatcher for ninth-rank civil official; nineteenth century, third quarter. Tapestry-woven silk, gilded paper, and peacock feather–wrapped thread *(kesi);* 26.5 × 26.8 cm. Beverley Jackson collection, Santa Barbara.

4.42

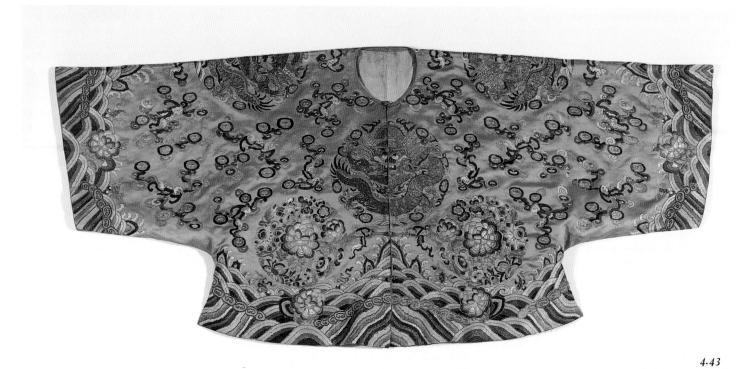

Officials wore the *magua* (horse jacket) with informal costume, but it was also worn in the palace. While normally a dark blue color, generals and captains were permitted to wear a *magua* in the color appropriate to their regiment when in personal attendance upon the emperor. The *huang magua* (yellow riding jacket) was one of the most coveted honors bestowed by the emperor. Only the highest-ranking ministers and officers of the imperial bodyguard enjoyed this privilege of rank.

Fig. 4.43
Manchu man's short surcoat *(magua)*; nineteenth century, fourth quarter. Embroidered silk satin; length 49 cm. Cincinnati Art Museum. Gift of Mrs. James Handasyde Perkins. 1929.170.

those shown in profile. Princes of the blood of the fifth through the eighth rank were assigned *mang* insignia displayed in squares. Nobles of imperial lineage from the ninth through the twelfth rank and all military officers were assigned animal insignia (see figures 4.28–33). Birds indicated the nine classes of civil officials (see figures 4.34–42).

A short surcoat called *huang magua* (yellow riding jacket) was the most prestigious honor bestowed by the emperor on Qing courtiers. Only the highest-ranking ministers and officers of the imperial bodyguard were entitled to wear it as a privilege of rank. The distinction designated the recipient as an honorary captain of the imperial banner and a member of the emperor's bodyguard (see figure 2.20 in chapter 2). Toward the end of the dynasty, the prestige of this garment had declined when it was awarded for a wide range of services to the imperial throne, including contributions to the treasury. Plain, solid-colored silk garments were replaced by ones with embroidered decoration.

INFORMAL CLOTHES

As described earlier in this chapter, at court the emperor and his family required extensive wardrobes to meet the complex festive, ceremonial, and social obligations associated with the office of the emperor. Every court event implied an imperial action whether it was attended by hundreds or observed by only a few, so each was a public performance that demanded appropriate clothing to demonstrate virtuous display. The coats *(neitao)* and surcoats *(waitao* and *magua)* for traveling, practicing calligraphy, studying, visiting family members, hunting, and military maneuvers were classified as *changfu* (literally, "ordinary dress").

The clothing worn domestically by the Manchu population was also classified as *changfu.* Like court attire, the domestic wardrobe was graded as formal, semiformal, and informal. The grouping of various costume components also imitated court wear; for example, formal domestic wear included a robe and surcoat with a hat and collar that closely paralleled semiformal *jifu.* Because this domestic costume fell outside the consideration of the official court costume edicts, its ornament was often expressive of personal preferences. On formal domestic occasions such as weddings, births, the new year, and significant birthdays, a man might wear his semiformal court dress, but a Manchu woman often wore garments that were designed for the occasion. Women's formal *changfu* consisted of a robe and surcoat with roundel ornament. The robe had *matixiu* (horse hoof cuffs) and a band of ornament above the sleeve extension like the female court garment in figure 4.9. By the end of the nineteenth century, the cuff had become completely debased and was commonly worn turned back, in a manner comparable to Chinese women's wear. Like all other classes of Manchu women's garments, women's coats were slit at the sides and generally worn unbelted.

Because there were no prescribed decorations for *changfu,* it is often difficult now to determine whether a garment was used at court. However, a robe like the embroidered silk gauze *changyi* with hydrangea in figure 4.47 is associated with the personal tastes of the Dowager Empress Cixi. Cixi (1835–1908) served as regent between 1862 and 1873, during the minority

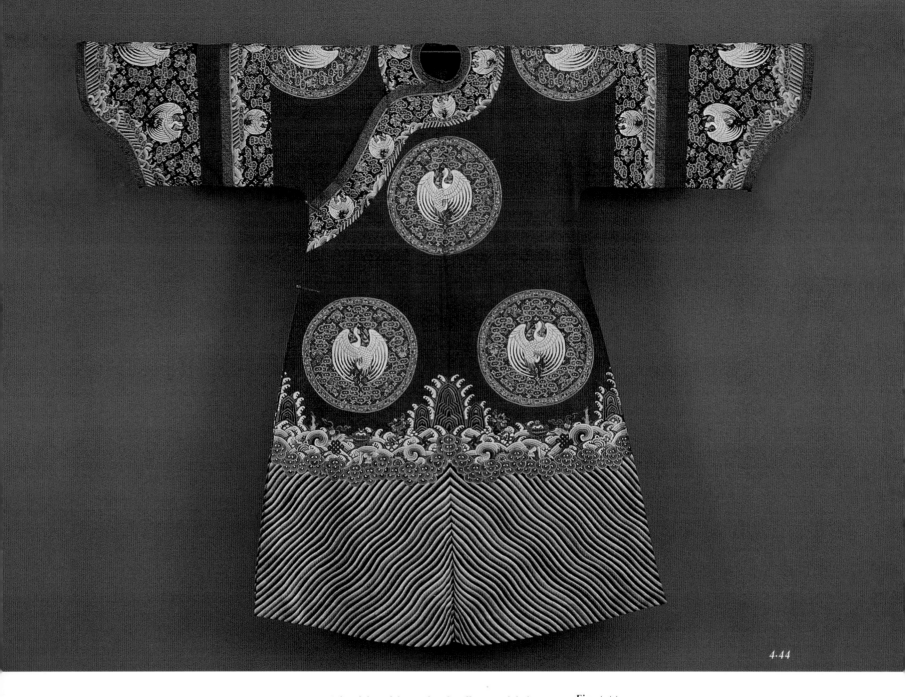

4.44

The debased horse hoof cuffs, roundel decoration, and extra band of ornament at the elbow mark this garment as the most formal of all domestic attire for Manchu women. The red ground and roundels with cranes symbolizing wishes for long life were appropriate for birthday celebrations.

Fig. 4.44
Manchu woman's formal domestic robe *(chenyi);* late nineteenth or early twentieth century. Embroidered silk gauze; length 137 cm. Mactaggart collection, Edmonton.

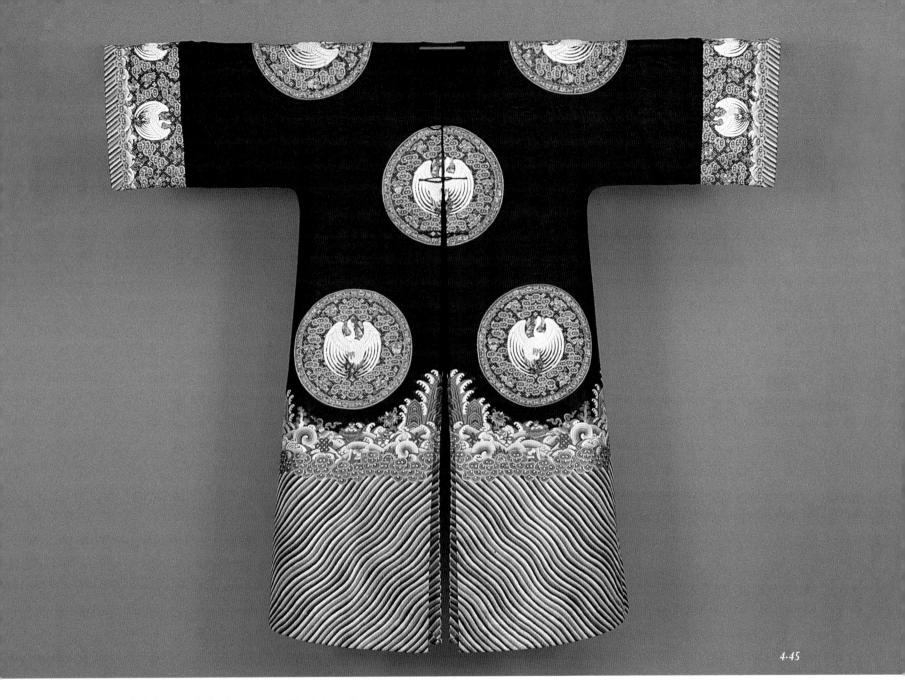

4.45

Formal clothing made for domestic use, like their court-related counterparts, consisted of an ensemble of robe and surcoat. Sets that were designed to be worn together rarely survived.

Fig. 4.45
Manchu's woman's formal domestic surcoat *(waitao)*; late nineteenth or early twentieth century. Embroidered silk gauze; length 137 cm. Mactaggart collection, Edmonton.

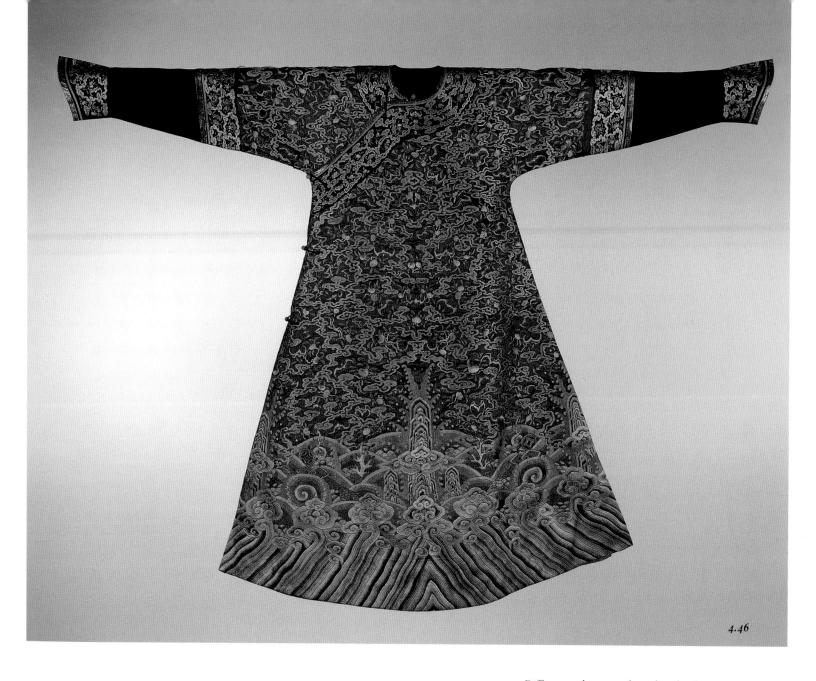

4.46

Differences between formal and informal clothes at court were largely matters of iconography. Imagery on this rare eighteenth-century robe conveyed wishes for long life, marking it as appropriate for unofficial wear.

Fig. 4.46
Manchu woman's informal court robe *(changfu)*; eighteenth century, third quarter. Embroidered silk

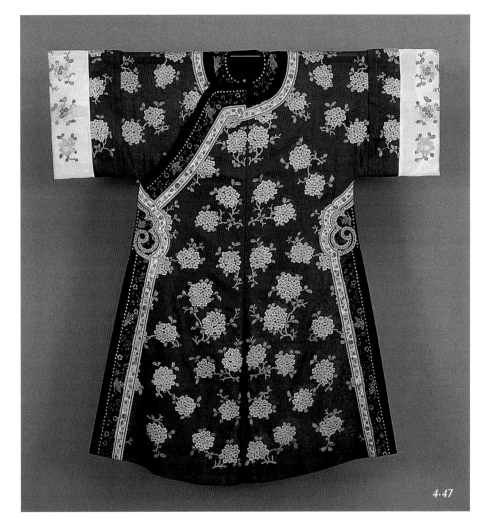

4.47

The harmonious relationships suggested by shifting the scale of the design and color schemes favored at the informal court of Dowager Empress Cixi at the end of the Qing dynasty are indistinguishable from Han Chinese costume aesthetics.

Fig. 4.47
Woman's semiformal domestic robe *(changyi)*; nineteenth century, last quarter. Embroidered silk gauze; length 129 cm. Mactaggart collection, Edmonton

of her son Zaichun, who became the Tongzhi emperor; she ruled as regent again from 1875 to 1889 after her nephew Zaitian was declared the Guangxu emperor. She was fond of boldly drawn, rather sentimental flower painting; numerous hanging scrolls of colorful, detailed flowers of the seasons bear her seal. By the last quarter of the nineteenth century, the silk workshops responsible for producing the fabrics for her informal attire and those of her ladies-in-waiting flatteringly reproduced these floral images. Portraits taken by Yu, a palace photographer, at the end of the nineteenth and beginning of the twentieth century show the empress and women at her court wearing these dazzling garments.

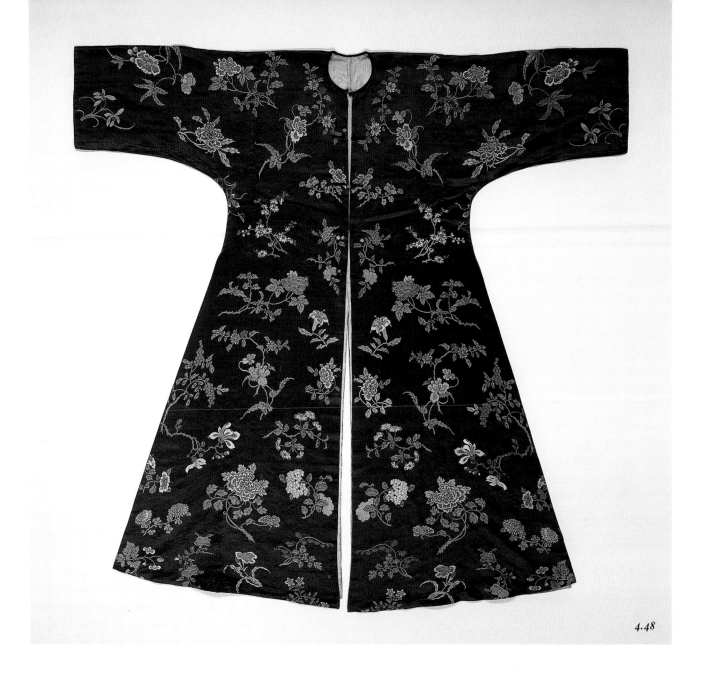

4.48

The pattern of scattered sprays of flowers of the seasons imparts a feminine grace to this rare eighteenth-century surcoat.

Fig. 4.48
Manchu woman's domestic semiformal surcoat *(waitao)*; eighteenth century, third quarter. Brocaded silk satin; length 127.5 cm. The Cleveland Museum of Art. 2000.77.

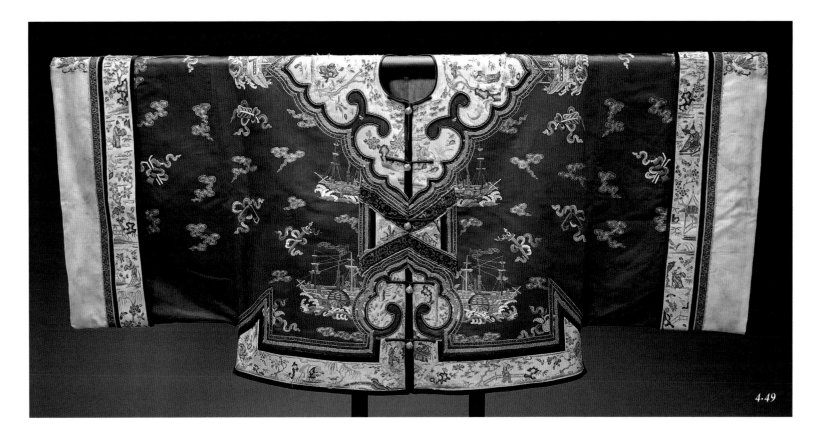

4.49

Women's semiformal domestic garments were decorated with more casual ornaments, such as the overall hydrangea pattern on the *changyi* described above. The sleeves on these and the plainer, often undecorated informal garments are straight and wide. They are faced with contrasting fabric, which is exposed when turned back to form decorative cuffs. Semiformal *waitao* were similarly patterned and in some cases may have matched the robe worn with them. For less formal occasions, a variety of vests, both long and short, and *magua* were worn (see figure 2.23 in chapter 2 and figure 3.5 in chapter 3). These garments were worn informally and often contrasted in color and pattern with *chenyi* worn under them.

For more formal domestic occasions, women wore hats. These were reminiscent of semiformal winter court hats, or *jiguan* (see figure 3.20 in chapter 3), but without rank insignia. A pair of streamers hung down the back. These and the crown of the hat were often embellished with auspicious motifs. Manchu woman's domestic shoes, called *qixie* (literally, "banner

The decor of this semiformal domestic jacket was both topical and exotic (British, and later American, steamboats plied Chinese waters at the end of the nineteenth century).

Fig. 4.49
Manchu woman's short jacket *(magua)*; late nineteenth or early twentieth century. Embroidered silk satin; length 56 cm. Jon Eric Riis collection, Atlanta.

shoes"), were constructed with a silk upper attached to a wooden sole. The level of formality determined the height of the sole. For formal occasions, the wooden platforms, positioned under the instep, measured ten to fifteen centimeters; the various shapes were described as "flowerpot," "horse hoof," or "boat." The soles of semiformal shoes measured five to ten centimeters; those for informal shoes were flat, measuring two to three centimeters. Elevated soles were covered with gesso or had cotton fabric glued over the form. While the shoe was adopted from Jurchen forms, its exaggerated height during the Qing dynasty appears to have been a response to Chinese culture. Although Manchu women did not bind their feet as elite Chinese women did (see figure 2.10 in chapter 2), it is obvious from the number of imperial edicts issued throughout the dynasty forbidding bannerswomen from practicing footbinding that extremely small feet were prized. By raising a Manchu woman's foot on a narrow wooden platform, particularly if the hem of the robe covered the slipper, the foot appeared small and delicate. The stiltlike platforms also affected a woman's gait, creating a mannered, stiff-legged step that also resonated with Chinese notions of feminine grace.

On Manchu women's domestic garments, floral imagery linked the wearer to the cycle of the seasons and implied a concern with harmonious coexistence with nature, one of the principal tenets of Chinese Daoism. Manchu's nomadic origins are acknowledged in such features as the curved front overlap and loop-and-toggle fastening and in the multiple fabric assemblage that imitates the *jifu* constructions discussed above. Nonetheless, the designer of such garments was more clearly concerned with Chinese aesthetics and sentiments. The shift in scale and color contrast as demonstrated by matching patterns on the light-colored facings of the turned-back sleeves, black or navy blue borders, and the ground fabric suggests an aesthetic of harmony and balance prized by Chinese connoisseurs. On the one hand, such stylistic and technical revisions can be interpreted as debasements of Manchu ideals or nomadic self-sufficiency and ethnic purity, but they are also manifestations of the long and complex interaction between nomadic conquerors and the Chinese empire.

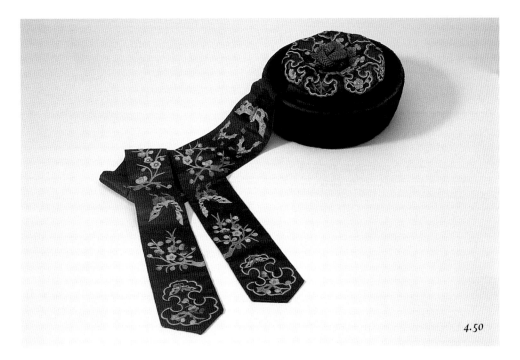

4.50

Appropriate hats and collars were also worn with formal and semiformal wear domestically.

Fig. 4.50
Manchu woman's domestic formal hat; nineteenth century, fourth quarter. Appliquéd silk satin; diameter of crown 21 cm. Royal Ontario Museum, Toronto. L978.11.

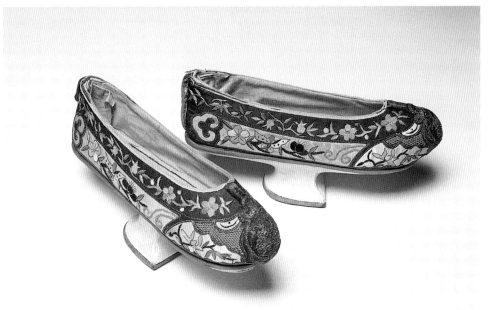

4.51

Manchu women's shoes were often elevated on fabric- or gesso-covered wood platforms. Levels of formality were indicated by increased elevations.

Fig. 4.51
Manchu woman's shoes *(qixie)*; early twentieth century. Appliquéd silk satin, cotton tabby over wooden platform; height 9.5 cm. Glenn Roberts collection, New York.

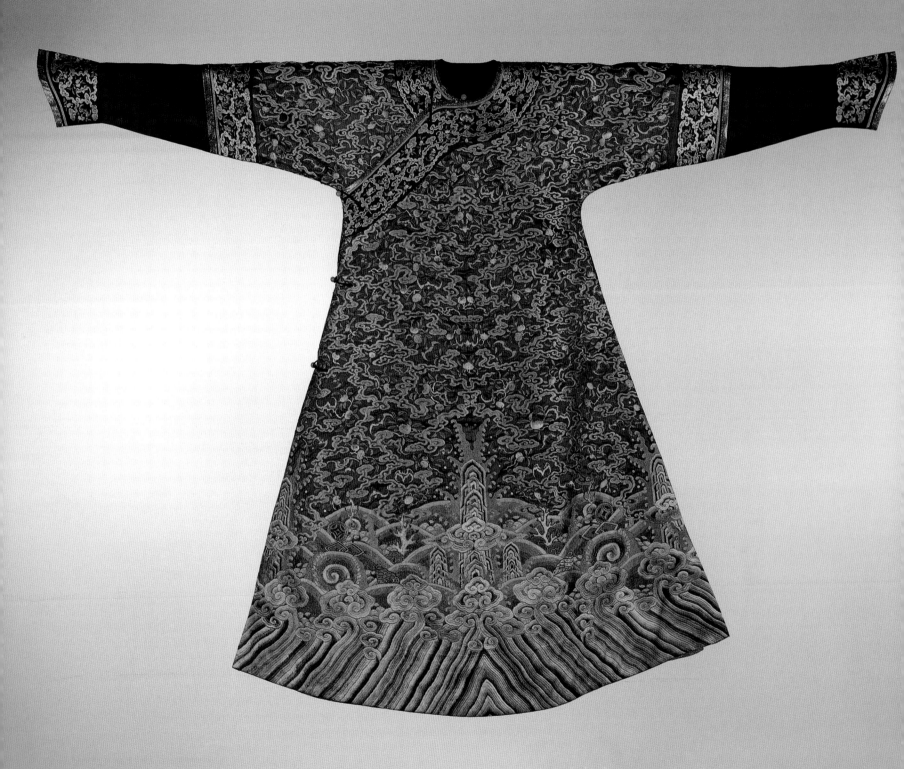

ACKNOWLEDGMENTS

Much of the information in this book was originally published in the catalogue *In the Presence of the Dragon Throne: Ch'ing Dynasty Costume (1644–1911) in the Royal Ontario Museum* (1977) to mark a special exhibition based on the magnificent Chinese costume collection at that museum. Other material first appeared in the catalogue of another exhibition, *Five Colours of the Universe: Symbolism in Clothes and Fabrics of the Ch'ing Dynasty (1644–1911)*, which was held at the Edmonton Art Gallery in 1980. I thank both the Royal Ontario Museum and the Edmonton Art Gallery for permitting me to utilize materials originally under copyright to those museums.

Special thanks go to Beverley Jackson, who insisted that this book be written and published while she could still appreciate it. The original books were the reason Beverley first contacted me about items in her collection. We struck up an immediate friendship that existed first through correspondence and only later led to our meeting and examining Chinese textiles together. Beverley is responsible for suggesting to her publisher, Phil Wood, that he consider publishing my book. Phil, the driving force at Ten Speed Press, was receptive and, indeed, became an enthusiastic supporter of the project. In

our discussions we decided to completely reorganize the book. In so doing we have created a new book with a new title. While some of the original text from *In the Presence of the Dragon Throne* dealing with the origins and development of Manchu clothing has been retained, I have corrected errors and misconceptions that were present in the earlier edition. Other sections have been expanded and new information has been included. The illustrations include some of the best examples of key garment types that survive in private and public collections, many of which I have had the good fortune to examine over the twenty-five years since the original publication.

My thanks go to colleagues and friends who have assisted along the way in the search for answers to some of the fundamental questions about Chinese costume: How and why were these garments made? Who made them? Who wore them? What did they mean? The work of my colleagues Dorothy K. and Harold B. Burnham at the Royal Ontario Museum on garment construction and its relationship to technology and raw materials shaped my approach to this subject. Their counsel and patience resulted in the conclusions that first appeared in print in the late 1970s and have continued to drive this exploration. The encouragement and support of Katharine Brett and Dorothy Burnham following the death of Harold Burnham in 1972 allowed me to work at the Victoria and Albert Museum in a kind of postgraduate internship in preparation for my heading the Textile Department at the Royal Ontario Museum from 1979 to 1983. In London I had the opportunity to work with Donald King and others in the Department of Textiles and Dress, Indian Section and Far Eastern Department. Part of my work involved a detailed examination of the Victoria and Albert's Chinese costume collection, which began a study of Qing costume that now includes notes on more than 3,000 garments.

The publication of *In the Presence of the Dragon Throne* was followed by an extended research project with support from a Canadian Social Sciences and Humanities Research Council grant. I examined the Chinese costume collections in twelve North American museums, including animal skin garments from eastern Siberia held by the American Museum of Natural History and by the Peabody Museum of Anthropology at Harvard University. While some of my findings related to these prototypical garments were

published in academic papers, the integration of this data into the larger picture of Manchu clothing appears here for the first time.

During the 1980s and 1990s my career moved away from the study of Chinese costume, but an exhibition and conference focused on Chinese textiles organized by the Textile Society of Hong Kong in the summer of 1995 brought me back to a topic for which I have great fondness. At the conference I reconnected with Krishna Riboud, a textile scholar of incredible breadth and insight, who insisted I visit her textile study center in Paris and then made it possible for me to publish a selection of the Qing dynasty costume and accessories in her collection.

I am deeply indebted to my wife, Eleanor Goldhar, whose love and belief in my work affords me the luxury of time and support to deal with the demands of projects like this. Thanks also to my editor, Kathryn Hashimoto, for shepherding this book's journey at Ten Speed Press. Without her diligence, careful attention to detail, good counsel, and loving dedication to the printed word this work would have been much diminished. Jeff Puda's design has brought clarity and insight to my work and added a dimension that an author usually only dreams about. Special thanks also go to Clancy Drake, whose copyediting helped me find better ways to express my ideas and whose questions inspired better thinking, and to Richard Sheppard, who took my rough drawings and transformed them into the elegant diagrams and illustrations that are the heart of this book.

My sincere appreciation for help and assistance in many ways goes to: Cynthia Amneus of the Cincinnati Museum of Art; Janet Baker of the Phoenix Museum of Art and formerly of the Bowers Museum of Cultural History; Susan Bean of the Peabody Essex Museum in Salem, Massachusetts; Dilys Blum of the Philadelphia Museum of Art; Dr. Bennett Bronson of the Field Museum; Lorna Carmel of New York and formerly of the Textile Museum; Will Chandler of San Diego; Young Yang Chung Ikeda of New York; Dr. Bruce Coats of Scripps College in Claremont, California; Elizabeth Ann Coleman of the Museum of Fine Arts in Boston; Teresa Coleman of Hong Kong; Diana Collins of Hong Kong; Vincent Comer of Seattle; Carol Connover of New York; Joyce Denney of the Metropolitan Museum of Art; Gary Dickinson of London; Shannon Elliott of the Royal Ontario Museum;

John Finlay of the Orlando Museum of Art; Dodi Fromson of Los Angeles; Barton and Flavia Gale of New York; Francesca Galloway of London; Valery Garrett of Hong Kong; Dale Gluckman of the Los Angeles County Museum of Art; Chris Hall of Hong Kong; Ralph and Mary Hays of Los Gatos, California; Lizbet Holmes of London; Niloo Imami-Paydar of the Indianapolis Museum of Art; Beverley Jackson of Santa Barbara, California; Helen Jahnke of Chicago; Shirley Johnson of Washington D.C.; Mary Hunt Kahlenberg of Santa Fe; Jennifer Kaye of the Textile Museum of Canada in Toronto; Marijke Kerkhoven of the Textile Museum of Canada in Toronto; Fred and Stella Krieger of Los Angeles; Arthur Leeper of Belvedere, California; Anu Liivandi of the Royal Ontario Museum; Louise Mackie of the Cleveland Museum of Art; Mary MacNaughton of the Ruth Chandler Williamson Gallery at Scripps College in Claremont, California; Sandy and Cécile Mactaggart of Edmonton, Alberta; Richard Mafong of Atlanta; Gail Martin of New York; Stephen McGuinness of Hong Kong; Sandra Morton Weizman of the Glenbow Museum in Calgary, Alberta; Myrna and Sam Myers of Paris; Alexandra Palmer of the Royal Ontario Museum; Merrily Peebles of Carpenteria, California; Valrae Reynolds of the Newark Museum; Jon Eric Riis of Atlanta; Frances Roback of the Glenbow Museum; Glenn Roberts of New York; Judith and Ken Rutherford of Castle Cove, Australia; Jacqueline Simcox of London; Jan Stuart of the Arthur M. Sackler Gallery, Smithsonian Institution; Susan Tai of the Santa Barbara Museum of Art; Christa Mayer Thurman of the Art Institute of Chicago; Barry Till of the Art Gallery of Greater Victoria; Antonia Tozer of London; Kabo Tsang of the Royal Ontario Museum; Nuyet Tuyet of Hong Kong; Sandra Tygum of the Petterson Museum of Cultural Art in Claremont, California; Ann Watson-Parson of the American Museum of Natural History; Lisa Whitman of the American Museum of Natural History; Verity Wilson of the Victoria and Albert Museum; Linda Wrigglesworth of London; Feng Zhao of the China National Silk Museum, Hangzhou; and Athena Zonars of Christie's in New York.

IMAGE CREDITS

Photographs

American Museum of Natural History, New York.
 Photography by J. Beckett. *Figs.* 2.12, 2.14, 2.28

Art Institute of Chicago, Oriental Department.
 Photography by Nancy K. Finn. Photograph © The Art Institute of Chicago. *Fig.* 4.30

Arthur M. Sackler Gallery, Smithsonian Institution.
 Photography by Robert Harrell. *Figs.* 3.6, 3.11, 4.27

Association pour l'Etudes et la Documentation des Textiles d'Asie collection, Paris.
 Photography by Bruno Leo Hir la Fallois. *Figs.* 2.25, 4.10, 4.21, 4.22

Beverley Jackson collection, Santa Barbara.
 Photography by Scott McClaine. *Fig.* 3.17

Beverley Jackson collection, Santa Barbara.
 Photography by Kevin Delahay. *Fig.* 4.42

Cincinnati Art Museum.
 Photography by Tony Walsh, 2002. *Fig.* 4.43

The Cleveland Museum of Art.
 Photography © The Cleveland Museum of Art, 2002. *Fig.* 4.48

Glenn Roberts collection, New York.
 Photography by Tibor Ardi. *Figs.* 2.9, 2.10, 2.27, 4.51

Jacqueline Simcox Ltd., London.
 Photography by Alan Tabor Photography. *Fig.* 2.16

Jobrenco Limited, trustee, Hall Collection Trust, Hong Kong.
 Photography by Man-wai Wong. *Figs.* 0.3, 4.11, 4.28, 4.39

Jon Eric Riis collection, Atlanta. Photography by Bart's Art. *Figs.* 2.20, 3.2, 4.29, 4.31, 4.32, 4.33, 4.38, 4.49

Judith Rutherford collection, Sydney, Australia.
Photography by Jackie Dean. *Figs.* 4.36, 4.41

Mactaggart collection, Edmonton.
Photography by Garth Rankin. *Figs.* 0.2, 2.7, 2.8, 2.19, 2.23, 3.4, 3.5, 4.2, 4.3, 4.9, 4.12, 4.15, 4.16, 4.17, 4.26, 4.35, 4.40, 4.44, 4.45, 4.47

Mactaggart collection, Edmonton.
Photography by The Metropolitan Museum of Art. *Figs.* 1.1, 1.3

The Metropolitan Museum of Art, New York.
Photograph © 1995 The Metropolitan Museum of Art. *Fig.* 2.17
Photograph © 1980 The Metropolitan Museum of Art, New York. *Fig.* 4.1
Photograph © 1986 The Metropolitan Museum of Art. *Fig.* 1.2

Musée des Arts Asiatiques, Nice.
Photography by Thierry Plat, Conseil general des Alpes-Martimes. *Fig.* 4.20

Musée National des Arts Asiatiques—Guimet, Paris.
Photography by Michel Urtado, Reunion des Musees Nationaux/Art Resource, New York. *Fig.* 4.6

Museum fur Ostasiatische Kunst, Koln.
Photography by Linda Wrigglesworth. *Fig.* 3.13

Museum of Art, University of Oregon, Eugene. *Fig.* 3.14, 3.19

Museum of Fine Arts, Boston.
Photography © 2001 Museum of Fine Arts, Boston. *Figs.* 2.29, 4.4, 4.18

Myers collection, Paris. Photography by Thierry Plat. *Figs.* 2.4, 3.8, 4.5, 4.23, 4.24, p. XII

National Palace Museum, Taiwan, Republic of China.
Figs. 3.21, 3.22

Petterson Museum of International Culture, Claremont, California.
Photography by David Gautreau. *Figs.* 3.15, 4.25

Private collection.
Photography by Teresa Coleman. *Fig.* 4.46, p. 134

Royal Ontario Museum, Toronto.
 Photography © ROM Royal Ontario Museum. *Figs.* 2.2, 2.5, 2.6, 2.22, 2.24, 2.26, 3.1, 3.10, 3.16, 3.18, 3.20, 4.13, 4.14, 4.50

Ruth Chandler Williamson Art Gallery, Scripps College, Claremont, California.
 Photography by Susan Einstein. *Fig.* 3.3

Santa Barbara Museum of Art.
 Photography by Scott McClaine. *Figs.* 4.7, 4.34

Seattle Art Museum.
 Photography by Paul Macapia. *Fig.* 2.1

Textile Museum of Canada, Toronto, Canada.
 Photography by Ron Wood. *Fig.* 4.37

Drawings

Richard Sheppard. *Figs.* 0.1, 2.3, 2.11, 2.13, 2.15, 2.18, 2.21, 3.7, 3.9, 3.12, 4.8, 4.19, 4.24

NOTES

CHRONOLOGY

All dates reflect a consensus of modern scholarship.

SPELLING

All Chinese words are spelled according to the Pinyin system.

DATING

Most Qing dynasty costume is undocumented and only datable on stylistic grounds. Scholars have long isolated the Twelve Symbol *jifu* as having special bearing on dating, because they can be associated with emperors whose reign dates are fixed. In 1943, Metropolitan Museum of Art curator Alan Priest proposed a dating system based on careful comparison of the various decorative elements of these coats; the sequence he arrived at was then assigned to the reigns of individual emperors. On the premise that stylistic changes would emanate from the court and filter through society, this sequence serves as a standard on which to base stylistic comparisons for other garments. Priest began his sequence with the reign of the Kangxi emperor, roughly a century too early as these symbols did not appear on Qing imperial attire until the middle of the reign of the Qianlong emperor, as was pointed out by Helen Fernald in 1946. Her suggestions for revising the sequence were substantiated and elaborated by Schuyler Cammann in 1952 from his research on historical documents. To a large extent the dating system suggested here is based on Cammann's work. In most cases I have

suggested a century, quarter century, or decade attribution rather than a reign title. Using imperial reign titles implies a specific association with the court that can only rarely be substantiated. In those rare cases where an imperial attribution is warranted, the emperor's reign title and the proposed date are both provided.

SOURCES

1. The Qing Dynasty: Historical Background

Fairbank and Reischauer's *China: Tradition and Transformation* provides a most readable overview of Chinese historical, cultural, and social developments.

Among the best references to Manchu history are Lattimore's *Inner Asian Frontiers of China;* Oxnam's *Ruling from Horseback;* Rossabi's *China and Inner Asia;* Brandauer and Huang's *Imperial Rulership and Cultural Change in Imperial China;* and Mote's *Imperial China 900–1800.*

The discussion of Manchu political and social development during the sixteenth century draws on Wakeman, Jr.'s *The Fall of Imperial China,* particularly pages 55–80. For the origin and later developments of the Manchu banner *(gusa or qi)* system, see Feuerwerker's "State and Society in Eighteenth-Century China," pages 4–5 and 54–58, and Elliott's *The Manchu Way.*

In "State and Society," Feuerwerker also describes early Qing administrative structure (35–75), as does Wakeman, Jr., in *The Great Enterprise.*

2. East Asian Clothing Traditions

Studies of regional clothing styles and types are indebted to Tilke's *Costume Patterns and Designs.* Burnham's pioneering work, *Cut My Cote,* set forth the hypothesis that weaving technology is directly related to the types of garments that cultures produce. The book examines the construction of traditional garments from around the world. Invariably, these clothes exhibit economy and a reverence for cloth itself. While loom lengths are cut to make garments, little or no cloth is actually wasted, thus acknowledging the value of the time and effort required to produce threads and interlace them into fabric. Strategies for garment construction vary but demonstrate remarkable consistency within geographic regions and among ethnic and

linguistic groups. A second generation of scholars at the Royal Ontario Museum applied Dorothy Burnham's hypothesis to the garments of Turkey and central Europe and those of east Asia. Gervers-Molnar's *The Hungarian Szur* traced the development and of pendant-sleeved coats from central Asia through Iran and to the Hungarian plains. My own work on east Asian constructions has been published in the catalogue *In the Presence of the Dragon Throne* and in several articles, including "Sources for Manchu Costume of the Ch'ing Dynasty (1644–1911)."

Comprehensive surveys of Chinese historical costume include Shen's *Zhongguo gudai fushi yanjiu* (Examination of ancient Chinese costume); Zhou and Gao's *5000 Years of Chinese Costume*; and Huang and Chen's *Zhongguo fushi yishu yuanliu* (Origins of the art of Chinese national costume).

For an overview of the history of sericulture and weaving in China, see Zhao's *Treasures in Silk*. A useful reference to the restoration of Chinese-style costume under the Ming dynasty is found in Jacobsen's *Imperial Silks,* pages 35–39.

Three books written by Jochelson—*The Koryak; The Yukaghir and the Yukaghirized Tungus;* and *The Yakut*—are among the earliest works focusing on the inhabitants of eastern Siberia. The standard and most comprehensive survey of the peoples and cultures of Siberia is Levin and Potapov's (eds.) *The Peoples of Siberia,* which was originally published in Russian in 1956. On the Yakut, see the classic study of Okladnikov, *Yakutia Before Its Incorporation into the Russian State.* On the Evenk there are the works by Shirokogoroff: *Social Organization of the Northern Tungus* and *Psychomental Complex of the Tungus.*

In 1897, Morris Jesup, president of the American Museum of Natural History in New York, sponsored a five-year expedition to Alaska and Siberia. This immense research project left a legacy of classic ethnographies, extensive museum collections, and some three thousand photographs; see Kendall, Freed, and Miller's *Drawing Shadows to Stone* for a recently published volume based on these important collection trips.

Hansen's *Mongol Costume* remains a standard reference to early twentieth-century Mongol material culture. Since the 1970s, excavated material from Yuan dynasty (1260–1368) tombs has helped fill in the record for earlier

Mongol materials; see Jacobsen's *Imperial Silks,* pages 34–35. A survey of Tibetan costume can be found in Reynold's *Tibet: A Lost World.*

Reference to the mounted-archer costumes of the Jao army is recorded in the *Shiji* (Historical records) largely compiled by Sima Qian (c. 145–c. 86 B.C.); see Watson's translation, *Records of the Grand Historians of China.* The origins of the paired apron or skirt *(qun)* can be traced to the steppes of northeastern Asia, where it served as an auxiliary garment covering leggings or trousers for more formal occasions. See my *In the Presence of the Dragon Throne,* pages 21–38, and Hays' "Chinese Skirts of the Qing Dynasty."

For reference to the costume of the Miao and other minorities now living in southeast Asia, see Kanomi's *People of Myth.*

3. Manchu Garments

Garrett's *Chinese Clothing* provides a good survey of Manchu costume types, both male and female. The best history of Qing dynasty court attire in English remains Cammann's *China's Dragon Robes.* Other references include Wang's *Longpao.* The mid-Qing comprehensive categorization of court attire is discussed in Dickinson and Wrigglesworth's *Imperial Wardrobe.*

The evolution of Manchu formal court garments is discussed in my "Sources for Manchu Costume," pages 47–61.

Reference to Qing court collars can be found in Cammann's *Dragon Robes,* pages 135–136. Cammann discusses *chaozhu* in "Ch'ing Dynasty 'Mandarin Chains.'"

In *Imperial Wardrobe,* Dickinson and Wrigglesworth provide the most accessible description of Qing court hats and sashes; see pages 97–114 and 155–157.

4. In Service of the Dragon Throne

For a discussion of the roles of Qing dynasty emperors, see Uitzinger's "Emperorship in China" in *De Verboden Stad / The Forbidden City,* edited by Ter Molen and Uitzinger, pages 71–91.

The cosmological significance of imperial rule is discussed in my "Power in the Inner Court of the Qing Dynasty."

The significance of the color yellow in Qing dynasty court attire is discussed in Cammann's *China's Dragon Robes,* pages 25–27.

Various Ming dynasty decorative schemas are illustrated in Jacobsen, *Imperial Silks,* pages 35–39, and in Hall, Gluckman, and Reynolds, et al., *Heaven's Embroidered Cloths,* an exhibition catalogue for the Hong Kong Museum of Art, pages 198–209.

In *China's Dragon Robes,* Cammann covers Qing dynasty costume in detail. The *Huangchao liqi tushi* is discussed by Medley in *The Illustrated Regulations for Ceremonial Paraphernalia of the Ch'ing Dynasty* and in Dickinson and Wrigglesworth's *Imperial Wardrobe.*

The stylistic development and dating of Qing dynasty court costume is discussed by Priest in *Costumes from the Forbidden City;* by Fernald in *Chinese Court Costumes* (an exhibition catalogue); and by Cammann in *China's Dragon Robes.* My discussion of the redesign of eighteenth century Manchu court costume can be found in *Chinese Costume and Accessories 17th–20th Century.*

One of the clearest discussions of the Twelve Symbols of Ancient Imperial Authority is found in Dickinson and Wrigglesworth's *Imperial Wardrobe,* pages 76–96.

Surcoats and rank insignia are discussed by Cammann in "Development of the Mandarin Square," and more recently by Jackson and Hugus in *Ladder to the Clouds.*

The domestic, or nonofficial, wardrobe of Manchu women is addressed by Huang and Chen in their contribution to Roberts's catalogue, *Evolution & Revolution.* Comparable clothing worn at court is described by Yuan in *Empress Dowager Cixi.*

GLOSSARY

Ao Upper-body garment or coat worn by Han Chinese women, knee length and cut with wide sleeves. Also used in phrases to describe entire Han costumes: *aoqun* (coat and skirt) and *aoku* (coat and trousers).

Bufu (court surcoat) Literally, "coat with a patch." A front-opening surcoat worn at court by those other than members of the imperial family. Insignia badges *(buzi)* were attached at the chest and back. For men, *bufu* was three-quarter length; for Manchu women, it was full length. See also *gunfu* and *longgua*.

Buzi (insignia badge) Worn at court to designate ranking. *Buzi* for the emperor and members of his clan were round in shape; other nobles, civil officials, and military officers had square badges. The badge applied at the chest was split vertically to accommodate the front opening of the *bufu*.

Caishui A ceremonial kerchief worn by imperial Manchu women as part of *chaofu*.

Changfu Literally, "ordinary dress." The term used to describe the least formal level of court attire worn at official events not associated with ritual or governance. *Changfu* includes specialized travel and hunting attire. The clothing worn domestically by the Manchu population was also classified as *changfu*.

Changyi Manchu woman's domestic full-length robe featuring a high, round neck and front overlap to the right fastened at the neck, clavicle, and right side with loops and toggles. The body was relatively straight, the sleeves were wide, and the seams were left open at each side to just below the armpit. See *chenyi*.

Chaodai (court belt) A card-woven silk belt with four plaques and hook closure. Ceremonial kerchiefs, small purses, a flint, and a knife are suspended from the two side plaques. Worn by men as part of *chaofu*.

Chaofu Literally, "court dress." The most formal level of costume used at the Qing court. The style of costume was reserved for court ritual and its use restricted to the highest-ranking members of the Qing court.

Chaogua (court vest) A full-length, sleeveless, front-opening coat worn by women over *chaopao*.

Chaoguan (court hat) A hat worn by men and women as formal court dress. There were two types, one for summer and one for winter; both had tall, faceted finials to designate rank.

Chaopao (court robe) A full-length robe worn as part of formal court dress. Although men and women's styles differ in cut from each other, both have asymmetrical front overlaps fastened with loops and toggles.

Chaoqun (court apron) An undergarment worn by Manchu women as part of formal court dress. Several inches of this garment were exposed below the hem of the *chaopao*.

Chaozhu (court necklace) A court accessory based on a Buddhist rosary. Worn by both men and women with formal court dress.

Chenyi Manchu woman's domestic full-length robe with round neck and front overlap to the right held with loop and toggles at the neck, clavicle, and side. Like the *changyi*, the body was relatively straight with full sleeves, but *chenyi* was made with only short vents at the sides.

Dai (belt) Narrow band of card-woven silk fastened with a hook. Worn informally by Manchu men with *neitao*.

Dianza Manchu woman's hat consisting of a black floss silk-wrapped framework of rattan or wire that covered the hair. Reminiscent of an inverted basket, *dianza* was often decorated with a kingfisher feather and other jeweled ornaments.

Diaowei Literally, "sable tail." A semiformal court hat ornament consisting of a bat-shaped piece of card or leather to which was attached two strips of fur, worn by soldiers on active service. The card or leather piece was secured under the hat finial and the fur strips worn at the back. Originally, *diaowei* were worn on hunting expeditions.

Doudou A square of cloth worn diagonally suspended from the neck and tied at the back from the opposite diagonal corners. Worn by Han Chinese women as an undergarment.

Duanzhao (ceremonial surcoat) A three-quarter-length, front-opening surcoat completely faced with fur, worn by men. The type of fur was determined by court rank.

Facing Lining or trimming sewn to edges of a garment and turned to the inside or to the exterior of the garment as reinforcement.

Fengguo Literally, "wind bonnet." A hood worn by women.

Finial An ornamental fitting attached to the crown of court hats that consisted of a tall, faceted, colored stone or a ball-shaped stone in a metal holder. The shape of the stone indicated the level of formality; its color denoted rank.

Flange A projecting edge on a garment; on Ming dynasty court robes, flanges concealed elaborate side vents.

Flounce A narrow piece of material usually gathered and sewn to the edge of a garment. The lower edge of a flounce is loose and wide.

Fu Literally, "blue and black stripes." Sometimes translated as "symbol of distinction," one of the Twelve Symbols of Ancient Imperial Authority displayed on the emperor's ritual clothing. On Qing robes it is depicted as a pair of blue, mirror-image square hooked lines.

Gore A wedge-shaped insert sewn into a garment to widen that part of it.

Gualan A full-length, sleeveless coat or vest worn by Manchu women domestically.

Gunfu (royal robe) The term used to describe the front-opening surcoat worn at court for semiformal functions by the emperor. Similar garments for other members of the imperial family were called *longgua,* and for those outside the imperial family they were called *bufu.*

Guo Generic term for a variety of hoods worn by men and women.

Gusa (banners) The major divisions of the Manchu army. Originally there were four *gusa* distinguished by their red, yellow, blue, and white flags. As the army expanded during the seventeenth century, four additional *gusa* were created. They were distinguished by flags of the original yellow, blue, and white with red borders and a red flag with white borders. The Chinese equivalent is *qi.*

Gusset A triangular or other specially shaped piece of material inserted into a garment to reinforce the area or to add room to facilitate movement.

Hala Manchu clan groups.

Huang (yellow) A significant color in Qing court garments, selected to link Qing rulers to earlier Chinese dynasties. The clear yellow color *minghuang* was reserved for use by the emperor, empress, dowager empress, and the highest-ranking imperial consorts. The heir apparent and his consort used *xinghuang* (apricot yellow) and the emperor's other sons used *jinhuang* (golden yellow).

Huangchao liqi tushi Translated as "Illustrated precedents for the ritual paraphernalia of the [Qing] imperial court," title of the illustrated catalogue of the costume and trappings of the Qing dynasty; first published in 1759. Originally in eighteen volumes with more than 6,000 illustrations. Incomplete sets of folios are now in the collections of the Victoria and Albert Museum, Royal Scottish Museum, National Museum of Ireland, British Library, and a private Canadian collection.

Huang magua (yellow riding jacket) Originally worn by the highest-ranking ministers and officers of the imperial bodyguard; toward the end of the dynasty, though, the prestige of this garment had declined. See also *magua.*

Jalan (regiment) A group of five *niru* (companies of three hundred warriors). The Chinese equivalent is *jiala.*

Jiazitou Manchu woman's hairstyle with a pair of flat, wing-like buns arranged on the crown of the head and extending to the sides, parallel with the shoulders. This term was later used for the hat that resembled the hairstyle.

Jifu Literally, "auspicious attire or coat." Semiformal court robe.

Jifudai (festive dress belt) A woven silk belt with plaques, kerchiefs, and purses worn with *jifu.*

Jiguan (festive hat) Court hat worn with semiformal dress. There were two types, one for summer and one for winter; both had round finials to designate rank.

Jingtien (well-field) A pattern of nine fields suggested by the character for "well," which depicts two pairs of logs crossing each other at right angles. In Confucian teaching, *jingtien* represents the ideal of agricultural management and communally shared production. It was claimed that during the early Zhou dynasty, eight peasant families, each with its own field, would cultivate among them a central field for the support of the lord.

Jinhuang (golden yellow) See *huang.*

Jinyue Narrow gold headband worn by imperial Manchu women with *chaoquan.*

Kanjian A short sleeveless coat or vest, usually padded or lined. Worn by both men and women.

Kesi (carved or cut silk) Tapestry-woven silk fabric.

Ku Loose trousers or leggings.

Li (1) A conical sunshade made of plaited split bamboo. (2) A Confucian term, often translated as "virtue," but literally meaning "ritual." The term implies the thorough understanding of proper etiquette and social usage as established in ancient times. According to Confucian teachings, it was believed that inner attitudes were instilled through practice of external forms of proper and appropriate behavior. See also *wenren.*

Lingtou A stiffened round collar worn with robes and surcoats. *Lingtou* worn with semiformal court wear were faced with fur; *lingtou* worn with *changfu* or domestically were faced with satin or plush, depending on the season.

Lingyue A rigid gold torque set with jewels worn by imperial Manchu women as part of *chaofu.*

Lingzhi A hat ornament made of peacock tail feathers signifying distinguished service to the throne. The plume was inserted into a tubular fitting attached under the finials of court hats and worn at the back.

Lishui Literally, "standing water." The pattern of parallel sets of wave bands at the hem of robes and insignia badges symbolizing the universal ocean surrounding the earth.

Long A five-clawed dragon. See *mang.*

Longao (dragon coat or jacket) A knee-length or three-quarter-length robe with high, round neck and front overlap to the right fastened at the neck, clavicle, and right side with loops and toggles or pairs of ties and decorated with five-clawed dragons. *Longao* were worn by Han Chinese brides and by the wives of Chinese officials.

Longgua (dragon coat) A full-length, front-opening surcoat decorated with dragon roundels worn by imperial Manchu women. See also *gunfu.*

Longpao (dragon robe) A full-length court robe featuring a high, round neck, front overlap to the right fastened at the neck, clavicle, and right side with loops and toggles and decorated with five-clawed dragons, worn as part of *jifu. Longpao* may also refer to dragon robes used in quasi-official contexts such as weddings and for garments presented to deities to be displayed on statues in temples. See also *gunfu.*

Loop and toggle A system of fastening or holding garments closed, in which a fabric loop is attached to one edge of the garment. On the corresponding edge, a second fabric loop with a knotted fabric or metal toggle button is engaged in the loop.

Magua Literally, "horse jacket." A waist-length, front-opening jacket. Worn as a short surcoat by men and women.

Majia A waist-length sleeveless jacket or vest.

Mang A four-clawed dragon. See *long*.

Mangao (dragon coat or jacket) A knee-length or three-quarter-length robe with high, round neck and front overlap to the right fastened at the neck, clavicle, and right side with loops and toggles or pairs of ties and decorated with four-clawed dragons. *Mangao* were worn by Han Chinese brides and by the wives of Chinese officials.

Mangpao (dragon robe) A full-length robe featuring a high, round neck, front overlap to the right fastened at the neck, clavicle, and right side with loops and toggles and decorated with four-clawed dragons, worn as part of *jifu*. *Mangpao* may also refer to dragon robes used in quasi-official contexts like weddings and for garments presented to deities to be displayed on statues in temples.

Matixiu Literally, "horse hoof cuffs." Flaring sleeve extensions that provided protection for the back of the hand in the absence of gloves and mitts.

Maxie Literally, "horse boots." Boots worn by men with court attire.

Minghuang (brilliant yellow) See *huang*.

Neitao (inner tunic) A full-length robe featuring a high, round neck, front overlap to the right fastened at the neck, clavicle, and right side with loops and toggles, and horse hoof cuffs *(matixiu)*, worn as *changfu* by men and women. Also used to name the full-length robes worn domestically by Manchu men.

Neiwufu (Office of the Imperial Household) Qing dynasty bureau responsible for the management of the Forbidden City and members of the imperial family.

Niru (arrow) Name for companies of three hundred warriors in the Manchu army organization. The Chinese equivalent is *niulu*.

Pao (robe) A full-length garment.

Peplum A flounce or a short flared skirt attached at the waist of a garment and extending over the hips.

Piling Wide, flaring collar worn with *chaopao*.

Plastron A breastplate or a separate attached front part of an upper body garment.

Princes of the blood See *qinwang*.

Qi (banner) A colloquial term for Manchu. See also *gusa*.

Qilin One of the four fabulous beasts of Chinese mythology, a composite quadruped with a dragon's head, scaly body, deerlike legs, and a bushy tail. Used as the insignia for first-rank military officers and for imperial nobles of the ninth rank.

Qinwang (princes of the blood) Main line of nobility of the imperial clan. The Qing court ranked imperial kinsmen into two groups: a main line *(zongshi)* of those who were directly descended from Nurgaci and his brothers, and a collateral line *(jueluo)* of those who descended through other members of Nurgaci's grandfather's family. The main-line descendants were further graded into precise ranks. The first eight were called "princes of the blood," followed by four titles for nobles of imperial lineage. These four titles were further divided into ten grades.

Qipao (banner gown) A generic term for any Manchu robe, but used specifically for tight-fitting, full-length women's robes with side slits and stand-up collars that became popular at the end of the Qing dynasty. The Cantonese pronunciation of the term gives us the modern *cheungsam*.

Qiuxiangse (tawny incense) A color, ranging from brown to plum tones, used by members of the imperial clan other than the emperor and empress and their sons and highest-ranking consorts. See also *huang*.

Qixie (banner shoes) Manchu women's shoes set on a wooden sole or platform.

Quatrefoil A design convention mimicking the four petals of a flower.

Quatrefoil yoke See yoke.

Qun Paired aprons worn over leggings or trousers by Han Chinese women.

Ren The small tab at the lower-right waist of male *chaopao.*

Roundel A decorative arrangement of consolidated ornament that contrasts with the rest of the garment fabric.

Sericulture The procedure of cultivating or rearing *Bombyx mori* moth larva until they spin cocoons, then unwinding (reeling) the silk filament before the mature moth emerges.

Shujing (Book of historical records) Compilation describing events dating back to the third millennium B.C.E., written during the later Han dynasty (23–220 C.E.).

Tabard Upper body garment that slips over the head and is usually made without side seams.

Tabby Basic weave structure in which wefts alternately pass over and under warp threads.

Tienming (mandate of Heaven) The moral authority by which the emperor ruled the Chinese empire.

Torque A rigid necklace or collar. See *lingyue.*

Twelve Symbols of Ancient Imperial Authority A set of emblems symbolizing the emperor's power and authority that embellished ritual attire since the later Han dynasty (23–220 C.E.), but which were claimed to date from the third millennium B.C.E. Since the Han dynasty, each succeeding dynasty added them to the imperial wardrobe.

Waitao (outer coat) A front-opening surcoat of varying length, ranging from full length to hip length. Worn by both men and women.

Warp In weaving, the longitudinal threads that are arranged on the loom.

Weft In weaving, the transverse threads that are passed through the warp.

Wenren (man of culture) The Confucian ideal of an educated man who cultivates *li.*

Wuxing (Five Phases system) The five elements of the universe—earth, fire, water, metal, and wood—were believed to have a direct correspondence to seasons, directions, musical scales, and colors, affecting all activities in the world.

Xiangse (incense color) A greenish-yellow color worn by imperial consorts and some ranks of imperial princesses. See also *huang.*

Xiapei A sleeveless overgarment or vest, usually trimmed with knotted silk cord fringe, worn by Han Chinese women on formal occasions. During the Ming dynasty, *xiapei* were part of women's *chaofu* and carried decoration relating to court rank.

Xie (shoes) Generic name for closed footwear.

Xinghuang (apricot yellow) See *huang.*

Xingshang (riding coat) A full-length robe featuring a high, round neck, front overlap to the right fastened at the neck, clavicle, and right side with loops and toggles. To facilitate riding, the overlap is cut short and held with loops and toggles and the skirts are slit at the side, front, and back seams. It was worn as *changfu* by men.

Yoke In garment construction, a part of the garment that is fitted closely to the shoulders or hips as support for the gathered parts of the skirt. In Chinese costume decoration, the area of consolidated pattern that surrounds the neck opening. During the Ming and Qing dynasties, there were three variations of yoke patterns: multi-lobed composition, a four-pointed composition that evoked the points of a compass (see *yunjian*), and a quatrefoil composition often with protective dragons.

Yunjian (cloud collar) A four-pointed yoke worn with points at the shoulders, front, and back, worn by Han Chinese women with formal dress.

BIBLIOGRAPHY

Afpel, Iris Barrel. *Dragon Threads: Court Costumes of the Celestial Kingdom.* Newark, N.J.: The Newark Museum, 1992.

Alexander, William. *The costumes of China: picturesque representations of the dress and manners of the Chinese; illustrated in fifty coloured engravings, with descriptions.* Revised edition, Singapore: Grahm Brach, 1990.

Ayer, Jacqueline. *Oriental Costume.* London: Studio Vista, 1974.

Bartlett, Beatrice. *Emperors and Ministers: The Grand Council in Mid-Ch'ing China, 1723–1820.* Berkeley: University of California Press, 1991.

Beijing Archaeological Team. "Beijing Nan-yuan wai-zi keng ming dai mu zang qing li jian-pi" (Notes on the Ming dynasty burials at South Park Marsh, Beijing). *Wen Wu* 11 (1964): 45–47.

Brandauer, Fredrick P., and Chun-chieh Huang, eds. *Imperial Rulership and Cultural Change in Imperial China.* Seattle: University of Washington; Shanghai: Kelly and Walsh, 1931.

Burnham, Dorothy K. *Cut My Cote.* Toronto: Royal Ontario Museum, 1973.

Bussagli, Mario. *Cotton and Silk Making in Manchu China.* New York: Rizzoli, 1980.

Cammann, Schuyler V. R. "Notes on the Development of Mandarin Squares." *Bulletin of the Needle and Bobbin Club,* 1942: 2–28.

————. "Development of the Mandarin Square." *Harvard Journal of Asian Studies* 8 (1944): 71–130.

————. "Origins of the Court and Official Robes of Ch'ing Dynasty." *Artibus Asiae* 12 (1949): 189–201.

————. *China's Dragon Robes.* New York: The Ronald Press, 1952. Reprint, Chicago: Art Media Resources, Ltd., 2001.

————. "Chinese Mandarin Squares: Brief Catalogue of the Letcher Collection." *University of Philadelphia Museum Bulletin* 17, no. 3 (1953): 5–72.

————. "Embroidery Techniques in Old China." *Archives of the Chinese Art Society in America,* 16 (1962): 16–40.

————. "Ch'ing Dynasty 'Mandarin Chains.'" *Ornament: A Quarterly of Jewelry and Personal Adornment* 4 (April 1979): 25–29.

————. "Birds and Animals as Ming and Ch'ing Badges of Rank." *Arts of Asia,* May–June 1991: 88–94.

Capon, Edmund. "Chinese Court Robes in the Victoria and Albert Museum." *Victoria and Albert Museum Bulletin* 4, no. 1 (1968): 17–25.

Chi Jo-hsin and Chen Hsia-sheng. *Qingdai fushi zhanlan tulu* (Ch'ing Dynasty costume accessories). Taipei: National Palace Museum, 1986.

Chou-hsien Cultural Protection Office. "Shantung Chou-hsien Yuan tai Li Yu-an mu Chu-ti" (Excavation of the Yuan dynasty tomb of Li Yu-an at Chou-hsien Shantung Province). *Wen Wu* 4 (1978): 14–20.

Chung, Young Yang. *The Art of Oriental Embroidery.* New York: Charles Scribner and Sons, 1980.

Da Qing Huidian shili (The collected institutes and precedents of the great Qing [dynasty]). Chinese government edict. 1899. Reprint, Taipei: Chiwen Book Co., 1963.

D'ardenne de Tizac, J. *The Stuffs of China: Weavings and Embroideries.* London: Ernest Benn, 1924.

Datong City Museum. "Datong qin dai Ye Deyuan mu zang qui pi" (Excavations of the Qing dynasty tomb of Ye Deyuan at Datong in Shansi Province). *Wen Wu* 4 (1978): 1–13.

DeGraw, Imelda G., ed. *Secret Splendors of the Chinese Court: Qing Dynasty Costume from the Charlotte Hill Grant Collection.* Denver: Denver Art Museum, 1981.

Dickinson, Gary, and Linda Wrigglesworth. *Imperial Wardrobe.* Berkeley: Ten Speed Press, 2000.

Digby, George Wingfield. "Chinese Court Costume and Dragon Robes." Parts 1 and 2. *The Connoisseur,* September 1950: 11–18; November 1950: 95–105.

Douin, G. "Ceremonial de la Cour et coutumes du peuple de Pékin." Parts 1–3. *Bulletin de l'Association amical franco-chinoise* 2, no. 2 (April 1910): 105–38; 2, no. 3 (July 1910): 215–37; 2, no. 4 (October 1910): 347–68.

Elliott, Mark C. *The Manchu Way: The Eight Banners and Ethnic Identity in Late Imperial China.* Stanford, Calif.: Stanford University Press, 2001.

Fairbank, John K., and Edwin O. Reischauer. *China: Tradition and Transformation.* Boston: Houghton Mifflin, 1978.

Fairservice, Walter A., Jr. *Costumes of the East.* Riverside, N.Y.: The American Museum of Natural History, 1971.

Fernald, Helen C. *Chinese Court Costumes.* Toronto: Royal Ontario Museum of Archaeology, 1946.

Feuerwerker, Albert. "State and Society in Eighteenth-Century China: The Ch'ing Empire in Its Glory." *Michigan Papers in Chinese Studies,* vol. 27 (1976).

Fung Yu-lan. *A History of Chinese Philosophy.* 2 vols. Princeton, N.J.: Princeton University Press, 1952–53.

Galloway, Francesca, and Jacqueline Simcox. *The Art of Textiles.* London: Spink & Son, Ltd., 1989.

Gao Hanyu. *Chinese Textile Designs.* London: Penguin Books Ltd., 1992.

Garrett, Valery M. *Traditional Chinese Clothing in Hong Kong and South China, 1840–1980.* Hong Kong: Oxford University Press, 1987.

———. *Mandarin Squares: Mandarins and Their Insignia.* Hong Kong: Oxford University Press, 1990.

———. *Chinese Clothing: An Illustrated Guide.* Hong Kong: Oxford University Press, 1994.

———. *A Collector's guide to Chinese dress accessories.* Singapore: Timese Editions, [1997].

Gervers-Molnar, Veronika. *The Hungarian Szur: An Archaic Mantle of Eurasian Origin.* Toronto: Royal Ontario Museum, 1973.

Haku, Insei, et al. *Shikinjo no kohi kyutei-geijutsu: Pekin kokyu hakubutsuin-ten* (Empresses and their Court Art in the Forbidden City: From the collection of the Palace Museum, Beijing). Tokyo: Sezon Museum of Art, 1997.

Hall, Chris, Carolyn Dale Gluckman, Valrae Reynolds, et al. *Heaven's Embroidered Cloths: One Thousand Years of Chinese Textiles.* Hong Kong: Urban Council of Hong Kong, 1995.

Hansen, Henny Harald. *Mongol Costume.* 1950. Reprint, Copenhagen: Rhodes International Science and Art Publishers AIS, 1993.

Hays, Mary V. "Chinese Skirts of the Qing Dynasty." *Bulletin of the Needle and Bobbin Club* 72, nos. 1 and 2 (1989): 5–41.

Heissig, Walther, *The Religions of Mongolia.* Translated by G. Samuel. Berkeley and Los Angeles: University of California Press, 1980.

Hevia, James. "Lamas, Emperors and Rituals: Political Implications in Qing Imperial Ceremonies." *Buddhist Studies* 16, no. 2 (Winter 1993): 243–78.

Hsia Ho-hsiu and Ch'ao Feng. "Ta-mao-ch'I Fa Ssu Ch-Hsiang Ming-shui Mu-ti Chu-tu Te Ssu-Ch'I-Pin" (Ancient fabrics uncovered at the Ming shui tomb Ta-ssu-ch'I-hsiang Ta-mao banner). *Nei-Meng-Ku Wen wu Kao-ku* (Inner Mongolian journal of archaeology and cultural relics), 1992: 1–2.

Huang Nengfu and Chen Juanjuan. *Zhongguo fushi yishu yuanliu* (Origins of the art of Chinese national costume). Beijing: Zhongguo luyou chubanshe, 1994.

Huang Nengfu and Chen Juanjuan. "The Emperor's Clothes." In *Evolution & Revolution: Chinese Dress 1700s–1990s,* edited by Claire Roberts. Sydney: Powerhouse Publishing, 1997.

Huangchao liqi tushi (Illustrated precedents for the ritual paraphernalia of the [Qing] imperial court). 18 vols. Chinese government edicts. Beijing: 1759, 1761.

Hughes, Lindsay. *The Kuo Ch'in Wang Textiles.* New York: Gallery Press, 1945.

Jackson, Beverley. *Splendid Slippers: A Thousand Years of an Erotic Tradition.* Berkeley: Ten Speed Press, 1998.

Jackson, Beverley, and David Hugus. *Ladder to the Clouds: Intrigue and Tradition in Chinese Rank.* Berkeley: Ten Speed Press, 1999.

Jacobsen, Robert D. *Imperial Silks: Ch'ing Dynasty Textiles in the Minneapolis Institute of Arts.* 2 vols. Minneapolis: Minneapolis Institute of Arts, 2000.

———. *Imperial Silks of the Qing Dynasty.* Minneapolis: Minneapolis Institute of Arts, 1991.

Jochelson, Waldemar. *The Koryak.* 1908. Reprint, New York: American Museum of Natural History, 1975.

———. *The Yukaghir and the Yukaghirized Tungus.* 1926. Reprint, New York: American Museum of Natural History, 1975.

———. *The Yakut.* 1933. Reprint, New York: American Museum of Natural History, 1975.

Kahn, Harold L. *Monarchy in the Emperor's Eyes: Image and Reality in the Ch'ien-lung Reign.* Cambridge: Harvard University Press, 1971.

Kanomi, Takako. *People of Myth, Textiles and Crafts of the Golden Triangle.* Kyoto: Shinkosha Publishing Company, 1991.

Kendall, Laurel, Stanley A. Freed, and Thomas R. Miller. *Drawing Shadows to Stone: The Photography of the Jesup North Pacific Expedition, 1897–1902.* Seattle: University of Washington Press, 1997.

Ko, Dorothy. "Power in the Inner Court of the Qing Dynasty: Footbinding among Manchu Women." *Proceedings of the Denver Museum of Natural History* 3, no. 13 (Summer 1998): 37–48.

Krahl, Regina. "Early Bronze Age Dress." *Orientations* 26, no. 5 (May 1995): 58–61.

Kuhn, Dieter. "The silk-workshops of the Shang dynasty (16th–11th Century B.C.)." In *Explorations in the History of Science and Technology in China: A Special Number of the "Collections of Essays on Chinese Literature and History" in Honour of the Eightieth Birthday of Dr. Joseph Needham, FRS, FBA,* edited by Li Guohao, Zhang Mengwen, and Cao Tianqin, 367–408. Shanghai: Shanghai Chinese Classics Publishing House, 1982.

———. *Le Vêtement sous la Dynastie des Qing: La Cité interdite, vie publique et privée des empereurs de Chine 1644–1911.* Paris: Association Française d'Action Artistique Ministère des Affaires étrangères, 1997.

Lattimore, Owen. *Manchuria: Cradle of Conflict.* New York: Macmillan, 1932.

———. *Inner Asian Frontiers of China.* Boston: Beacon Press, 1962 (paperback).

Laumann, Maryta. *The Secret of Excellence in Ancient Chinese Silks.* Taipei: Southern Materials Center, Inc., 1984.

Leavitt, Ernest E., Jr. *The Silkworm and the Dragon.* Tucson: Arizona State Museum, 1968.

Levin, M. G., and L. P. Potapov. *Istoriko-etnograficheskii atlas Sibiri* (Historical ethnographical atlas of Siberia). Moscow: USSR Academy of Science, 1961.

————, eds. *Narody Sibiri*. Moscow: Russian Academy of Science, 1956. Published in English as *The Peoples of Siberia*, edited by Stephen Dunn, Chicago: University of Chicago Press, 1964.

Levy, Howard. *Chinese Footbinding: The History of a Curious Erotic Custom*. New York: Bell Publishing Co., 1967.

Lin Shuxin. *Yi jin xing: Zhongguo fu shi xiang guan zhi yan jiu* (The history of Chinese textiles, costumes and accessories). Taipei: Guo li li shi bo wu guan, 1995.

Lu Chuangen and Li Wenzhao, eds. *Zhong-guo mei shu chuan ji* (The great treasury of Chinese fine arts). Vols. 6 and 7. Beijing: Peoples' Fine Arts Publishing House, 1989.

Lubo-Lesnichencko, Evgeny I. *Drevniye Kitaiskiye shelkoviye tkani i vyshivki V v. do n.e. - III v n.e. v. sobranii Gosudarstvennom Ermitazha* (Ancient Chinese silk textiles and embroideries, fifth century B.C. to third century A.D. in the Collection of the State Hermitage Museum). Leningrad: State Hermitage Museum, 1961. English translation by N. Priverts, edited by H. B. Burnham, available at the CIETA library, Lyon, France.

Ma Qiang, et. al. *Chung-kuo his chu fu chuang tu chi* (Pictorial album of costumes in Chinese traditional opera). Tai-yuan: Chung-kuo hsin hua shu tien tsung tien tsung Pei-ching fa hsing, 1995.

Mailey, Jean E. "Ancestors and Tomb Robes." *The Metropolitan Museum of Art Bulletin* XXII, no. 3 (November 1963): 101–15.

————. *Chinese Silk Tapestry: K'o-ssu, from Private and Museum Collections*. New York: China Institute in America, 1971.

————. *Embroidery of Imperial China*. New York: China Institute in America, 1978.

————. The Manchu Dragon: Costumes of the Ch'ing Dynasty 1644–1912. *New York: Metropolitan Museum of Art, 1980*.

McGuinness, Stephen, and Sae Ogasawara. *Chinese Textile Masterpieces: Sung, Yuan, and Ming Dynasties*. Hong Kong: Plum Blossoms, 1988.

Medley, Margaret. *The Illustrated Regulations for Ceremonial Paraphernalia of the Ch'ing Dynasty*. London: Han-Shan Tang, 1982.

Milhaupt, Terry. "The Chinese Textile Collection at the Metropolitan Museum of Art." *Orientations* 23, no. 1 (January 1992): 72–78.

Mingshi (History of the Ming dynasty). Chinese government–sponsored publication. 1739. Reprint, Beijing: Zhonghua shuju Distribution, 1974.

Minnich, Helen Benton. *Chinese Imperial Robes at the Minneapolis Institute of Arts*. Minneapolis: Minneapolis Institute of Arts, 1970.

Moore, Oliver. "Arms and Armour in Late Imperial China." *Apollo* 140, no. 396 (1995): 16–19.

Mote, Fredrick W. *Imperial China 900–1800*. Cambridge: Cambridge University Press, 1999.

Nanjing Municipal Museum. "Mingchao shoushi guanfu" (Jewelry and costumes of the Ming dynasty). In *Zhongguo Nanjingshi Bowuguan Cang Wenwu Jingpin Xilie Tul*. Beijing: People's Fine Arts Publishing House, 2000.

National Museum of History, Republic of China. *Chinese Costume, Brocade, Embroidery*. Taipei: National Museum of History, 1977.

Okladnikov, A. P. *Yakutia Before Its Incorporation into the Russian State*. 1950, 1955. Second edition published in English in *Anthropology of the North: Translations from Russian Sources*, no. 8, edited by Henry N. Michael. Montreal: McGill-Queen's University Press, 1970.

Oxnam, Robert B. *Ruling from Horseback*. Chicago: University of Chicago Press, 1975.

Pal, Pratapaditya. *Art of Tibet: A Catalogue of the Los Angeles County Museum of Art Collection*. Los Angeles: Los Angeles County Museum of Art, 1990.

Pan Xingrong and Yi Zao. "Yuan Jininglu gucheng chutu de jiaocang sizhiwu ji qita" (The hoard of ancient silk fabrics uncovered at the ancient Yuan city Jininglu and other matters). *Wen Wu*, 8 (1979): 32–35.

Pang, Anna Mae, ed. *Dragon Emperor: Treasures from the Forbidden City.* Melbourne: National Gallery of Victoria, 1989.

Priest, Alan. "Prepare for Emperors." *Metropolitan Museum of Art Bulletin,* Summer 1943.

———. *Catalogue of an exhibition of imperial robes and textiles for the Chinese court.* Minneapolis: Minneapolis Institute of Art, 1943.

———. *Costumes from the Forbidden City.* New York: Metropolitan Museum of Art, 1945.

Reynold, Valrae. *Tibet: A Lost World.* New York: The American Federation of Arts, 1978.

———. "From a Lost World: Tibetan Costumes and Textiles." *Orientations* 12, no. 3 (March 1981): 6–22.

Riboud, Krishna. "A Cultural Continuum: A New Group of Liao and Jin Dynasty Silks." *Hali* 82 (August–September 1995): 92–105; 119–20.

Rossabi, Morris. *China and Inner Asia.* New York: Pica Press, 1975.

Scott, A. C. *Chinese Costumes in Transition.* Singapore: Donald Moore, 1958.

Shen Congwen. *Zhongguo gudai fushi yanjiu* (Examination of ancient Chinese costume). Hong Kong: Commercial Press, 1981.

Shirokogoroff, S. M. *Social Organization of the Northern Tungus.* 1929. Reprint, New York: Garland Publishing Inc., 1979.

———. *Psychomental Complex of the Tungus.* London: Kegon Paul, 1935.

Sirich, Marjorie W. *An Exhibition of Chinese Imperial Robes and Textiles Selected from the Collection of the Minneapolis Institute of Arts.* Minneapolis: Minneapolis Institute of Arts, 1960.

Spence, Jonathan D. *Emperor of China: Self Portrait of Kang-hsi.* New York: Vintage Books, 1975.

Ter Molen, J. R., and Ellen Uitzinger, eds. *De Verboden Stad/The Forbidden City.* Rotterdam: Museum Boymans-van Beuningen, 1990.

Tilke, Wolfgang Bruhn Max. *Costume Patterns and Designs: A Survey of Costume of All Periods and Nations from Antiquity to Modern Times Including National Costume in Europe and Non-European Countries.* New York: Praeger, 1957.

Tucci, Guiseppi. *The Religions of Tibet.* Translated by G. Samuel. Bombay: Allied Press, 1980.

Vollmer, John E. *In the Presence of the Dragon Throne: Ch'ing Dynasty Costume (1644–1911) in the Royal Ontario Museum.* Toronto: Royal Ontario Museum, 1977.

———. "Costume and Chinese Portraits." *Canadian Antiques Collector* 12, no. 3 (May–June 1977): 26–29.

———. "Sources for Manchu Costume of the Ch'ing Dynasty (1644–1911)." *Bulletin du Centre International d'Etudes des Textiles Anciens* 47–48 (1979): 47–61.

———. *Five Colours of the Universe: Symbolism in Clothes and Fabrics of the Ch'ing Dynasty (1644–1911).* Hong Kong: Edmonton Art Gallery, 1981.

———. *Decoding Dragons: Status Garments in Ch'ing Dynasty China.* Eugene, Ore.: University of Oregon Museum of Art, 1983.

———. "China and the Complexities of Weaving Technology." *Ars Textrina* 5 (June 1986): 65–89.

———. "Power in the Inner Court of the Qing Dynasty: The Emperor's Clothes." *Proceedings of the Denver Museum of Natural History* 3, no. 13 (Summer 1998): 49–54.

———. *Chinese Costume and Accessories 17th–20th century.* Paris: Association pour l'Étude et la Documentation des Textiles de Asie, 1999.

———. "Clothed to Rule the Universe: Ming and Qing Dynasty Textiles at the Art Institute of Chicago." *Museum Studies* 26, no. 2 (2000): 12–79; 99–112.

———. *Celebrating Virtue: Prestige Costume and Fabrics of Late Imperial China.* Study guide for a traveling exhibition circulated by Textile Museum of Canada in cooperation with the Glenbow Museum. Toronto: Textile Museum of Canada, 2000.

Vuilleumier, Bernard. *The Art of Silk Weaving in China: Symbolism of Chinese Imperial Ritual Robes.* London: The China Institute, 1939.

Wakeman, Frederic, Jr. *The Fall of Imperial China.* New York: Free Press, 1975.

————. *The Great Enterprise: The Manchu Reconstruction of Imperial Order in Seventeenth-Century China.* 2 vols. Berkeley: University of California Press, 1985.

Wang Zhimin. *Longpao* (Dragon robes). Taipei: Yishu tushu gongsi, 1994.

Wardwell, Anne E. "Recently discovered textiles woven in the western part of central Asia before A.D. 1220." *Textile History* 20, no. 2 (1989): 175–84.

————. "Two silk and gold textiles of the early Mongol period." *Bulletin of the Cleveland Museum of Art* 79, no. 10 (December 1992): 354–78.

————. *"Important Asian textiles recently acquired by the Cleveland Museum of Art."* Oriental Art *33, no. 4 (Winter 1992–93): 244–51.*

Watson, Burton. *Records of the Grand Historians of China.* 2 vols. New York: Columbia University Press, 1961.

Watt, James C. Y., and Anne E. Wardwell. *When Silk Was Gold: Central Asian and Chinese Textiles.* New York: The Metropolitan Museum of Art in cooperation with the Cleveland Museum of Art, 1998.

Williams, Edward T. "The State Religion of China During the Manchu Dynasty." *Journal of the North China Branch of the Royal Asiatic Society* 44 (1913): 11–45.

Wilson, Verity. *Chinese Dress.* Far Eastern Series. London: Victoria and Albert Museum, 1986.

Wrigglesworth, Linda. *The Accessory: China.* London: Linda Wrigglesworth, 1991.

————. *The Badge of Rank II: China.* London: Linda Wrigglesworth, 1991.

————. *Making the Grade: The Badge of Rank III.* London: Linda Wrigglesworth, 1996.

————. *The Sway of the Golden Lotus: An Exhibition of Manchu and Bound Feet Shoes Worn by Chinese Children and Women in Imperial China, Qing Dynasty 1644–1911.* London: Linda Wrigglesworth, 1996.

Wu Hung. "Emperor's Masquerade—'Costume Portraits' of Yongzheng and Qianlong." *Orientations* 26, no. 7 (July–August 1995): 25–41.

Yu Hui. "Naturalism in Qing Imperial Group Portraiture." *Orientations* 26, no. 7 (July–August 1995): 42–50.

Yuan Hongqi, et. al. *Empress Dowager Cixi: Her Art of Living.* Hong Kong: Regional Council, Hong Kong; Beijing: The Palace Museum, 1996.

Zhao Feng. *Treasures in Silk: An Illustrated History of Chinese Textiles.* Hong Kong: ISAT/Costume Squad Ltd., 1999.

Zhou Xibao. *Zhougguo gudai fushi shi* (History of Chinese costume and accessories). Beijing: Zhongguo xiju chubanshe, 1984.

Zhou Xun and Gao Chunming. *5000 Years of Chinese Costume.* Hong Kong: C & C Joint Publishing Co., 1987.

Zwalf, W. *Heritage of Tibet.* London: British Museum Publications Limited, 1981.

INDEX